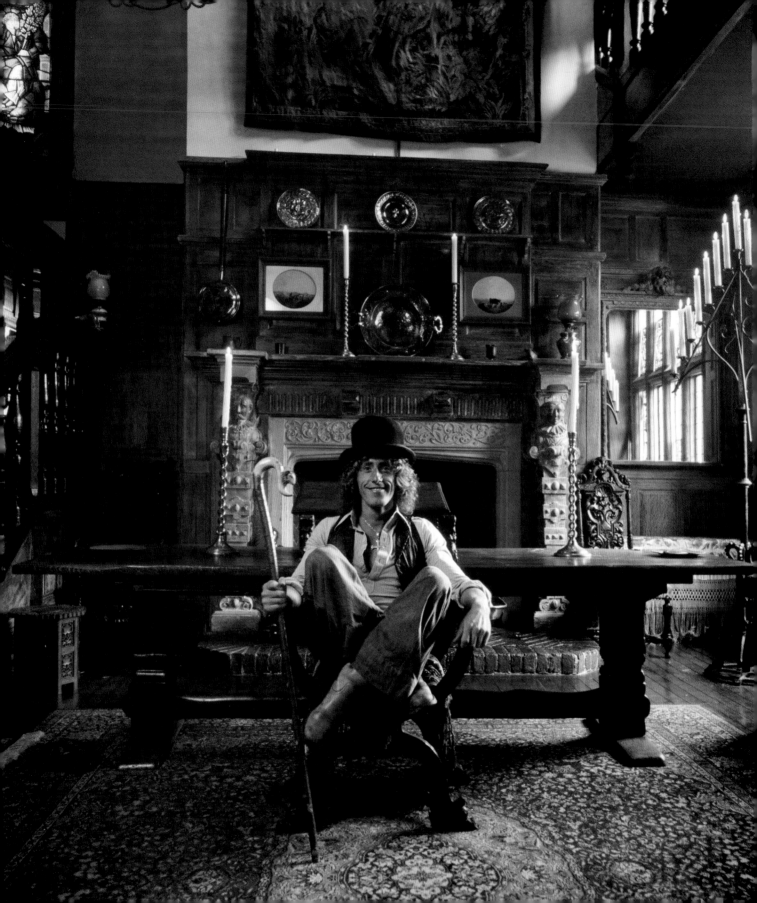

Rock Stars
AT HOME

with contributions from

CHRIS CHARLESWORTH ★ **DARYL EASLEA** ★ **EDDI FIEGEL**
BRYAN REESMAN ★ **COLIN SALTER** ★ **SIMON SPENCE**

APOLLO
PUBLISHERS

Rock Stars at Home
Copyright © 2018 by Elephant Book Company Limited

Apollo Publishers books may be purchased for educational, business, or sales promotional use. Special editions may be made available upon request. For details, contact Apollo Publishers at info@apollopublishers.com.

Visit our website at www.apollopublishers.com.

Library of Congress Cataloging-in-Publication Data is available on file.

Editorial Director: Will Steeds
Project Editor: Tom Seabrook
Cover and interior design by Paul Palmer-Edwards, GradeDesign.com

Print ISBN: 978-1-94-806228-2

Ebook ISBN: 978-1-94-806229-9

Printed in China

FRONT COVER: Elton John shows off his collection of platform shoes in a walk-in wardrobe at his home in Beverly Hills, 1975. Perched on his shoulder is a soft toy in his own likeness.

PREVIOUS SPREAD: Lord of the manor: Roger Daltrey of the Who at Holmhurst Manor, his estate near Burwash, East Sussex, 1978.

ROCK STARS

and their homes

THROUGH THE KEYHOLE...

INTRODUCTION

By Tom Seabrook

They say you can learn a lot about people from the way they live, and rock stars are no exception. This book opens a window into the homes and domestic lives of some of the biggest names in music from the fifties to the present day.

Rock Stars at Home kicks off with the owners of two of the finest voices in music history, Frank Sinatra and Elvis Presley, whose choices of home would prove almost as remarkable as their recorded output. While Ol' Blue Eyes favored modernist Californian villas within a stone's throw of the nearest golf course, the King, in his first flush of success, bought the palatial Graceland, now one of the most visited buildings in North America. They needed their creature comforts too, though, which in Presley's case meant three TVs for simultaneous viewing of live football games, and fried banana and peanut butter sandwiches on hand at all times.

If a home befitting newfound wealth was top of the list, an extravagant pool would become a must, too: Sinatra, like Liberace, had his in the shape of a piano; Chuck Berry's echoed the curves of his favorite Les Paul Custom, *Lucille*.

Rock and pop's peak years in the sixties and seventies also coincided with some of the greatest examples of the rock star home, from Keith Richards's country pile—filled to the brim with rare books filed using the Dewey decimal library system—to Neil Young's sprawling ranch. Throughout this period, it was not uncommon for stars to give journalists, photographers, or even fans a guided tour of their domiciles.

Things changed irrevocably on December 8, 1980, when John Lennon was shot and killed on the doorstep of his home at the Dakota apartment building in New York City. Shortly after that, Lennon's fellow Beatle, George Harrison, closed the grounds of his once-public home in Henley-on-Thames, and plenty of his peers would follow suit.

Many of the biggest stars of recent decades have proven similarly guarded, with the likes of Prince, Michael Jackson, and today Kanye West putting up tall fences and making privacy and seclusion a high priority. Thankfully, others remain more welcoming, with a slew of rock and rap stars queuing up to show viewers of MTV's *Cribs* their homes—or at least the ones they'd borrowed for the day to show just how lavish their lives had become.

It's not all pools and private planes, though. Along the way, you'll find some surprising shared interests: the crooner and the Canadian rocker with a mutual passion for trains; the rock 'n' roll pioneer and the prog-rock prophet who both enjoyed nothing more than to wind down with a game of croquet. David

"YOU WOULD THINK THAT A ROCK STAR BEING MARRIED TO A SUPERMODEL WOULD BE ONE OF THE GREATEST THINGS THERE IS. IT IS."
David Bowie

Bowie, meanwhile, ended up selling his island paradise in Mustique because it was so peaceful that he couldn't get any work done there. By contrast, he produced some of his finest music during the two years he spent living in a rundown corner of Berlin. That's rock stars for you.

Get ready, then, for a guided tour of the homes and gardens, the planes and playgrounds, and the unusual habits and hobbies of some of the biggest and most extravagant stars the music world has ever seen.

OPPOSITE: Alice Cooper with his wife and daughter (in masks) by the pool at their home in Hollywood, 1974. He moved to California from New York in part because the golf courses were better.

FOLLOWING SPREAD: Rod Stewart poses in leopard-print suit with a horse and a foal on the grounds of his home in Old Windsor, which he bought for £89,000—a huge sum at the time—in 1971.

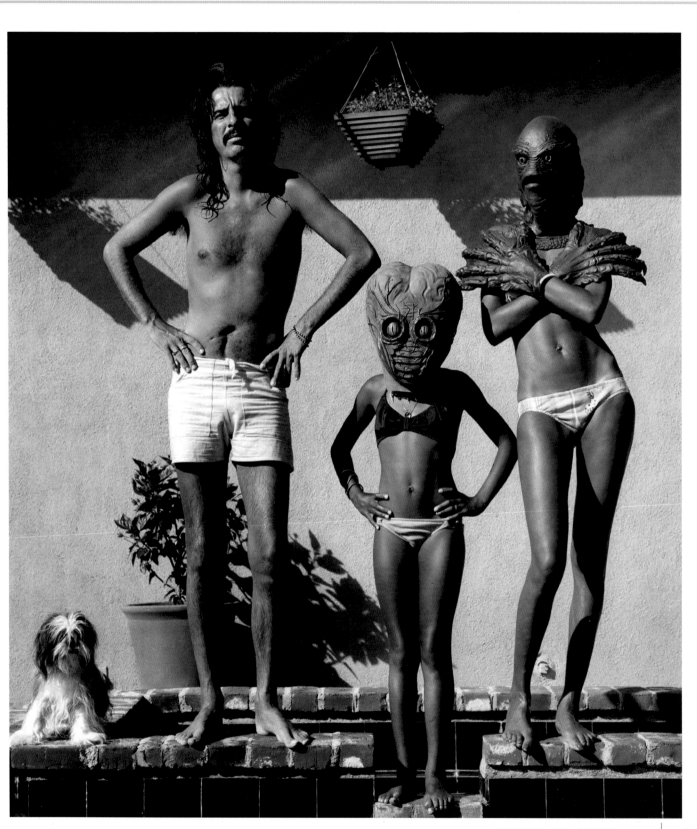

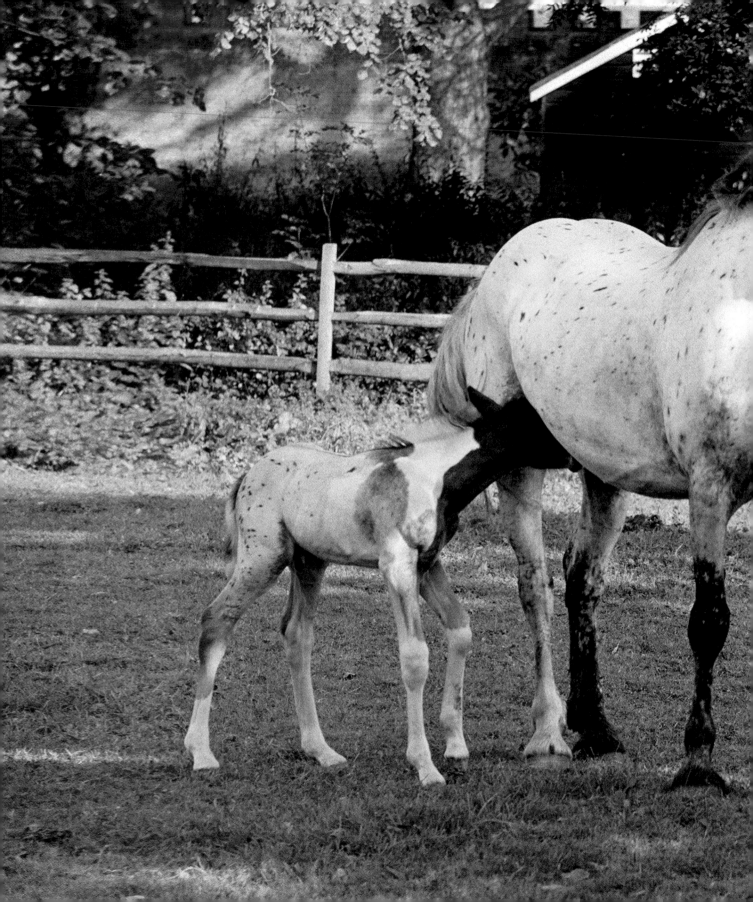

"INSTEAD OF GETTING MARRIED AGAIN, I'M GOING TO FIND A WOMAN I DON'T LIKE AND JUST GIVE HER A HOUSE."

Rod Stewart

FRANK SINATRA

TWIN PALMS, PALM SPRINGS, CALIFORNIA (HOME FROM 1947 TO 1957)
THE COMPOUND, COACHELLA VALLEY, CALIFORNIA (HOME FROM 1957 TO 1995)

By Simon Spence

Noted for his immaculate sense of style, Frank Sinatra owned a remarkable array of luxury homes during his lifetime, many of which were linked with the famous ladies in his life and the notorious parties he held there. For instance, a penthouse he owned from 1961 to 1972 on the Upper East Side of Manhattan, with sweeping views of the East River and a spectacular wraparound terrace, was the city location for his short-lived mid-'60s marriage to a then-twenty-one-year-old Mia Farrow. It was also where, in the glassed-in rooftop party room, the fifty-year-old "King of the Rat Pack" entertained such luminaries as President John F. Kennedy, Marilyn Monroe, and Andy Warhol. (When he wasn't entertaining, he used the room to work on his vocals.)

The first Sinatra home to achieve truly iconic status, however, was Twin Palms, his home in the desert city of Palm Springs in Riverside County, California, sometimes dubbed "Sinatra House." It was both architecturally stunning and the stage for his tempestuous '50s marriage to the infamous actress Ava Gardner. Sinatra actually had the house built to spec in 1947 while still married to his first wife, his childhood sweetheart, Nancy. With two young children and a third on the way, it was hoped that in this new home, away from the Hollywood glare, they might patch their marriage, which was on the rocks due to Sinatra's philandering, often with high-profile stars such as Marlene Dietrich.

Sinatra had just turned thirty, a newly minted millionaire in the first flush of solo recording success and movie stardom, with an army of zealous teenage girl fans—"bobbysoxers," as they became known. He chose the land where Twin Palms was to sit for its remoteness; back then, the only other nearby landmark was a landing strip. Already a keen photographer, he loved the beauty of the vast desert landscape, and the new house was built specifically to least disturb the serenity of the environment. A modernist single-story house—open-plan and flat-roofed, with vast glass walls that brought the outside in—Twin Palms was named after the two palm trees that towered above the large piano-shaped swimming pool, which was designed so that when the sun hit the openings in the veranda at the right angle, the shadows formed piano keys on the pool sidewalk. It was fitted with one of the first home recording studios, too: a custom system assembled by Valentino Electronics in Los Angeles. The star of the setup was a turntable that could transfer mono recordings on to acetate discs; unfortunately, none of Sinatra's home recordings have so far surfaced.

Nancy did not get to enjoy Twin Palms for long. Following the birth of their third child, Tina, in 1948, she and Frank split up. Romantic scandals had continued to dog the singer, and he was rumored to have bedded stars such as Lana Turner and Dinah Shore in the master bedroom at Twin Palms, which took up an entire wing of

—

"WHAT I DO WITH MY LIFE IS OF MY OWN DOING. I LIVE IT THE BEST WAY I CAN. I'VE BEEN CRITICIZED ON MANY, MANY OCCASIONS BECAUSE OF . . . ACQUAINTANCES, AND WHAT HAVE YOU. BUT I DON'T DO THESE THINGS TO HAVE ANYBODY FOLLOW ME IN DOING THE SAME THING."
Frank Sinatra

—

the building. It was his relationship with Gardner, however, that had finally done for the marriage.

Sinatra—already the recipient of much adverse publicity due to his links to senior Mafia figures, having

OPPOSITE TOP: A poolside view of Sinatra's Twin Palms estate, built to his specifications in 1947 by the architect E. Stewart Williams.

OPPOSITE BOTTOM: Sinatra and his fourth (and final) wife, Barbara Marx, in a sunroom at the Compound in the mid-1970s.

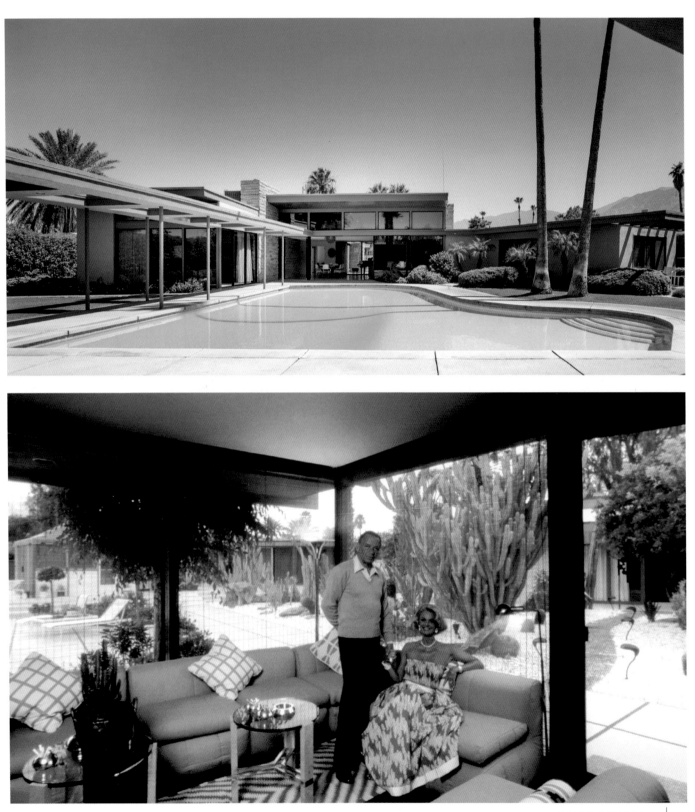

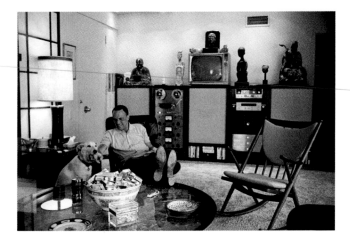

Sinatra at the Compound, 1965, reading a film script while his sheepdog, Ringo, sits by his side. Behind him is a $5,000 hi-fi system featuring reel-to-reel and 78rpm players.

famously attended the "Havana Conference" in 1946—was blasted by the press for his abandonment of Nancy, who continued to live in another of their properties, a luxury mansion in the ultra-exclusive Toluca Lake area of Los Angeles, now home to the likes of Justin Bieber and Miley Cyrus. Gardner, at thirty-six, was already twice married, to actor Mickey Rooney and jazz great Artie Shaw, and considered a *femme fatale*. When she moved into Twin Palms, the house quickly became known for its decadent parties, with Sinatra hanging a flag bearing the Jack Daniels emblem whenever one was happening.

—

"FRANK HAD ALWAYS COLLECTED TRAINS. HE WOULD CLIMB UP THERE AND MOVE THINGS AROUND. IT'S NOISIER THAN A REAL STATION WHEN EVERYTHING IS RUNNING."
Interior designer Bea Korshak to *Architectural Digest*

—

Sinatra's presence turned Palm Springs into a Hollywood hotspot, with stars such as Cary Grant, Bob Hope, and Bing Crosby all making homes close by in a neighborhood that came to be dubbed the "Movie Colony." Sinatra's marriage to Gardner, whom he wed in 1951, was turbulent; their fights at Twin Palms were legendary, with champagne bottles flying and possessions dumped on the driveway. Twice Gardner fell pregnant, and twice she had abortions. Both had not-so-discrete affairs. One night, Sinatra was said to be so distraught about the failing marriage that he took an overdose of sleeping pills.

Sinatra's career had stalled during the early '50s, a period he would later refer to as "the dark ages." He did however discover a new passion during that time that would provide him with a lifetime of enjoyment: painting. One of his best-known early oil paintings, of a dog Gardner owned, was a gift to her; a self-portrait depicting himself as a melancholy clown reflected his feelings after their divorce in 1954.

Sinatra moved out of Twin Palms soon after his divorce from Nancy was finalized and sold the house in 1957. (When it was last on the market, in 2005, it fetched $2.9 million.) The place he bought next, only a few miles away, would become, if anything, even more famous, if not quite so well noted for its architecture. Sinatra said the move was due to Palm Springs becoming too crowded, but in reality Twin Palms held too many bad memories for him to stay.

Setting himself up in nearby Rancho Mirage, in California's Coachella Valley, offered the chance of a new start. By now, he had spectacularly revived his career, an Oscar for "Best Supporting Actor" for the 1953 war movie *From Here to Eternity* leading to a slew of major hit films over the next decade, including *The Man with the Golden Arm*, *The Manchurian Candidate*, and *High Society*. And, with the assistance of a new arranger Nelson Riddle, his recording career was also given new life, the famous 1954 hit album *Songs for Young Lovers* presaging a shift to jazz and swing.

Initially, Sinatra's new house, Villa Maggio—built beside the seventeenth fairway on land that was part of Tamarisk Country Club on Wonder Palms Road, now known as Frank Sinatra Drive—was modest, and much smaller than Twin Palms. The one-story home only had two bedrooms and a tiny kitchen when he moved in, but would soon be expanded and remodeled, with two small cottages added to flank the swimming pool. Sinatra also snapped up adjoining lots, and before long owned two and a half acres of land surrounding the house. In 1960, Senator John F. Kennedy—months from becoming president—spent two days at Villa Maggio in a guest room.

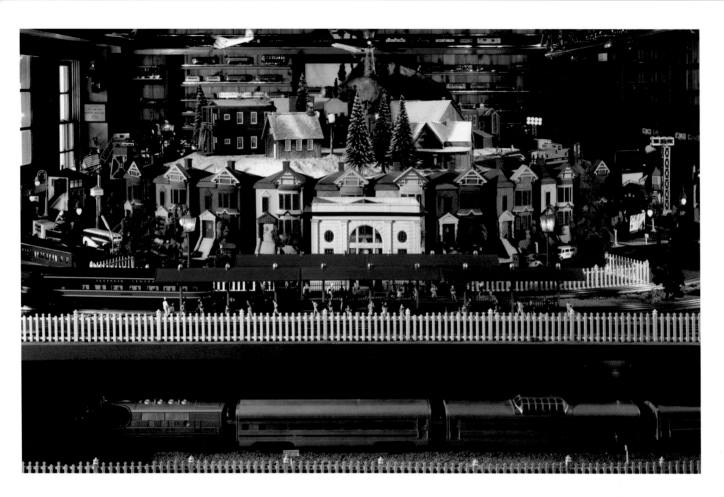

Further additions to the estate over the years led to it being dubbed "The Compound." Sinatra installed a heliport and a huge restaurant-style kitchen, and built more cottages for security staff, an additional guesthouse, a tennis court, a new office, and a small movie theater and projection room. For a while, the heliport—built in expectation of another visit from Kennedy that never happened—was used to chopper in Rat Pack pals such as Dean Martin and Sammy Davis Jr., plus showgirls from Las Vegas, for wild parties. Meanwhile, the house's proximity to the golf course sparked a longstanding love of the game—albeit one he never quite mastered.

After his brief marriage to Farrow ended in 1968, Sinatra spent more time at the Compound, adding an artist's studio to the estate. Painting remained his favorite way to relax and restore his energy, although for many years he refused to show his work. The first glimpse the public had into his artwork came in 1991, when the book *Frank Sinatra: A Man and His Art* was published. His style had undergone a transformation in the 1980s, influenced by the bright colors and abstract shapes of artists such as Mark Rothko. Examples of such paintings are now valued at approximately $10,000 each.

Sinatra also pursued another unlikely interest at the Compound: building and operating his own model railroad. He attended toy exhibitions and sought the advice of other hobbyists as he built an impressive array of big, heavy, electric "tinplate" trains of the sort that he had marveled at as a child, having grown up at a time when every major department store in North America would have them on display during the holiday season.

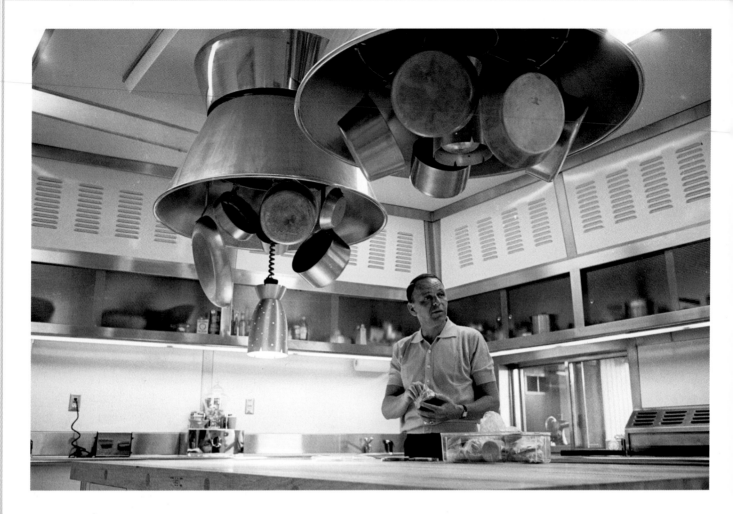

The value of Sinatra's collection would eventually exceed $1 million. In 1971, he was gifted a real caboose (or railway wagon), which he kept at the Compound, fitting it out with a sauna, massage table, barber's chair, and exercise bench.

—

"THAT WAS HIS HOME, AND YOU COULD FEEL IT. IT WAS FULL OF GREAT TIMES. I MET THE WORLD IN THAT HOUSE."
Daughter Tina Sinatra on the Compound

—

The Compound was also home to Sinatra's fourth wife, Barbara, a former Vegas showgirl and ex-wife to Zeppo Marx. They married in 1976, and Barbara set about modernizing and renovating the Compound's lived-in,

ABOVE: Sinatra in his newly refurbished kitchen, on which he spent a reported $100,000 in 1965. Though he loved to cook, he also had staff on hand to prepare meals day and night.

bachelor-style interior. Until now, many of the decorations and furnishings—including the refrigerator—had been orange, since it was Sinatra's favorite color (the "happiest color," he called it). Even as it grew to include eighteen bedrooms and twenty-three bathrooms, the house remained more comfortable than opulent, with Sinatra's own bedroom left untouched by Barbara's redesigns, orange hues still dominating, his paintings hanging on the wall and his model trains intact. It was, his family later said, his "little cave."

In 1995, with his health declining, Sinatra sold the Compound and moved to Los Angeles, where he died in May 1998.

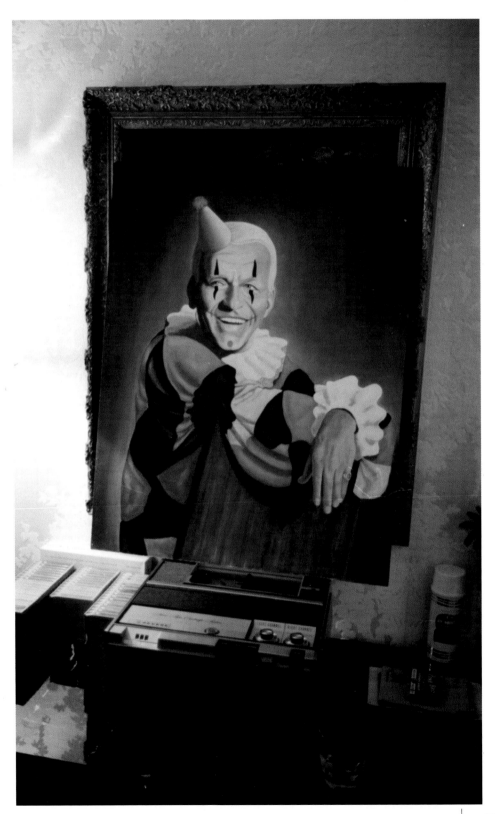

CHUCK BERRY

BERRY PARK, WENTZVILLE, MISSOURI (HOME FROM 1957 TO 2017)

By Colin Salter

At 691 Buckner Avenue in Wentzville, Missouri, a huge stone slab around seven feet wide and three feet tall is engraved:

WELCOME TO
BERRY PARK
FOUNDED AUGUST 15TH 1957
BY THE FAMILY
FOR THE PEOPLE
MARTHA BELL BANKS HENRY W. BERRY SR
THELMA HANK LUCY CHUCK PAUL BENNIE
THEMETTA SUGGS BERRY
FRANCINE GILLIUM

Chuck, in the third row from the bottom, was Charles Edward Anderson Berry, fourth of six children of Martha and Henry Berry. He was also Chuck Berry, the father of rock 'n' roll, who built Berry Park and made it his home for sixty years from 1957 until his death, aged ninety, in 2017. Among the other names on the stone, Themetta, who survived him, was his long-suffering wife of sixty-eight years; and Francine, who worked for him for thirty years, his long-serving secretary.

Berry Park—or "Berry Land," as it was sometimes known—was the fruit of Chuck's musical labors. By early 1957 he was a sensation, with seven Top 10 R&B hits to his name, including "Maybellene," "Roll Over Beethoven," and "School Days," as well as an appearance in an early rock 'n' roll movie, *Rock, Rock, Rock*. In April of that year, he invested some of his earnings in thirty acres of real estate in Wentzville, St. Charles County, Missouri. On it, he built Berry Park, a rock 'n' roll–themed leisure complex, with a golf course, accommodation, a concert stage, and that classic accessory of the period—a guitar-shaped swimming pool.

Over the years, Chuck expanded the Berry Park estate, which eventually covered 160 acres, and promoted the Park as a venue for gigs and festivals. But after enraged fans threw stones at his home when Leon Russell didn't turn up for a rock festival held there on July 4, 1974, Berry agreed with the Wentzville mayor that enough was enough.

The park's accommodation also provided homes for members of the Berry family, and for Chuck himself. In the 1970s, he installed a recording facility, producing his 1979 album *Rockit*, a critically admired return to form, at Berry Park Studios. He recorded periodically there throughout the 1980s, and had completed thirteen tracks at the studio when, in the early hours of March 26, 1989, fire broke out. The thirty-year-old building containing the studio, the Berry Park concert stage, and the precious master tapes was completely destroyed.

It was a blow to Berry, now over sixty, but worse was to come. In 1990, it was alleged that he had spied on customers by installing cameras in the park's bathrooms. The cameras reportedly caught not only the park's unsuspecting customers but also Berry's sexual exploits. The revelations shocked the public and led to the closure of Berry Park as an attraction. The pool was filled in; Berry gave fewer interviews and stopped recording. The words "Welcome To" on that stone slab were covered over, first with a crude strip of black duct tape and eventually with a printed card reading, "No Trespassing."

Although Berry Park was now very much a private residence, Chuck continued to live there for the rest of his life, enjoying time with his family and indulging in his favorite nonmusical pursuits, which included playing softball and chess. Although he continued to tour well into his eighties, he would not make another album for thirty-eight years. When it emerged, like his name on the stone slab, it was called, simply, *Chuck*. He died at home in March 2017, just three months before its release.

OPPOSITE: Chuck Berry at home, 1986. Parts of the film *Hail! Hail! Rock 'n' Roll*, made on the occasion of his sixtieth birthday, were shot that year at Berry Park.

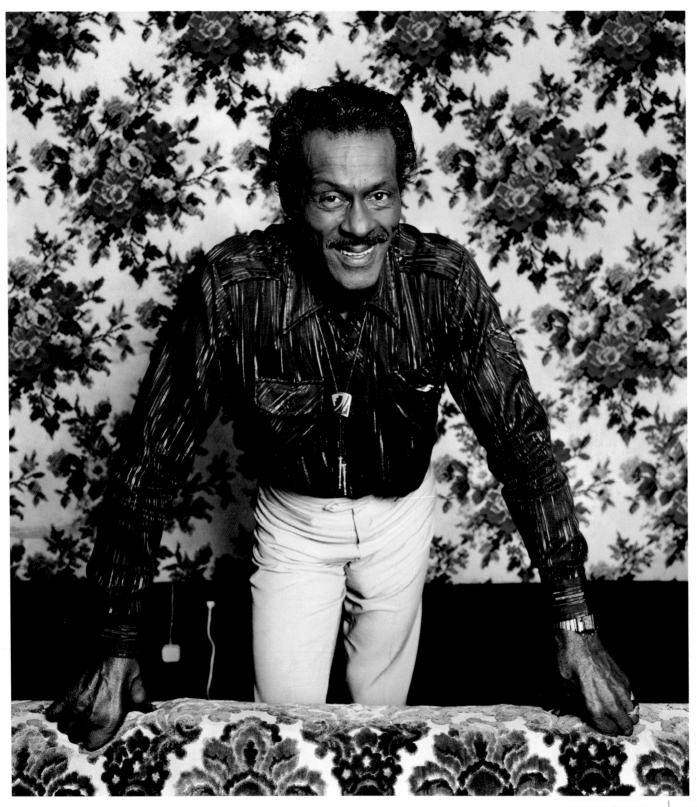

ELVIS PRESLEY

GRACELAND, MEMPHIS, TENNESSEE (HOME FROM 1957 TO 1977)

By Eddi Fiegel

There are two houses in America that receive more visitors than any other attraction in the country, and both of them are white. One is famously at 1600 Pennsylvania Avenue in Washington, D.C., while the other—the daddy of all rock star mansions—sits on Elvis Presley Boulevard in Memphis.

Some 600,000 pilgrims pass through the white colonnaded entrance of the eighteen-room, neoclassical mansion known as Graceland every year. Many come simply because they are Elvis fans, but part of the house's attraction is also unquestionably its prime place in popular culture as a shrine to the American dream— the ultimate story of how a poor boy from the wrong side of the tracks ended up living the millionaire life.

In April 1957, shortly after Elvis completed work on his second Hollywood film, *Loving You*, and the accompanying soundtrack album, a Memphis newspaper reported that the twenty-two-year-old "guitar strummer . . . today became a country squire," paying $100,000 for what was, at the time, one of the most expensive properties in the area.

The house belonged to a world of wealthy "Big Daddy" plantation owners and was a long way, in every sense, from Elvis's first childhood home, a small, wooden "shotgun" bungalow in the wooded hinterland of rural Tupelo, Mississippi. It was also a long way from his first home in Memphis. He had moved to the city as a teenager with his mother and father, settling into a $35 a month apartment in Lauderdale Court, Memphis's first public housing project. But from an early age he had promised that one day he would buy his parents a home of their own.

After his initial success with Sun Records, Elvis did just that, buying a four-bedroom, single-story, ranch-style house on Audubon Avenue in East Memphis. But Elvis had moved into the house too, and as his star status reached stratospheric levels, the entrance to the house had fast become overrun by fans desperate to catch a glimpse of their idol. Other residents of the previously peaceful, leafy neighborhood were, perhaps unsurprisingly, far from thrilled.

Elvis needed to find somewhere new, but apart from problems with fans and neighbors, there was also the issue of space. He was now looking for a home not only for himself and his parents but also his grandmother, Minnie Mae. Similarly, the King's around-the-clock social scene meant that he needed space to accommodate the revolving cast of friends, acquaintances, hangers-on, and local flotsam and jetsam who came to be known as the Memphis Mafia. When Elvis saw Graceland, it seemed like the perfect choice.

Part of the house's attraction was its privacy and distance from marauding fans. Although the grandiose villa now falls within Memphis's urban sprawl, back then, the leafy suburb of Whitehaven, eight miles south of central downtown, was still heavily rural.

—

"MONEY IS MEANT TO BE SPREAD AROUND. THE MORE HAPPINESS IT HELPS TO CREATE, THE MORE IT'S WORTH. IT'S WORTHLESS AS OLD CUT-UP PAPER."
Elvis Presley

—

Graceland was also much larger than the house on Audoubon Avenue. As well as the main two-story villa, built in the Classical Revival style in 1939, there was also a barn and some fourteen acres of rolling pastures—more than enough to guarantee privacy. The estate had originally been part of a five-hundred-acre cattle farm that dated back to the Civil War and was named after the owner's daughter, Grace.

OPPOSITE: Elvis Presley poses outside Graceland with his newly acquired Rolls-Royce Silver Cloud II, which he purchased during the filming of *Flaming Star* in 1960.

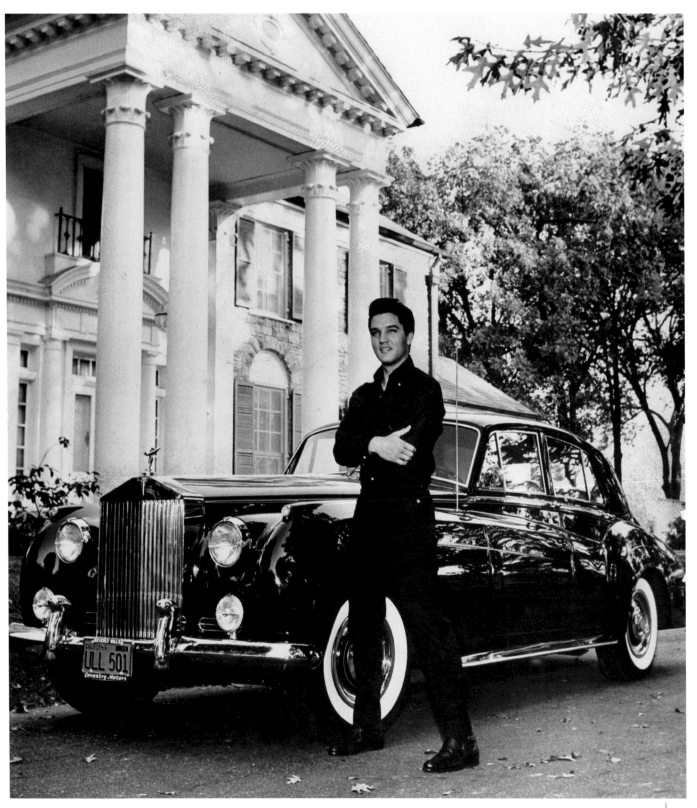

The house would remain Elvis's home for the rest of his life.

A few weeks after moving in, Elvis commissioned the now famous custom-made iron gates featuring images of himself playing his guitar in classic hip-swinging stance alongside a pattern of musical notes. Over the coming years, he would make the house his own, adding a recreation area, Jacuzzi, and dressing rooms, spending around $12,000 in all—a princely sum in the late '50s.

He also wanted to build himself a den, and the result was the legendary "Jungle Room," so nicknamed thanks to its singular combination of bottle-green shag-pile carpets, faux-animal-fur sofas, plastic plants, and heavy, ruched blinds. There was also a suite of Polynesian-style teak furniture, including a faux-zebra-skin wooden throne featuring intricately carved sea-serpent heads on the arm

rests, and sofas with staring owls, not to mention a film projector, an ice cream bar, a giant color TV, and an artificial waterfall.

Accounts differ as to the origins of the tiki-style carved furniture. One story goes that Elvis's father, Vernon, came

—

"EVERYTHING YOU'VE HEARD ABOUT GRACELAND DURING ELVIS'S GLORY DAYS IS TRUE, AND THEN SOME. THERE WAS ALWAYS SOME FUN GOING ON."
Bill Medley of the Righteous Brothers

—

home one day and announced, "I just went by Donald's Furniture Store and they've got the ugliest furniture I've ever seen in my life." "Good, sounds like me," Elvis reportedly replied, and within a few hours he had the

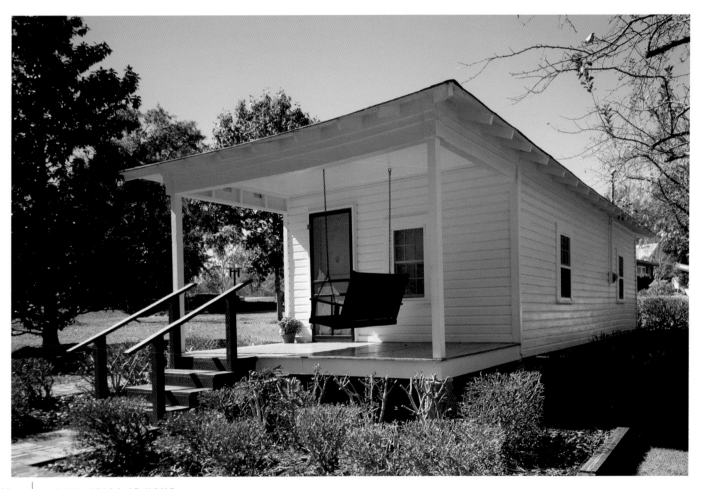

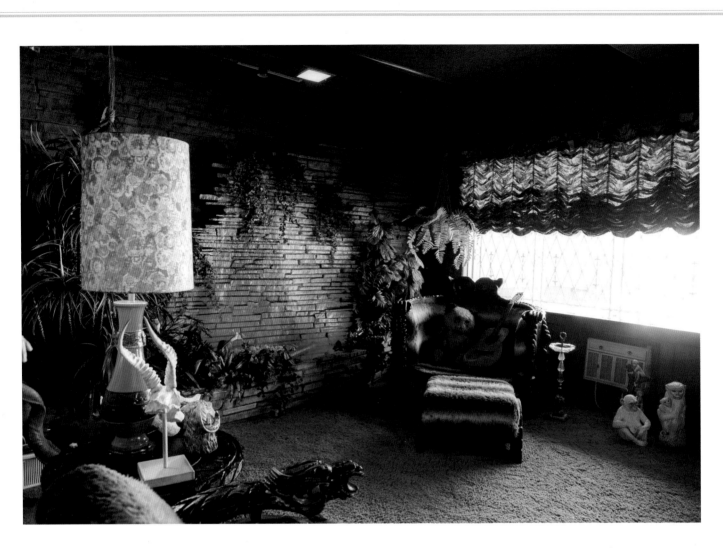

OPPOSITE: The "shotgun" bungalow in Tupelo, Mississippi, where Elvis spent the first few years of his life.

ABOVE: The "Jungle Room," built as an adjunct to Graceland in 1965, where he made his final recordings.

whole suite delivered to the den, reveling in the joke. Others claim that Elvis loathed furniture shopping but wanted to redecorate, and, desperate to get the whole ordeal over as quickly as possible, bought the whole lot in the space of half an hour. Whatever the truth may be, most reports agree that Elvis grew to love the room, its Hawaiian theme reminding him of happy times filming and holidaying in the Pacific.

Elvis also enjoyed jamming and recording at home, and several songs recorded in the Jungle Room would eventually surface in 1976 on the albums *From Elvis Presley Boulevard* and *Moody Blue*, and later on *The*

Jungle Room Sessions. Elsewhere in the house there were Tiffany lamps and a white bedroom with a round bed covered in white fur, as well as stained-glass door panels separating the living room and music room, decorated with peacocks—a symbol of eternal life.

Many of the early changes to the house were made during Elvis's marriage to Priscilla Presley. In February 1968, their daughter Lisa Marie was born, and Graceland became home to the young family. The couple's divorce in 1972, however, was to herald another phase in the house's décor. Elvis's new girlfriend, Linda Thompson, moved in, and as Jordan Runtagh later wrote in *Rolling Stone* magazine, "The changes were severe. . . . antebellum pillars, balustrades, and doorways were shrouded in heavy red velvet fabric, lassoed with gold

tassels like a Las Vegas Versailles. Enormous overstuffed Louis XV chairs were reupholstered in candy-apple satin studded with rhinestones. . . . Floors were cluttered with white fur rugs . . . and gaudy lamps bejeweled with fake rubies and sequins. Even Liberace would have blushed."

In 1974, Elvis remodeled the TV room with a white sofa, a low, mirrored ceiling, and a wall of three TV screens. At a time when most Western households were still excited to be watching one set in black-and-white, this would have seemed positively space-age, but Elvis had seen that President Johnson liked to watch three news channels at once, and had adapted the idea to suit three simultaneous football games.

Another important hub at Graceland was the kitchen. Elvis's fondness for food is well documented, as are some of his more outlandish favorite dishes, most notably his beloved fried banana and peanut butter sandwiches. Having grown up poor—sometimes even having to resort to eating squirrel meat—he made sure that the cupboards at Graceland were always well stocked, compiling a list of items that were to be available at all times, from cans of sauerkraut and pickles to lean bacon and hot dogs, while banana pudding and brownies were to be "made fresh nightly."

As Elvis's cook of fourteen years, Mary Jenkins Langston, later recalled in the documentary *The Burger and the King*, "He said that the only thing in life he got

—

"I'D BRING THE TRAY UP TO HIS ROOM, AND HE'D SAY, 'THIS IS GOOD, MARY.' HE'D HAVE BUTTER RUNNING DOWN HIS ARMS."
Elvis's cook, Mary Jenkins, 1996

—

any enjoyment out of was eating." She would deliver his breakfast to him on a tray every morning, and he would eat it sitting up in bed, often at lightning speed.

Elvis also had a well-documented fondness for guns, and rumor has it that he would often sit with his .357 Magnum in hand. In these pre-remote days, if a TV show he was watching was beginning to annoy him, he would solve the problem by shooting at the set. At other times, he enjoyed letting off fireworks in the grounds

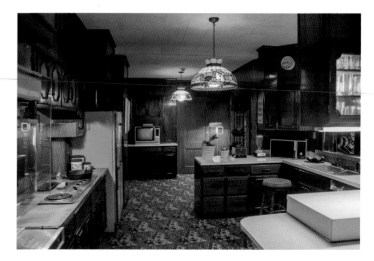

ABOVE: Graceland's kitchen was to be stocked at all times with Elvis's favorite foods. Its range of high-tech modern appliances included one of the first microwave ovens in the United States.

and riding his convoy of golf carts and collection of horses. In 1975, meanwhile, he developed a newfound passion for racquetball. Never one to do things by halves, he built a two-thousand-square-foot outhouse housing a racquetball court, a lounge with upright piano and private dressing room, a Jacuzzi spa, and guest facilities. His parents, meanwhile, added a vegetable garden and a chicken coop.

On August 17, 1977, at the age of forty-two, Elvis collapsed upstairs at Graceland and was taken by ambulance to the nearby Baptist Memorial Hospital. He was pronounced dead on arrival, with heart failure listed as the cause. He was initially buried at Forest Hill Cemetery, but due to problems with security, he was reburied a few months later in Graceland's Meditation Garden, which he had built as a private retreat. His parents and grandmother are also buried there, and their graves lie alongside each other. At the end of the row, there is another small headstone memorial to Jesse Garon Presley, Elvis's stillborn twin brother.

The garden's centerpiece is a circular pool with a twelve-foot-high fountain, lit by colored floodlights, while nearby a towering white marble crucifix and statue of Jesus, open-armed and flanked by angels, stands above the scene. On the edge of Elvis's grave, a small hexagonal glass vessel holds an eternal flame.

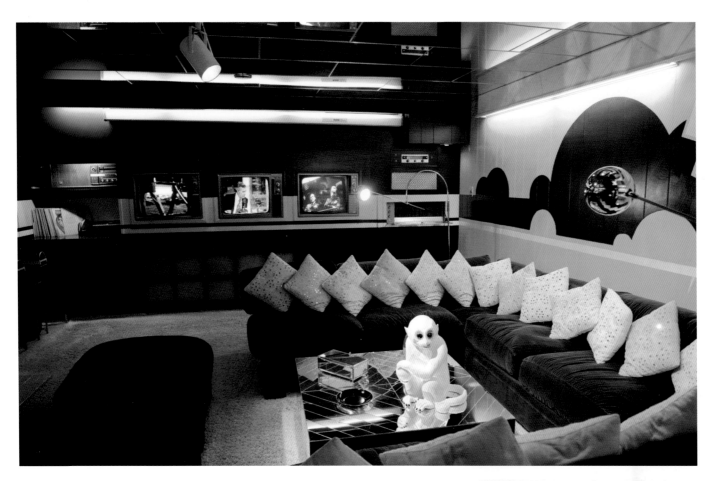

ABOVE: Graceland's media room was fitted out with three TVs so that Elvis could watch three games of football at the same time.

RIGHT: Elvis and Priscilla lounge under an umbrella by the pool with their baby daughter, Lisa Marie, in 1969.

Following Elvis's death, Priscilla Presley, acting as executor for Lisa Marie, who was still only a child, took over management of Graceland. The estate at that point cost some $500,000 a year to run, but over the next decades, by refurbishing parts of the house and opening it up the public, she transformed it into the USA's second-most-visited home—one now worth over $100 million.

In 1971, Memphis City Council voted to change the name of the street the house sits on from Highway 51 South to Elvis Presley Boulevard, and twenty years later, Graceland was added to the US National Register of Historic Places.

IKE & TINA TURNER

OLYMPIAD DRIVE, SOUTH LOS ANGELES, CALIFORNIA (HOME FROM 1964 TO 1977)

By Colin Salter

It's a large house on a small plot, built in 1956 and hemmed in on all sides by other similar properties. Outside the walls there's only room for a short, semicircular driveway between the street and the front door, and out back a modest, kidney-shaped swimming pool. What, then, could justify the million-dollar price tag when 4263 Olympiad Drive in Inglewood, South Los Angeles, was put on the market in late 2016?

Two things: one, the house is the former home of "Nutbush City Limits" R&B legends Ike and Tina Turner; two, the sellers had left the interior virtually unchanged since they bought it from the Turners in 1977. The home on sale was a time capsule of early '70s taste, fixtures, and fittings, from the telephones to the fish tanks, and from the mustard-colored vinyl floor patterns to the pink flocked wallpaper.

View Park, the area of Inglewood in which the Turners' old home sits, is known as the "black Beverly Hills." The Ike and Tina Turner Revue relocated to Los Angeles from St. Louis after Tina's first lead vocal for the band, "A Fool in Love," sold more than a million copies in early 1960. It reached no. 2 in the national R&B charts, and as more hits followed, Ike and Tina's relationship became more than merely musical. They were married in 1962, and in 1964 they bought the property on Olympiad Drive.

It was rarely a happy marriage, however, their domestic life complicated by their professional relationship. When Tina said she was considering ending both, Ike allegedly hit her with a shoe stretcher. In his autobiography, he admitted, "Sure, I've slapped Tina. . . . There have been times when I punched her to the ground without thinking. But I have never beat her."

The house was the Turners' home for most of their tempestuous time together; much of their violent domestic life was played out within these walls. Despite that, Olympiad Drive was where Tina raised not only their own son Ronnie but also Ike's two children from a previous marriage, Michael and Ike Jr. But after another fight in 1976, the start of divorce proceedings prompted the sale of the house.

The events surrounding the disintegration of their marriage were the subject of the 1993 Tina Turner biopic *What's Love Got to Do With It?*, and it's a sign of how perfectly preserved the décor is that many scenes were shot in the house. From the film you might recognize the enormous, snake-like couches, now upholstered in beige but in the Turners' time a luscious red velvet. One of the couches widens at one end into a double bed, with a mirror on the ceiling above it—a clue, perhaps, to the sort of parties that may have been hosted here.

There are more mirrors on the walls. In the same room the bar stools still have their red velvet covering, and behind the bar are two large fish tanks, also used as a backdrop in the film. Opposite the bar is a stone waterfall the height of the room, with plastic plants in the crevices over which water once tumbled into a pond of koi carp at the bottom.

Whoever owns the house in 2018 will have to decide whether to preserve this museum of '70s style or redecorate 4263 Olympiad Drive for the first time in forty years. Without doubt, the jaw-dropping showstopper of the house is the master bedroom. It is carpeted in deep red, and at the far wall a giant circular bed sits on a two-step raised platform, beneath pelmets of swags and tassels, within four ceiling-to-floor columns of pleated white velvet. Above it there is disco lighting and—inevitably—another mirrored ceiling.

OPPOSITE TOP LEFT: The bedroom at the Turners' View Park residence still looked, in 2016, exactly as it did in the 1970s, the subsequent owners of the propery having chosen not to redecorate in the years since.

OPPOSITE TOP RIGHT: Tina Turner shows off an elaborate sundial in her living room, 1972.

OPPOSITE BOTTOM: Ike and Tina pose in front of a portrait of themselves in happier times, 1974.

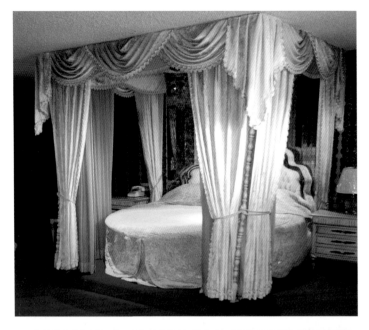

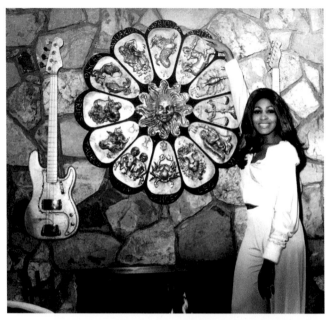

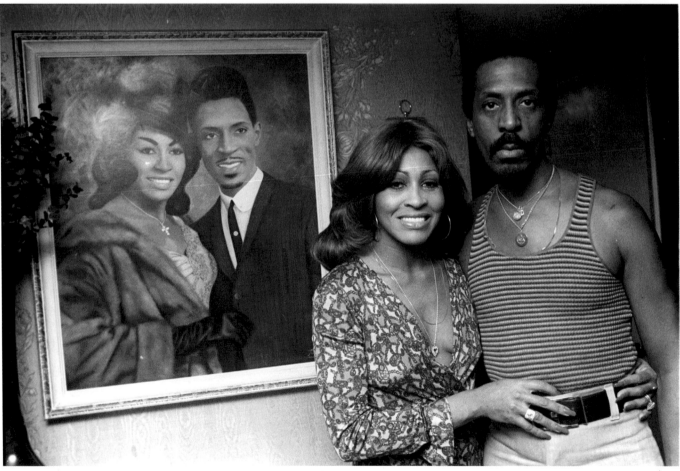

PAUL MCCARTNEY

CAVENDISH AVENUE, ST. JOHN'S WOOD, LONDON (HOME FROM 1965 TO PRESENT)

By Daryl Easlea

As if to underline just how successful the Beatles had been in such a short period of time, all four Fabs purchased houses in areas of the southeast of England traditionally populated by the professional classes. Leaving Liverpool in 1963 as their fame exploded, the lower-class outsiders had quickly risen to the Establishment. After a year of living initially in hotels, briefly in a communal flat, and then in apartments around London, they found dwellings commensurate with their level of success.

John Lennon, George Harrison, and Ringo Starr had all taken a conventional showbiz route of relocating out of London, buying houses in the commuter belt of Surrey alongside more established light entertainers and actors. Paul McCartney, meanwhile, bought a three-story Regency townhouse in London's St. Johns Wood, with Lord's Cricket Ground—the home of the English game— at the foot of his road. By being just a ten-minute walk away from EMI's studios at Abbey Road (and only a brief journey into London's West End), he ensured that he was the Beatle with his finger on the pulse.

It was from leafy, smart, but unpretentious Cavendish Avenue that McCartney made the short walk to the studios to make four of the Beatles albums with which he is most closely associated—*Revolver*, *Sgt. Pepper's Lonely Hearts Club Band*, *The Beatles*, and *Abbey Road*. With this proximity, he could easily put in the extra hours and capture quickly thought ideas. It was at Cavendish Avenue, too, that the other Beatles would congregate and have meetings prior to or after all being at Abbey Road. It was here on August 6, 1966, for example, that Lennon and McCartney chatted with Keith Fordyce for a BBC radio program entitled *The Lennon and McCartney Songbook*. It was here, too, that McCartney allegedly offered Mick Jagger his first ever joint, and, where, in his top-floor music room, he first sketched out some of his most enduring songs.

McCartney bought the property from physician Desmond O'Neill for the sum of £40,000 (around $110,000 at the time), sealing the deal on Tuesday, April 13, 1965. Eleven months later, after extensive renovations and the addition of various security features, during which time he had been living on the top floor of his then-girlfriend Jane Asher's house in Wimpole Street, he moved into his new house. "I've furnished it in traditional style because I don't go for this modern stuff that always looks as if it needs something doing to it," he told the *NME*. "I like it to be comfortable. Those mod leather chairs . . . ugh. They're too cold." Big homes with gardens need a household pet, and in the summer of 1966, McCartney acquired a sheepdog puppy, Martha, who was to add to the mythology of this suburban address, and who inspired the song 'Martha, My Dear.'

—

"I'VE FURNISHED IT IN TRADITIONAL STYLE BECAUSE I DON'T GO FOR THIS MODERN STUFF THAT ALWAYS LOOKS AS IF IT NEEDS SOMETHING DOING TO IT."
Paul McCartney to *NME*, 1965

—

Fans would soon be camped outside: there are pictures of McCartney and Asher leaving the house in 1967 in his new Aston Martin surrounded by fans jamming autograph books through the car windows. Even today, there are videos of admirers on YouTube waiting for the gates to open, asking staff if they have met McCartney ("Guys, look, it's fucking Paul's house!") or considering taking his recycling. Asher was spotted by fans while moving out during 1968. McCartney had started an affair with Francie Schwartz while Asher was away. Soon Schwartz was to be replaced by Linda Eastman, the love of

OPPOSITE: Two Beatles fans leave their child unattended to peer over the gates of Paul McCartney's London home on the day of his marriage to Linda Eastman, March 12, 1969.

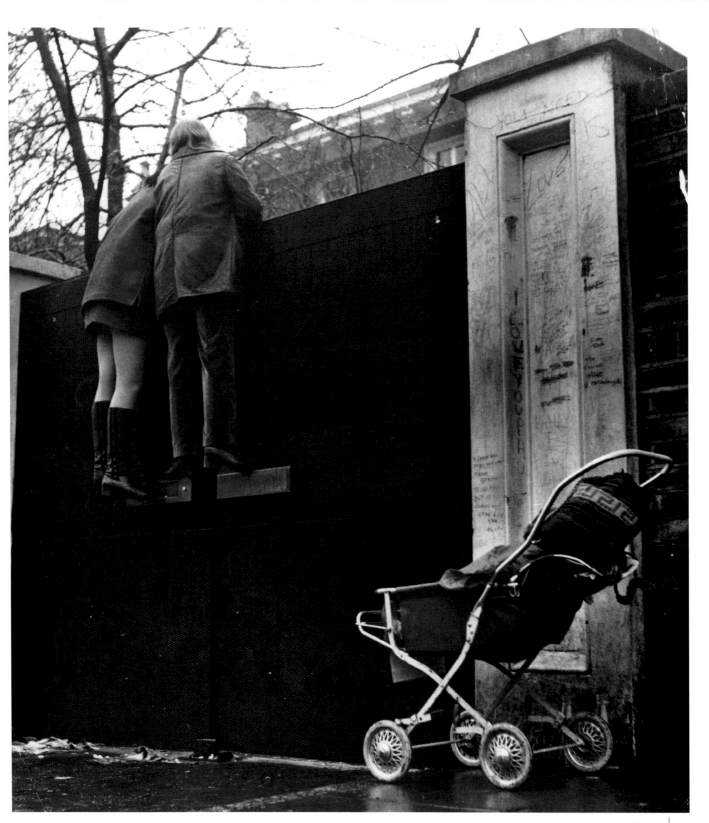

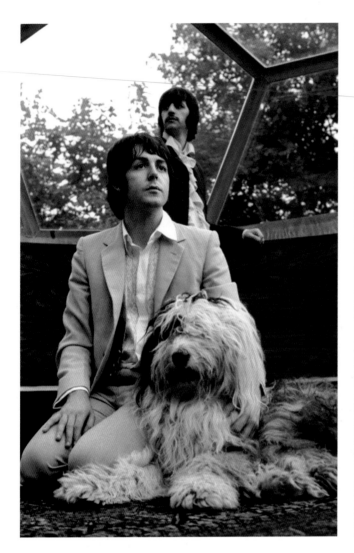

McCartney's life. He was so delighted with Eastman that he sat on an upstairs windowsill at Cavendish Avenue and sang his new composition, "Blackbird," to the fans gathered outside.

Also adding to the mythology of Cavendish Avenue was the Geodesic dome built in the garden for McCartney's meditation. The idea arose from a conversation with his friend, art dealer Robert Fraser. McCartney loved the idea of follies, and Fraser put him in touch with the architect Digby Bridges; the dome, fourteen feet high and thirty feet wide, cost the Beatle something in the region of £10,000. It was etched into Beatle history as one of the numerous London locations for the Beatles'

ABOVE LEFT: Paul, Ringo, and Martha the sheepdog in the Geodesic dome at Cavendish Avenue, July 28, 1968.

ABOVE RIGHT: Paul and Linda out in the fields at High Park Farm, Scotland, October 1964.

legendary "Mad Day Out" on Sunday, July 28, 1968. At the end of a day that had seen them traverse the capital, pictures were taken of the group hanging out with Martha the dog at the dome. They were captured by photographer Don McCullin, who later wrote that it was like something out of James Bond or *Doctor Who*: "We all lay around with a huge floppy dog in this strange science-fiction like space." The pictures of the Beatles splayed against the windows are a tremendous memento of another era.

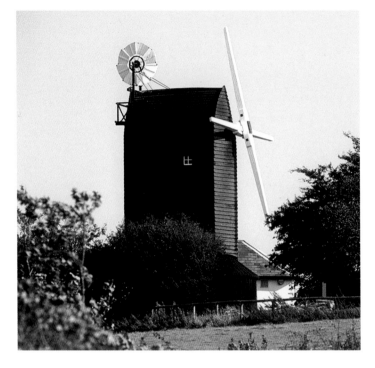

Another event enshrined in Beatles legend happened at Cavendish Avenue later that summer. On the evening of September 18, 1968, the group—plus Yoko Ono, Pattie Harrison, and engineer Chris Thomas—went back from Abbey Road to no. 7 to watch the first UK television screening of the legendary rock 'n' roll film *The Girl Can't Help It*. They then returned to Studio 2 to finish off the song they had been recording that day, "Birthday"— arguably the bounciest all-out rocker on *The Beatles*.

When Paul married Linda in March 1969, his "man about town" phase came to an abrupt end, and home became everything to him. Although he had bought the three-bedroomed High Park Farm on the Mull of Kintyre in Scotland in June 1966, it took on a whole new resonance when he went completely off-grid at the end of the decade amid the dissolution of the Beatles. It was to here that he was tracked down when the "Paul Is Dead" rumors surfaced; as the heavily bearded star greeted his audience, many failed to believe it actually was him. Later, Wings frequently rehearsed at the two-hundred-

acre farm, enshrined forever in the popular consciousness by the 1977 chart-topper "Mull of Kintyre."

While Paul had sought solace there in the period following the Beatles' split, the McCartneys were not as reclusive as legend would suggest. They would often be seen in town—sometimes covered in mud after trudging through farmland—or playing with their children on the nearby beach. In 2013, a neighbor, Anne Cousin, recalled to the *Daily Telegraph*, "One time a local girl was on the beach digging, and this voice said, 'You've a long way to dig to get to Australia.' She looked up and it was Paul." It was at High Park, too, that Paul and Linda began to embrace vegetarianism and animal rights—issues that would of course remain hugely important to them in the decades to come.

Since 1975, McCartney's main residence has been Waterfalls, the Woodlands Farm Estate in Peasmarsh, East Sussex, near his studios at Hog Mill Farm, where the "Threetles" material was recorded in the mid-'90s with Ringo Starr and George Harrison. His other residences include a Manhattan apartment, a place in Beverly Hills, and, for old times sake, a house on Merseyside. But Cavendish Avenue remains his main base in London. Later in his career, it was from here that he walked to nearby St. John's Wood Station on the

"CAVENDISH AVENUE BECAME WHAT I USED TO THINK OF AS MY BACHELOR PAD. THERE WOULD BE LOTS OF PEOPLE AROUND THERE. SOME OF MY RELATIVES WOULD BE STAYING UPSTAIRS, THEN THERE MIGHT BE MICK AND MARIANNE, JUST BECAUSE IT WAS A GOOD PLACE TO HANG. IT WAS A COOL PLACE."
Paul McCartney, *Many Years from Now*

London Underground, where he made a video for his unloved single "Press" in 1986. And it's from here that he still slips out to Abbey Road from time to time.

In 1966, McCartney said, "Don't think I'm a big property tycoon. I only buy places I like." This has been borne out by the fact that all of his principal UK dwellings have been homes in which to live, work, and raise families.

PSYCHEDELIC SUBURBIA

THE BEATLES INVADE SURREY

By Eddi Fiegel

In the mid to late '60s, while London's Carnaby Street was ablaze with the bubbling blues, reds, and oranges of psychedelic murals and pop stars were parading around in frills, flares, and military regalia, the more traditionally genteel suburbs of Surrey in southeast England were receiving an undercover makeover of their own.

With its close proximity to central London, rolling English countryside, and lavish mansions, Surrey had long been popular with celebrities, not least for three members of the world's most famous band. By 1964, Beatlemania had reached epic proportions, and after moving to London from Liverpool, all four Beatles were beginning to find the almost constant presence of fans trying.

In July 1964, John Lennon bought Kenwood, a six-bedroom mock-Tudor mansion on the exclusive St. George's Hill estate in Weybridge, while George Harrison bought Kinfauns, a rambling bungalow in nearby Esher. Less than a year later, Ringo Starr bought Sunny Heights, another sprawling mock-Tudor villa, just under a mile from John's.

Although each of the houses featured extensive gardens—especially Kenwood, which was set in one and a half acres of grounds—inside the houses were relatively sedate, so the three Beatles and their wives set about redecorating to reflect their own styles and tastes. In George and Pattie's case, this meant swirling psychedelia. After returning from a trip to India in 1968 to visit the Maharishi Mahesh Yogi, the couple and their friend, bass player Klaus Voormann, decided to paint the outside of the house in a series of brightly colored murals inspired by a book of Tantric art.

On one wall, a vivid sunflower yellow formed the background to childlike red and white flowers, while other walls featured large, freeform swirls in red, yellow, and white—all of which created an interesting contrast with the formal rose beds just a few yards away in the gardens. Contributions from friends were similarly encouraged, and when Mick Jagger and Marianne Faithfull dropped by one day but found nobody home, they decided to paint a message on the wall of the house: "Mick and Marianne were here and we love you."

Inside the house, George and Pattie asked psychedelic design collective the Fool, who had already painted the Beatles' Apple Boutique and George's Mini, to add a mural around the fireplace in the living room. The floor-to-ceiling circular design showed a cross-legged, Buddha-like figure surrounded by flaxen-haired dancers amid a psychedelic cosmos and lava lamp–style bubbles.

—

"IT WAS THE FIRST ONE I SAW, AND I THOUGHT, 'THAT'LL DO.'"
George Harrison on Kinfauns

—

Down the road at Kenwood, meanwhile, John and Cynthia's personal decorating flourishes included a suit of armor and a gorilla suit, as well as a dining room wallpapered in purple velvet. John had also created his own piece of psychedelic art: a huge mosaic of an eye, which he had installed at the deep end of the swimming pool. The sixteen-foot mosaic was made from more than seventeen thousand quarter-inch tiles and showed a black-and-white, seemingly all-seeing eye surrounded by long black eyelashes and a mass of blue. When John sold the house in December 1968, he wrote a note to the buyer: "Take care of the eye in the pool." Despite his plea, the mosaic was later removed, and was lost for over twenty years until it resurfaced in 2011.

ABOVE: Kinfauns, George Harrison's colorfully painted Surrey abode. Beneath the bay window is a note painted by Mick Jagger and Marianne Faithfull on an unannounced visit.

Psychedelia also made its way to Sunny Heights, where Ringo and wife Maureen's home included a surreal mural—also, like George's, above the fireplace, this one by Dudley Edwards, a pop artist and friend of Paul McCartney's. Edwards had likewise painted a piano for Paul's newly purchased home in St. John's Wood, and with his colleagues in Binder, Edwards, and Vaughan, would paint the op-art car on the cover of the Kinks' *Sunny Afternoon* LP.

Such flourishes were to prove less of a draw when it came to Ringo's next Surrey home. After meeting Peter Sellers during the filming of *The Magic Christian*, Ringo

became captivated by Brookfield, the actor's vast fifteenth-century mansion in Elstead, near Guildford. As it so happened, Sellers was in the midst of a divorce from his wife, the Swedish actress and singer Britt Ekland, and was looking to sell the oak-beamed house, which came with several acres of birch-tree-filled grounds, walled gardens, and its own lake, paddocks, barns, private cinema, gym, and sauna.

Ringo also noticed a drum kit set up in the house, and was yet more smitten with the place when he discovered that Sellers had originally started out as a drummer himself, touring Britain with various dance bands during World War II. John Lennon is rumored to have doubled Ringo's offer, but Sellers had promised the house to Ringo, and in 1968 Ringo, Maureen, and their

children moved in. But despite the house's extravagant proportions and facilities, visitors would later report that Ringo and his family spent almost their entire time in

—

"'WEYBRIDGE WON'T DO AT ALL. I'M JUST STOPPING AT IT, LIKE A BUS STOP. I'LL TAKE MY TIME; I'LL GET MY REAL HOUSE WHEN I KNOW WHAT I WANT."
John Lennon to the *Evening Standard*, 1966

—

the living room, in which could be found not only baby Jason's cot and Maureen's sewing, but also Ringo's drums. The story also goes that after Sellers had spent a small fortune importing an elaborately crafted door from Italy, Ringo cut a flap into it for the family's Siamese cats to use.

Ringo eventually sold Brookfield to Stephen Stills, who would prove equally taken with not only the house but also its gardens and staff. The estate's long-serving, pipe-smoking gardener, John, would provide the inspiration for the song "Johnny's Garden" on Stills's

ABOVE: Ringo Starr nurses a beer at the Flying Cow, his bar on the grounds at Sunny Heights.

OPPOSITE, TOP LEFT: George Harrison puts his feet up in his favourite wicker armchair at Kinfauns, 1965.

OPPOSITE, BOTTOM LEFT: Ringo poses in the garden at Sunny Heights, his home in St. George's Hill, Weybridge.

OPPOSITE, TOP RIGHT: John Lennon and his son, Julian, take a ride through the library at Kenwood. Lennon set up a studio in a converted loft room at the house and wrote some of his greatest songs up there.

OPPOSITE, BOTTOM RIGHT: The unusual porthole-style entrance to the living room at Ringo's home.

album with Manassas, and would also form the basis for Peter Sellers's characterization of Chance the Gardener in *Being There*.

By the '70s, Surrey's brief foray into psychedelia seemed well and truly over. John Lennon had sold Kenwood following his separation from his first wife, Cynthia, and the Harrisons likewise left Kinfauns in 1970 after fans had begun climbing over the fences and breaking into the gardens. In 2003, Kinfauns was almost entirely demolished, and a new two-story house was built on the site. The murals may be long gone, but in May 2017 Pattie Boyd unveiled a blue plaque on the new house to commemorate George's time there.

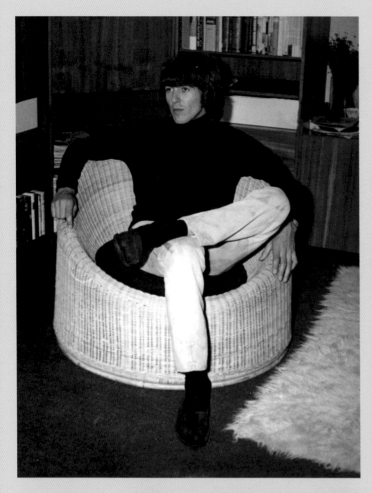

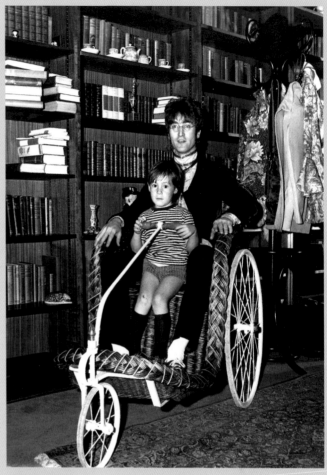

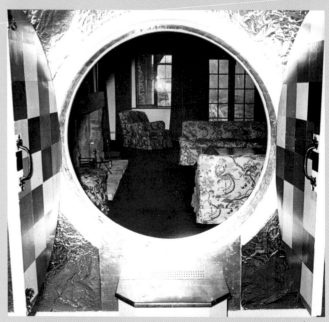

BOB DYLAN

HI LO HA, WOODSTOCK, NEW YORK (HOME FROM 1965 TO 1969)

By Colin Salter

Bob Dylan's introduction to Woodstock came through his manager, Albert Grossman, who moved to the area in 1963. Dylan lived in Grossman's house for several months and liked the area so much that in 1965 he paid $12,000 for Hi Lo Ha, an eleven-room Arts and Crafts mansion dating back to the start of the century. The house got its name from the first two letters of the names of the three sons of a previous occupant.

The Byrdcliffe Colony of Woodstock, New York, was an artists' haven long before Bob Dylan bought into the area in 1965. It was established in 1903 as a creative utopia by Ralph Radcliffe Whitehead—an English idealist who had studied under Arts and Crafts pioneer John Ruskin, and was a friend of the movement's leading practitioner William Morris—and his wife, Jane Byrd McCall. He had previously made unsuccessful attempts to found such a colony in Italy, Oregon, and California, but his dream took root at last in the fertile soil of the Hudson Valley.

Though Byrdcliffe (its name a combination of Ralph and Jane's middle names) failed to fulfill its aim of becoming a fully self-sufficient artistic community, the area continued to attract artists in many disciplines, with Woodstock establishing a reputation as a liberal, creative oasis. Leadbelly played there soon after his release from prison in 1937, and Pete Seeger, blacklisted as a communist by the Un-American Activities Committee, found sanctuary there in the 1950s. Outside of the music world, Timothy Leary was given a place to continue his psychedelic experiments in nearby Millbrook after he was sacked by Harvard University.

Dylan had at first little time to enjoy the peace and quiet of his new country home. He had secretly married Sara Lownds in November 1965, and their first child was due the following January, but he was at his creative peak, too, and working flat out. He had made the switch from acoustic to electric guitar in 1965 and scored a hit with both the album *Highway 61 Revisited* and its lead single,

"Like a Rolling Stone." Traditional folk fans were alienated, and a few days before his 1966 world tour ended in May, a member of the audience at the Free Trade Hall in Manchester, England, famously yelled out, "Judas!"

Even with the tour complete, Dylan remained under pressure, having been scheduled to make a TV special, write a book, and embark on another long tour that Grossman was booking for later in the year. Exhausted, he retreated to Hi Lo Ha for a rest. Then, on July 29, 1966, he sought to escape even his domestic pressures, setting off for a carefree ride on his Triumph Tiger 100 motorbike. He lost control and came off at some speed; although he was never hospitalized (some say he was not injured at all) it afforded him the perfect opportunity to cancel all engagements and recuperate in his Woodstock retreat. He would not undertake a tour again for over seven years.

Dylan was delighted to have found an excuse to get off the treadmill of fame and focus on his expanding family

—

> **"I HAD VERY LITTLE IN COMMON WITH AND KNEW EVEN LESS ABOUT A GENERATION THAT I WAS SUPPOSED TO BE THE VOICE OF."**
> **Bob Dylan, *Chronicles*, Vol. 1**

—

life. Four children were born in consecutive years from 1966: Jesse, Anna, Samuel, and Jakob. With time on his hands, he also acquired a couple of dogs, Buster and Hamlet, who became notorious among Dylan's fellow musicians for their delight in biting visitors. And it was during his time in Byrdcliffe that Dylan took up painting, too, inspired by a neighbor, the artist Bruce Dorfman.

OPPOSITE: Dylan at the piano at Hi Lo Ha, 1968. "Early on, Woodstock was hospitable to us," he writes in *Chronicles*. Later, though, it became rife with "dropouts and druggies," prompting Dylan to move elsewhere.

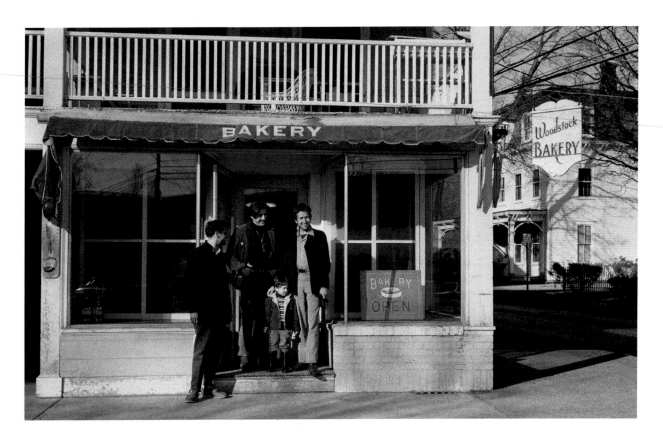

ABOVE: Dylan and his son pause for a photograph on the steps of their local bakery, Woodstock, 1968.

OPPOSITE: Dylan's Malibu home, Point Dume, photographed toward the end of its construction in 1976.

Mornings now became a time for canvas and brushes: a chance for the singer to see the world through different eyes. But Albert Grossman, concerned that a lack of live performance would reduce Dylan's public profile (not to mention his manager's income), had other plans. If Dylan couldn't or wouldn't perform, he could still

—

"I WAS FANTASIZING ABOUT A NINE-TO-FIVE EXISTENCE, A HOUSE ON A TREE-LINED BLOCK WITH A WHITE PICKET FENCE, PINK ROSES IN THE BACKYARD."

Bob Dylan, *Chronicles, Vol. 1*

—

compose songs for others to sing. Grossman, who owned a half-share of Dylan's publishing royalties, encouraged him to record demos at Hi Lo Ha, pointedly lending him a tape recorder for the purpose.

In the spring of 1967, Dylan settled down to the task, creating an ad hoc recording studio in the so-called "Red Room" at the house. He was joined there by members of

his backing band, the Hawks—Robbie Robertson, Richard Manuel, Garth Hudson, and Rick Danko—who were renting another house nearby. The sessions moved in the summer to the basement of the band's house, affectionately known as "Big Pink" for the pastel color of its wooden exterior. In all, Dylan and company made some 139 recordings, roughly half of them Dylan originals and the rest new arrangements of folk, blues, and country songs. In this relaxed atmosphere, his lyrics took on a more intimate tone, marking a turning point in his creative output.

Grossman ensured that copies of fourteen of these new recordings were circulated to interested musicians. They included "Too Much of Nothing," which became Peter, Paul and Mary's first hit; "Quinn the Eskimo (The Mighty Quinn)," which was covered by Manfred Mann and others; "This Wheel's on Fire," a Top 5 hit for Julie Driscoll and Brian Auger; and the instant classic "I Shall

Be Released." Rumors began to spread about the tapes, with a 1969 bootleg, *Great White Wonder*, containing seven songs from them. An official release, *The Basement Tapes* by Bob Dylan and the band (now known as the Band), was finally issued in 1975, but it still contained only fourteen tracks. In the decades since, more and more extracts from those Woodstock sessions circulated, but it wasn't until 2014 that all 139 got an official release as *The Basement Tapes Complete*.

The wide distribution of *Great White Wonder*, generally regarded as the first ever rock bootleg, is an indication of the demand for all things Dylan at the time. When he first moved to Byrdcliffe, the rest of the Woodstock creative community had closed ranks in an effort to keep his presence there a secret and give the great man some much-needed privacy. But inevitably word got out and fans started to arrive. They swarmed around his home, invading its grounds, climbing on the roof, and even trying to break in to steal pieces of Dylan memorabilia. By 1969, fans' obsession with their idol had become not just inconvenient but threatening. On one occasion, the singer is said to have found two naked hippies in his bedroom—an event that may have influenced his decision not to play at the Woodstock Festival that year. "I had very little in common with and knew even less about a generation that I was supposed to be the voice of," he later wrote in his memoir, *Chronicles, Vol. 1*. "I wanted to set fire to these people. I was fantasizing about a nine-to-five existence, a house on a tree-lined block with a white picket fence, pink roses in the backyard. Roadmaps to our homestead must have been posted in all fifty states for gangs of dropouts and druggies."

The Dylan family sold Hi Lo Ha in 1969 and moved to a larger, more private Woodstock mansion, appropriately the former home of the progressive intellectual Walter Weyl. Over the coming decades, Dylan would accrue various other properties across the United States and beyond, most notably a sprawling, gated compound built to his own specifications on Point Dume in Malibu, California, that has remained his primary residence since the '80s.

KEITH RICHARDS

REDLANDS HOUSE, WEST WITTERING, WEST SUSSEX (HOME FROM 1966 TO PRESENT)

By Simon Spence

Redlands, the Rolling Stones guitarist Keith Richards's country pile in West Sussex, will forever be associated with the most famous drug bust of the 1960s. Indeed, the public outrage, court proceedings, and media frenzy that followed the bust came to be neatly wrapped together under the banner of the "Redlands Trial," the house itself passing into immediate notoriety as salacious details of the case unfolded.

Richards bought the Grade II–listed building in late 1966 after falling in love with the picturesque, thatched-roofed Elizabethan mansion on first sight. The Stones were at the height of their fame, a flurry of hit albums and singles and a blur of gigs capitalizing on their first US no. 1, "Satisfaction," in mid-1965. They had just completed a mammoth North American tour and were in the middle of another series of gigs around the UK amid fresh controversy over their decision to pose in drag for the cover of their apocalyptic new single, "Have You Seen Your Mother, Baby, Standing in the Shadow?"

Richards, finding himself with a rare day off from the band's frenetic schedule, had decided to go house shopping, specifically looking for a country retreat in which to play lord of the manor. He was flush with cash—it was predicted that the Stones would earn $20 million in 1967—and in some urgent need: the landlord of his flat in St. John's Wood, unhappy with the many cigarette burns on the furnishings and graffiti on the walls, was evicting him.

Lady Luck was smiling on Richards that day. His chauffeur got lost and took the Bentley Continental down Redlands Lane, in the tiny, remote village of West Wittering, by mistake. They pulled up outside the perfectly presented Redlands House, surrounded by a moat and close to the beach near Chichester Harbour. Though Richards thought the place ideal, it wasn't for sale. But the owner, a retired naval officer, saw good fortune in the unlikely visitor asking for directions. A

quick chat and a few hours later, having driven the ninety miles to London and back, Richards handed over £20,000 in cash (around $55,000 at the time, or $450,000 today) and the place was his.

Soon, Richards was boasting of the house's heritage: how it had once hosted Anne Boleyn, how the trees in the garden had been there "when Shakespeare was jiving about," and how he had found Saxon arrowheads in the moat. He was not yet the rock legend of lore. His long-term girlfriend, Linda Keith, had only just dumped him—inspiring him to write "Ruby Tuesday," a track that, coupled with "Let's Spend the Night Together," would kick-start another round of hectic promotion for a new Stones album, *Between the Buttons*, in early 1967. The pace of the band's lives meant that, initially, Richards would spend little time enjoying his new country home, often staying instead at Brian Jones's London apartment, where the affair that ripped the band apart flickered into

—

"I FELL IN LOVE WITH REDLANDS THE MINUTE I SAW IT. NOBODY'S GOING TO LET THIS THING GO, IT'S TOO PICTURESQUE, IDEAL."

Keith Richards, *Life*

—

life. After two years together, Anita Pallenberg would soon be leaving Jones for Richards.

Richards's early visits to West Wittering may have been infrequent, but they were always eye-catching, as he and his newly acquired druggy friends treated the upmarket, idyllic village—a birdwatcher's haven with two churches, a campsite, and a pub—to some rock 'n' roll decadence. The Stones were flirting with Nazi regalia, and Richards

OPPOSITE: A dazed Keith Richards sits among a selection of possessions rescued from inside Redlands following the fire at the property on July 31, 1973. "The roof went with the whole top floor," he later recalled.

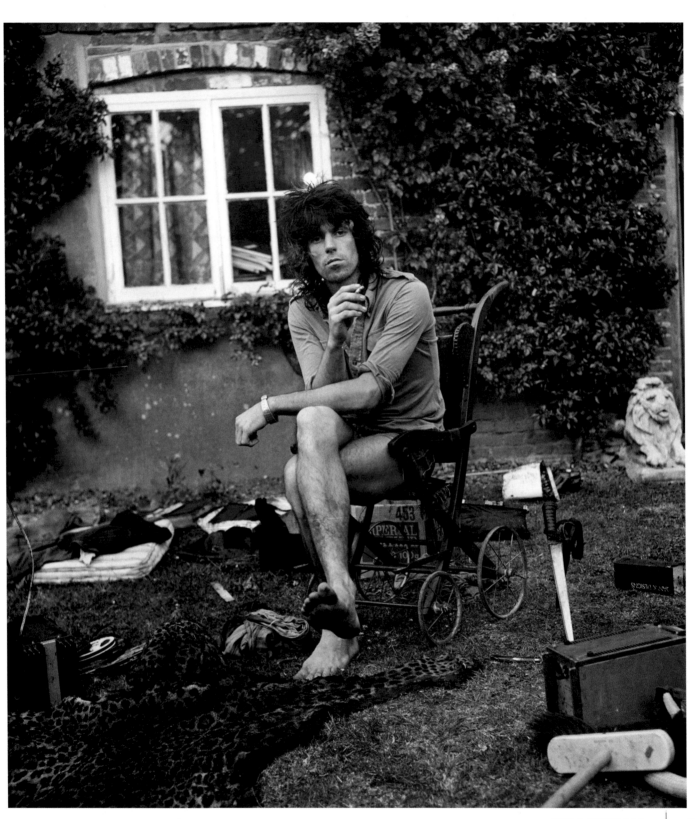

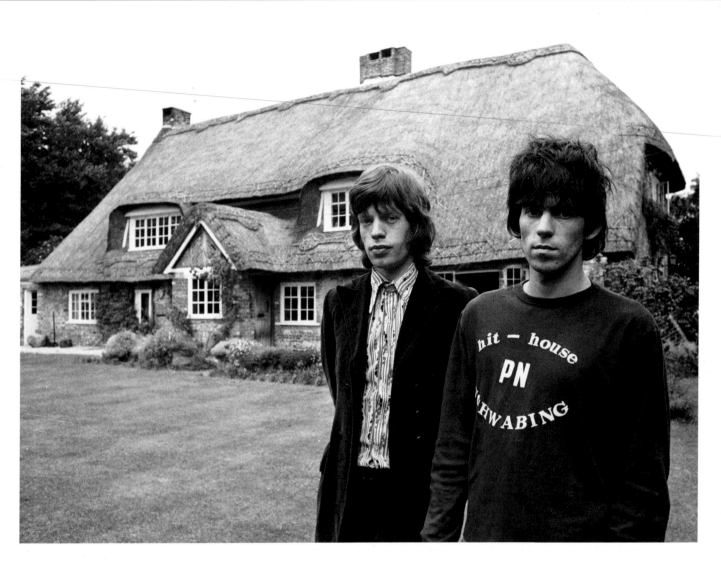

ABOVE: Mick Jagger and Keith Richards at Redlands in July 1967, shortly after their sentencing for drug offenses following a party at the house the previous February.

often wore a full-length leather coat emblazoned with accessories on such visits. Inside Redlands, he hung Moroccan drapes, tapestries, and silks with tie-dyed scarves over lamps, using brightly colored beanbags for seating. So far, so groovy. His two dogs, Ratbag and Syphilis (a wolfhound), roamed freely, and the inside lid of the downstairs toilets was decorated with photos of the Stones.

In February 1967, Richards hosted a weekend party at Redlands, during the course of which he intended to introduce Mick Jagger to acid. George Harrison had been and gone; Richards, Jagger and his new girlfriend, Marianne Faithfull, and assorted hangers-on, after a visit to the beach, tripping on acid, were gently coming down by the log fire in Redland's main lounge when they heard a knock at the door. The police had been tipped off that there would be drugs at the party; they arrived with a warrant, and Richards and Jagger were arrested.

Rumors immediately spread that the police had interrupted an orgy at Redlands—some stories even alleged that Faithfull had been caught pleasuring herself with a Mars Bar. (Richards had a sweet tooth, and dozens of chocolate bars were found at the scene.) Later, in

court, Faithfull was described as being found wrapped in a fur rug that she let slip, generating the headline, "Naked girl at Stone's party." Jagger was found guilty of possession of amphetamines and sentenced to three months in prison, while Richards was found guilty of the more serious offense of allowing his house to be used for the purpose of smoking cannabis and sentenced to a year behind bars. Both men appealed, and after each had served a night in prison, they were freed on bail. An infamous lead article in the *Times* headlined "Who Breaks a Butterfly on a Wheel?" was critical of the harshness of the sentences, and in August they were quashed. The Stones' image as rock 'n' roll outlaws, though, was freshly burnished.

Richards improved security at Redlands with a ten-foot wall erected around the property. During the trial he had left the country for Morocco with Pallenberg and Jones, returning with her on his arm and Jones devastated. Pallenberg settled into Redlands as the Stones took a prolonged break from touring and readjusted their musical sights. Richards relaxed: he built an impressive collection of records and books, enjoying both by the baronial log fire or the hammock on the back terrace. Walls in the timbered staff cottage at Redlands were knocked down to create a music room with a bar at one end and a statue of Buddha at the other.

It was here that the Stones began to put together a new, post-pop career. "Sister Morphine," "Honky Tonk Women," "Street Fighting Man," and "Jumpin' Jack Flash" (with lyrics inspired by Redlands gardener Jack Dyer) were all written at the house. As well as Stones rehearsals, the music room was put to good use when players such as Ry Cooder and Gram Parsons visited. Locals grew accustomed to luxury motors burning up the narrow country roads—Richards was lucky to escape with his life when, close to Redlands, he rolled a Mercedes with a pregnant Pallenberg by his side—and to hearing loud rock music drifting across the fields at all hours.

Parties at Redlands were described as being like stepping off the planet: Keith would show off his growing collection of guns and knives, and there was a "no daylight" zone to crash in, hookahs and drug gear everywhere (the main drug stash allegedly kept off the

property in a nearby oak tree), and even reports of visiting aliens—or at least weird lights in the sky. Underground filmmaker Kenneth Anger painted the front door gold as part of a pagan marriage ritual for Richards and Pallenberg (a union that ultimately never happened); Brian Jones dramatically threw himself in the moat, threatening suicide, following a row with Jagger.

As the band kicked back into touring and recording mode, the two-hour drive to London became problematic, life out in the sticks not compatible with being a working Stone. Richards began looking for a London home. He eventually settled on a place on the same road as Jagger, the historic Cheyne Walk in Chelsea, which ran parallel with the River Thames. With the help of Pallenberg, he turned no. 3, the home of a former Conservative Party minister, into a debauched lair, befitting his new rock 'n' roll image, with black candlesticks, mirror balls, psychedelic painted stairs, occult hieroglyphics, more hookahs, a "tripping room," and a hunchback caretaker. At no. 48, four hundred yards away, Jagger's mansion home was a much neater affair, its

—

"YOU FIND A LOT OF PEOPLE THESE DAYS WHO CANNOT STAND TO BE ALONE. YOU COULD LOCK ME UP IN SOLITARY FOR WEEKS ON END, AND I'D KEEP MYSELF AMUSED."
Keith Richards

—

interior décor including a chandelier for which he paid £6,000. Jagger lived an orderly life there with Faithfull and her three-year-old son, although he had followed Keith's lead and also invested in a country pile, the thirty-five-acre Stargroves, near Newbury in Berkshire.

In 1970, after receiving a huge and unexpected tax bill, the Stones were forced to wave goodbye to their newly acquired English homes and become tax exiles. Richards holed up in the South of France at the sumptuous Villa Nellcote on the Côte d'Azur, close to Nice, where the band put together a new album, *Exile on Main St*. He would spend the rest of the decade confirming his image as rock's most potent outlaw—mad, bad, and dangerous to know, regularly getting busted on drug offenses.

Redlands lost its allure during this period, in part because Richards was under constant surveillance whenever he returned to the UK. In 1972, he splashed out $152,000 in cash to buy a villa in Ocho Rios, Jamaica, far away from such hassles, and immersed himself in the music of the island. Such was his dissolute reputation, though, that it surprised no one when on a rare visit to the UK, with Pallenberg and their two children also present, Redlands was set ablaze. The roof and the whole top floor of the home were destroyed. Richards and drugs were the immediate suspect, but the fire was eventually blamed on mice that had chewed through electrical cables. It took three years to rebuild and remodel the mansion, and during that time Richards lost interest in the house, renting it out for the next twenty years.

In 1985, Richards bought what would become his primary home, an eight-thousand-square-foot colonial house set in eight acres with river and lake views, in the affluent, scenically rural town of Weston, Connecticut, an hour's drive from Manhattan. It was custom-built with an enormous guesthouse in the grounds, along with a swimming pool, tennis court, and Japanese gardens. Here, Richards set up a vast library and even considered "professional training" to manage the thousands of books he had acquired over the years.

—

"GIVE ME A GUITAR, GIVE ME A PIANO, GIVE ME A BROOM AND STRING; I WOULDN'T GET BORED ANYWHERE."
Keith Richards

—

Now worth in excess of a quarter of a billion dollars, Richards also owns a Manhattan penthouse and a two-acre oceanfront getaway on the private Parrot Cay resort in the Turks and Caicos Islands (where other villa owners include Donna Karan and Bruce Willis). The pull of his homeland remains strong, however, and in 1995, as a more sanguine Richards emerged from the long dark shadow of his image, he moved himself back into Redlands for stays in the UK. He claimed to enjoy decorating, cooking (shepherd's pie with HP Sauce being a favorite), gardening, and low-keys visit to a

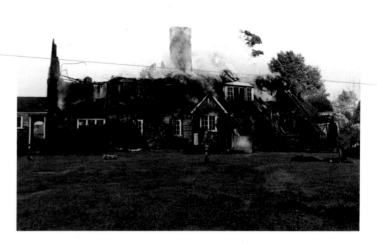

ABOVE: Firemen respond to the blaze at Redlands in 1973, which resulted in the destruction of the property's roof.

OPPOSITE: Richards in the library at his home in Weston, Connecticut, surrounded by thousands of books, many of them rare first editions.

nearby pub, where the locals were warming to him. And it is in West Wittering where, in recent years, Richards has showed off the lighter shades of his personality. When the village hall was in need of repair, he donated the £30,000 needed to fix it. Such was his newfound standing among his neighbors that the local council even backed him when, in 2002, he asked them to reroute a public footpath used by ramblers, cross-country cyclists, and the occasional fan that ran close to Redlands.

Over the years, surprising perhaps even himself, Richards has become a well-loved and respected member of the well-heeled and traditional community in West Wittering, who value him as a gentle and alert conservationist. He bought a section of local woodland to protect colonies of rare bats, and in 2013 he joined his neighbors in the fight to keep a nearby meadow as a haven for rare plants and insects.

By 2017, his transition from public enemy number one to national treasure seemed almost complete. He even wrote to the planning authorities objecting to a proposal for a restaurant on the secluded West Wittering beach. It would, he noted, degrade the area's character. An arch smile must surely have crinkled that famously lived-in face as he signed off.

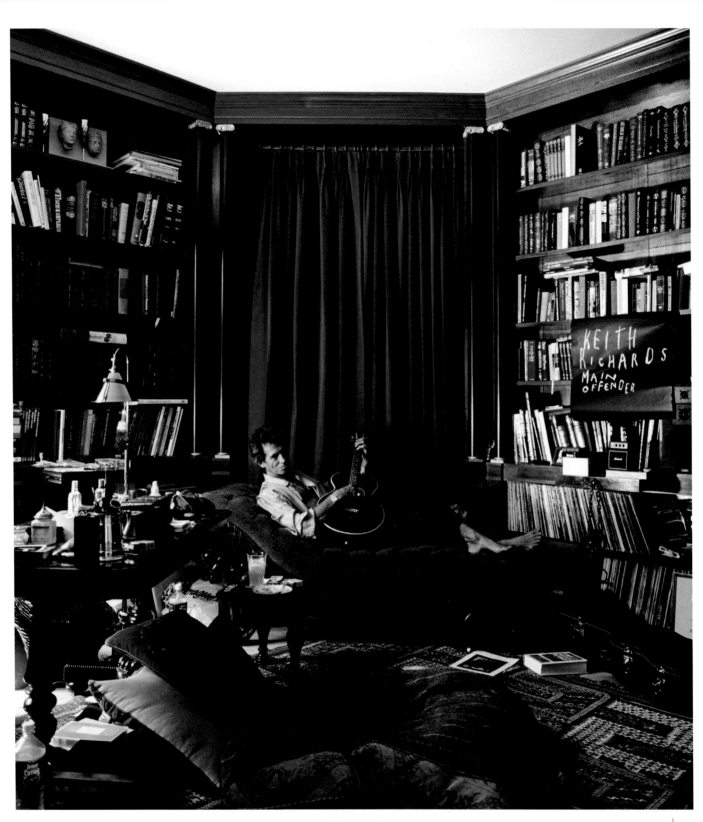

JIMI HENDRIX

23 BROOK STREET, LONDON (HOME FROM 1968 TO 1969)

By Eddi Fiegel

You would think a rock star at the peak of his career ought to have somewhere he could call home, but for Jimi Hendrix, that was not always the case. By early 1968, his guitar wizardry, along with his charisma and captivating flares, fedoras, and feather boas, had led to major British hits with "Hey Joe," "Purple Haze," and "The Wind Cries Mary," not to mention the album *Are You Experienced*. Thanks to his popularity in Britain—which was at the time much greater than in his North American homeland—Hendrix was spending most of his time in London, but it was not until he moved into an attic flat on Brook Street in Mayfair that he really began to feel settled. "This is my first real home of my own," he said in 1968.

Hendrix had been forced to leave the Montagu Square apartment he had sublet from Ringo Starr after he had thrown whitewash over the walls during an acid trip. His long-term girlfriend, Kathy Etchingham, had consequently embarked on a search to find somewhere else. She soon spotted an ad in a London evening newspaper advertising a flat complete with fully fitted kitchen—still a relatively new and glamorous feature at this point, in Britain in the '60s, at least—as well as what would then have been a highly fashionable pink bathroom suite.

The flat was at 23 Brook Street—a three-story Regency townhouse, near Bond Street in Mayfair, which during this period was not nearly as smart and rarefied as it is today. The apartment was on the upper floors above a bistro called Mr. Love, and there were rumors of a brothel in a mews behind the house. In fact, the whole area was a popular rock 'n' roll stamping ground, with an occasionally louche air.

Having agreed to pay the rent of £30 a month (around $75 at the time, or $650 in today's money), Hendrix and Etchingham moved in on July 4, 1968, and Jimi was immediately keen to make the flat as homey as possible.

He gave Kathy what was then the lavish sum of £1,000 in cash to kit the place out, but he didn't hand over responsibility for the décor entirely. As Kathy later recalled, he took a personal interest in fabrics and furnishings, and shoppers in the nearby John Lewis department store would occasionally be amazed to find the flamboyant star perusing the curtains and cushions department. The couple also shopped for furniture amid the antiques emporia on Portobello Road, buying various pieces there, including an oak chair.

The main living space in the flat was the bedroom, which despite being at the top of the building had grand, floor-to-ceiling picture windows, over which Hendrix and Etchingham hung turquoise velvet curtains. The centerpiece of the room, meanwhile, was the double bed, covered with a maroon and orange silk bedspread, scattered with brightly colored cushions. A fringed silk shawl was artfully draped from the ceiling to create a four-poster, canopy effect.

—

"MUSIC STUDENTS USED TO KNOCK ON THE DOOR. JIMI SHOWED THEM AROUND. THEN THEY WOULD SIT AND CHAT ABOUT HANDEL. JIMI THOUGHT HE'D BETTER LISTEN TO THIS GUY'S MUSIC."
Kathy Etchingham, Hendrix's girlfriend

—

Hendrix had a large record collection, including numerous records by Bob Dylan, Chicago blues supremo Howlin' Wolf, and jazz multi-instrumentalist Roland Kirk, as well as several by Baroque composer Georg Friedrich Handel. Since moving into the flat, he had discovered that Handel had lived in the house next door—no. 25—during the eighteenth century, and thanks to an ambiguously placed plaque on the wall, people were often confused as to exactly which house he had lived in, thinking it was perhaps Hendrix's.

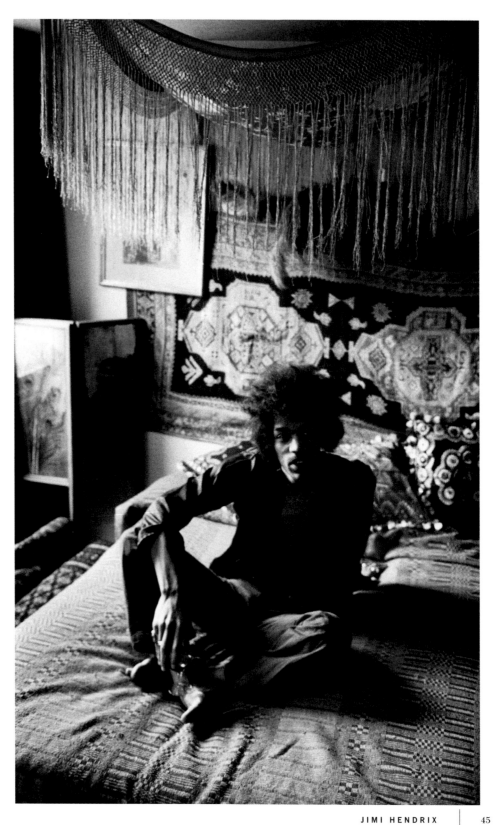

RIGHT: Hendrix sits on the bed at his Mayfair flat, January 1969, flanked by cushions and wall hangings purchased at the nearby John Lewis department store.

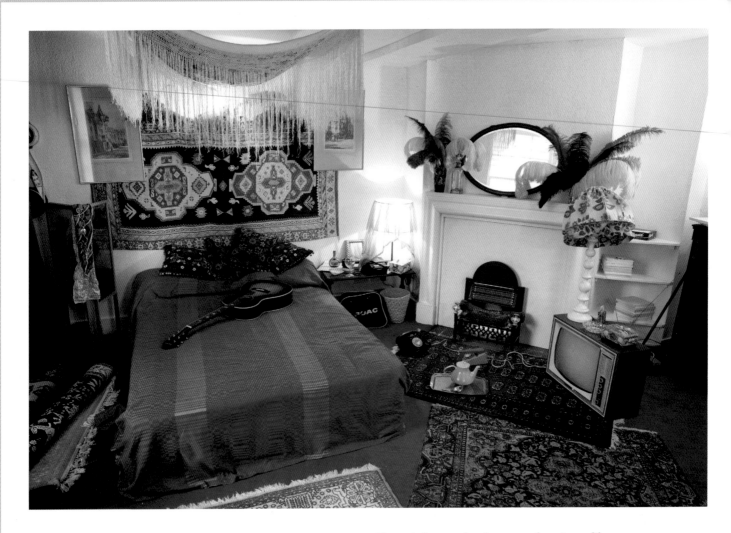

ABOVE: The flat today, following its restoration. The room is filled with his original possessions, including the Epiphone acoustic guitar on which he wrote "All Along the Watchtower."

Etchingham later remembered that music students—oblivious to who the guitarist was—would sometimes knock on the door and ask Hendrix to show them around. "Then they would sit and chat about Handel. Jimi thought he'd better listen to this guy's music."

Hendrix would later claim to have seen the composer's ghost—"an old guy in a night shirt and grey pigtail"—stepping through the wall, but that didn't make him any less intrigued to hear the music. He bought various Handel records, including a copy of the composer's *Messiah*, and used to like sitting on his bed and playing along to it on his guitar.

The attic flat was also the scene of parties and late-night jam sessions. Visitors included George Harrison, Graham Nash, and Cream's Ginger Baker, who would

—

**"IF I'M NOT WORKING, I RARELY LEAVE THE FLAT.
I SIT AT HOME HERE PLAYING RECORDS."**
Hendrix to *Jackie* magazine

—

invariably park illegally on the sidewalk outside. The small home was often packed to the gills with musicians well into the small hours—so much so that friends knew never to turn up at Hendrix's door before 2 p.m. in the afternoon, as Jimi would invariably be sleeping His nocturnal hours soon earned him the nickname "The Bat."

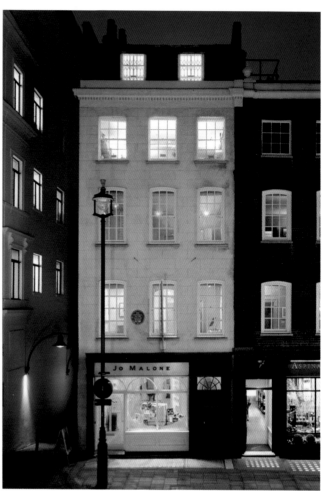

ABOVE LEFT: The English Heritage plaque that now adorns the exterior of the flat.

ABOVE RIGHT: A nighttime view of 23–25 Brook Street, home to both Hendrix and Handel.

Despite all that, by the following afternoon there would be little sign of the night's festivities. Hendrix may have embraced the rock 'n' roll lifestyle in many ways, but his army years had also left their mark, and each day he would make the bed with impeccable attention to detail, ensuring that every corner was turned down neatly and each pillow and cushion was lined up. On quieter nights, he and Etchingham would have cozy nights in with their cat, Pussy, watching Jimi's favorite TV shows, *David Frost* and *Coronation Street*.

There was a small kitchen in the flat, but generally the couple preferred to order up steak and chips, a bottle of Mateus Rosé, and a pack of twenty cigarettes—all delivered, room-service style, from Mr. Love's below.

Gradually, Jimi began to spend more time in the USA, and his relationship with Kathy dwindled. She stayed on at Brook Street for a short while but eventually gave up the flat and moved out. Hendrix himself returned to London, but in September 1970 was found dead in a hotel room in Kensington.

In February 2016, nearly forty years after Hendrix had lived there, 23 Brook Street was refurbished as a sister museum to the Handel House Museum next door. With Kathy Etchingham's help, the original furnishings were recreated and reinstalled alongside many of Hendrix's original belongings, and the flat that Jimi Hendrix once called home is now open to the public.

THE LAUREL CANYON SCENE

LIVING FREE IN THE HOLLYWOOD HILLS

By Eddi Fiegel

It's the ultimate rock trivia question: What links Joni Mitchell, Frank Zappa, the Doors, the Mamas and the Papas, and the Eagles? The answer is Laurel Canyon.

In the late 1960s, while TV newsreels were capturing the love-beaded flower children in San Francisco's Haight-Ashbury, a free-living, free-loving community of musicians, songwriters, and artists were creating their own hippie paradise elsewhere. The verdant woodland of Laurel Canyon—a dense network of winding, mountainous roads on the edge of Hollywood, just ten minutes north of Sunset Boulevard—had become the perfect retreat for musicians looking for a looser lifestyle.

In the '50s, the area had been home to Hollywood stars such as Clara Bow, Errol Flynn, and Harry Houdini, but the Canyon had in fact been a magnet for eccentrics, mavericks, and misfits as early as the 1900s. At that point it was still seen as a slightly distant outpost of Los Angeles, attracting creative types who settled in the newly built wooden chalet-style cabins. They also enjoyed the grand estates built by wealthy industrialists who had made their fortunes in the city, encompassing a range of styles, from Gothic Edwardian and English mock Tudor to Cape Cod clapboard siding and American Arts and Crafts.

A few decades later, Frank Zappa had become one of the Canyon's foremost scenesters, and the regular jam sessions at his house on the corner of Laurel Canyon Boulevard and Lookout Mountain helped make the wooded enclave what Doors drummer John Densmore later remembered as "the coolest spot in Hollywood." Wanting to be close to the "scene," Densmore and Doors guitarist Robbie Krieger soon found a house there, as did Jim Morrison and his girlfriend, Pamela Courson, who moved into a 1920s wooden bungalow which, according to local lore, Clark Gable had once used for clandestine romantic liaisons.

As Doors keyboard player Ray Manzarek later wrote in his introduction to Harvey Kubernik's *Canyon of Dreams: The Magic and the Music of Laurel Canyon*, "Jim would love to sit out on his balcony, and watch the comings and goings of both the elite and the hoi polloi. Or, as he liked to call the exuberantly dressed children of the light, 'the creatures.'"

"I see you live on Love Street," Morrison sings on "Love Street." "There's the store where the creatures meet," he adds, referring to the Canyon Country Store—essentially the corner shop for Canyon residents.

—

"MY DINING ROOM LOOKED OUT OVER FRANK ZAPPA'S DUCK POND, AND ONCE WHEN MY MOTHER WAS VISITING, THREE NAKED GIRLS WERE FLOATING AROUND."
Joni Mitchell

—

In an unofficial attempt to create a new kind of society freed of the highly conformist, twin-set and pearls rigidity of the 1950s and early '60s, the new residents lived a loose-robed, unhurried life. Doors were rarely locked, candlelight was de rigueur at night, and the wafting strains of musicians jamming were never far away.

"There were no sidewalks and no regimented lines the way I was used to cities being laid out," Joni Mitchell later recalled. "And then, having lived in New York, there was the ruralness of it. . . . My dining room looked out

OPPOSITE: Joni Mitchell at her home on Lookout Mountain Road in Laurel Canyon, Los Angeles, August 1968. Her boyfriend of the time, Graham Nash, later referenced the "illuminated" windows in his song "Our House."

over Frank Zappa's duck pond, and once when my mother was visiting, three naked girls were floating around on a raft in the pond. My mother was horrified by my neighborhood. In the upper hills the Buffalo Springfield were playing, and in the afternoon there was

—

"IT WAS VERY LAX AT CASS'S HOUSE . . . SHE WOULD LET PEOPLE WRITE THEIR PHONE NUMBERS AND MESSAGES ON HER WALLS WITH FELT PENS."
Michelle Phillips of the Mamas and the Papas

—

just a cacophony of young bands rehearsing. At night it was quiet except for cats and mockingbirds. It had a smell of eucalyptus, and in the spring . . . a lot of wildflowers would spring up. Laurel Canyon had a wonderful distinctive smell to it." Mitchell would famously write her *Ladies of the Canyon* album when living there, and

British blues supremo John Mayall his *Blues from Laurel Canyon*, while Jackie DeShannon, who had written hits for the Searchers and opened for the Beatles on their 1964 US tour, titled her 1969 solo album *Laurel Canyon*. One of the Mamas and the Papas' great, forgotten singles, "12:30 / Young Girls Are Coming to the Canyon" was similarly written while the group's John Phillips and Denny Doherty were sharing a home there, and significant numbers of girls did indeed seem to be flocking to the area.

"Mama" Cass Elliot's home on Woodrow Wilson Drive was another major hub. Often described as "the Gertrude Stein of the Canyon," Elliot, like many of her peers, kept a seemingly permanently open house; on any given day,

BELOW LEFT: Frank Zappa swings through the trees near his Laurel Canyon home, where he lived from 1968 until his death in 1993.

BELOW RIGHT: The Byrds' Roger McGuinn works in his home studio in Van Nuys while his infant son adjusts an amp, February 1970.

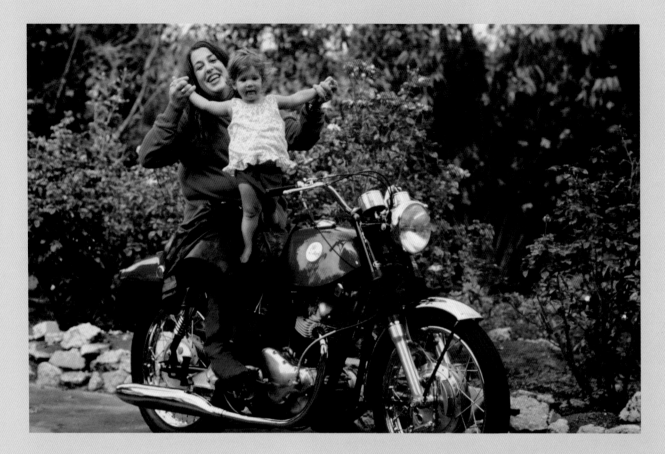

ABOVE: "Mama" Cass Elliot on her red Norton Commando motorcycle—one of the first such models to be produced—with her daughter Owen on Woodrow Wilson Drive, 1968.

you might find David Crosby, Graham Nash, Gram Parsons, and John Sebastian there, as well as visiting British rock stars like Eric Clapton.

By the early '70s, the Canyon had become the focal point of the singer/songwriter boom, playing host to not only Carole King, who wrote her million-selling *Tapestry* there, but also Linda Ronstadt and Judee Sill, among others. Eagles guitarist Glenn Frey similarly moved to the Canyon in 1974, and was soon hosting notorious poker games during the football season. "Joni Mitchell got wind of those card games," Frey later remembered, "and she always was a good hang, so she started coming every Monday night and playing cards with us. . . . They called our house the Kirkwood Casino."

Within a few years, however, the '60s and '70s ethos had given way to an increasingly corporate music industry fueled more by cocaine than free-spirited ideals. Decades on, rocketing property prices mean the Canyon is now mainly home to those with a few million dollars to spare; Jim Morrison's bungalow was recently on the market for over one and a half million dollars.

Despite the rising prices, the area has continued to inspire creativity. In the early '90s, the Red Hot Chili Peppers' *Blood Sugar Sex Magik* was recorded at producer Rick Rubin's Laurel Canyon home studio, as were later albums by Linkin Park and System of a Down. More recently, singer/songwriter and producer Jonathan Wilson, whose own work harks back to the Canyon's earlier days, has revitalized the local scene, creating a hub for a new generation of musicians. It was, however, the hippie idyll of the '60s and early '70s that produced the freewheeling, sun-drenched sound for which the area is still most famous—the sound of ladies and gentlemen of the Canyon on a jingle-jangle morning in L.A.

THE LAUREL CANYON SCENE | 51

BRIAN JONES

COTCHFORD FARM, HARTFIELD, EAST SUSSEX (HOME FROM 1968 TO 1969)

By Simon Spence

Cotchford Farm is perhaps the most infamous of all English rock star homes. It was here that former Rolling Stones kingpin Brian Jones died in July 1969, aged just twenty-seven, in circumstances that shocked the world and that many still consider to be suspicious.

The former farmhouse, situated on the outskirts of the small village of Hartfield, on the edge of Ashdown Forest, in the rolling East Sussex countryside, had once belonged to the celebrated writer A. A. Milne—a fact that appealed to the romantic in Jones when he purchased the property in November 1968 for £35,000. Milne had lived at Cotchford House for thirty years until he died in 1956, and had written all of his famous "Winnie-the-Pooh" books in situ, inspired by the local landscape and the nine acres of woodland attached to the property, including a stream at the bottom of the garden. Jones happily posed for photographs beside the statue of Christopher Robin and the sundial carved with characters from the Pooh books that came with the house.

It was a remote spot for the decadent Jones—often thought of as the ultimate '60s pop-star style icon—to find himself in. The nearest railway station had closed in 1967, and the center of London was at least an hour and a half's drive away. Jones, however, was in desperate need of sanctuary—of a retreat where, it was hoped, he might recover some of his sanity and musical prowess. The overriding consensus was that the Rolling Stones' colossal success over the past five years had badly affected the guitarist, and he had become a train wreck of a man, a heavy drinker and drug user who had fathered at least five children with five different women, and whose mood swings reportedly made him unpredictable and aggressive. Frozen out from the band's songwriting early on, he had suffered the twin indignity of seeing his band (which he had put together in 1962) and his girlfriend, Anita Pallenberg (who left him for bandmate Keith Richards in 1967) stolen away. His attendance at recent

Stones recording sessions for a new album that would become *Let It Bleed* was erratic, his input minimal, his behavior often embarrassing and alarming, not least when he was hospitalized after crashing a motorcycle into a shop window.

Updated since Milne's death, with the notable installation of an outdoor swimming pool, the timber-framed Cotchford Farm, dating back to at least the seventeenth century, was located down a concealed private lane, far away from prying eyes. Jones wanted to be free from the hassles of the police, who appeared to be in cahoots with the press on a sustained mission to send at least one Rolling Stone to prison for their flagrant use (and promotion) of drugs. In just under a year, Jones—the most outwardly "druggy" Stone—had been busted a remarkable seven times.

The police had got lucky in May 1967, shortly after the infamous "Redlands incident" that saw Mick Jagger and Richards arrested, when a raid at his luxury Kensington apartment uncovered marijuana, cocaine,

"IT WAS VERY NICE AND EASY. HE WAS VERY HAPPY ABOUT HIS COUNTRY LIFE. HE SAID IT WAS THE FIRST TIME IN HIS WHOLE LIFE THAT HE FELT HE HAD A HOME."
Jones's girlfriend, Anna Wohlin, on life at Cotchford

and methamphetamine. Jones admitted to marijuana possession and received a nine-month sentence that was overturned on appeal following his promise that he would continue to undergo medical treatment with a psychiatrist at the Priory Clinic, where he was diagnosed with paranoia.

In court, Jones was described as very sick and deeply disturbed—a potential suicide risk. In May 1968, he was arrested for a second time, while on probation, for possession of cannabis at his new apartment on the King's

Road in Chelsea (the landlord at his Sloane Square apartment having evicted him by simply throwing his possessions out on the street). The arrest meant almost certain jail time, and saw Jones's mental state unravel further. The jury found him guilty of possession, but the judge, remarkably, had sympathy for Jones's plight, fining him £50 rather than jailing him.

In the aftermath of the trauma, Jones stayed for a while at Redlands while Richards looked for a property in London, and had come to the conclusion that he wanted a countryside estate for himself. The Stones were suffering from acute financial worries due to unpaid taxes at the time, but Jones refused to tighten the belt. He left one Stones recording session in London to go shopping in the group's Jaguar, and after the parked car was towed away by police, he hired a chauffeur-driven car to take him to Cotchford Farm.

In the early days of his residency at the house, there were reports that Jones had given up drugs and was planning to settle down with his new girlfriend, nineteen-year-old Swedish student Anna Wohlin, who looked pointedly like Anita Pallenberg. Wohlin said Jones was happy and that he had recovered some of his charisma and enthusiasm for music, inspired by his recent trip to Morocco, where he had recorded with the Master

—

"WHEN BRIAN BOUGHT THE FARMHOUSE HE SAID HE WANTED TO LIVE THERE THE REST OF HIS LIFE. AND HE DID. BUT IT WAS TOO SHORT."
Anna Wohlin to the *Daily Mirror*, 2013

—

Musicians of Joujouka. The couple had several dogs, including three cocker spaniels and an Afghan hound, and spent time decorating the property together. The house was baronial, full of oak paneling and exposed wooden beams, with a giant inglenook fireplace blazing away in the main living room. The original thatched roof had been rehung with tiles, the wooden exterior refaced with red brick. Jones's own attempts to modernize the six-bedroom property were less successful. He installed pink fluorescent lighting, multi-colored window glazing, and attempted to paint the ceiling between the beams in

a shade of denim blue. He found the swimming pool almost impossible to keep warm, but was determined to try, using a remarkable four thousand gallons of oil trying to heat it in the eight months he was there.

While some said Jones was regaining his strength at Cotchford, others suggested all was not well. He was said to spend a worrying amount of time planning his own funeral. He was still drinking and taking drugs, and there were reports of him appearing befuddled in the recording studio. The Rolling Stones had certainly seen enough to suggest Jones was not physically or mentally capable of sustaining the heavy work schedule they had planned to promote the new album, including a tour of the United States—their first for three years. Jones's second arrest had also exacerbated problems with acquiring a US work visa. In June 1969, Jagger, Richards, and Stones drummer Charlie Watts visited Cotchford Farm to tell Jones he was out. They allowed him to tell the press he had left due to musical differences and was planning to set up a new group. (In the weeks between his sacking and his death, he contacted musicians including John Lennon to discuss the project.)

BELOW LEFT: Anna Wohlin, Jones's girlfriend at the time of his death, would later claim that he was murdered by Frank Thorogood.

BELOW RIGHT: A portrait of Jones in happier times, preparing to thumb through a rhyming dictionary in a London hotel room, July 1964.

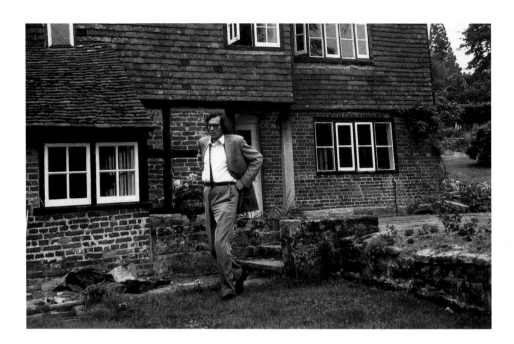

On the night he died, Jones had decided to go for a late-night swim after drinking wine and taking several sedative pills, including methaqualone (a.k.a. Quaaludes). Builder Frank Thorogood—who had been doing some work at Cotchford Farm, having previously worked on Jagger and Richards's homes—joined him in the pool. Neither was said to be in a fit state to go swimming. Shortly before midnight, Jones's body was found at the bottom of the pool. First reports suggested he had died after an asthma attack brought on by the high pollen count. A coroner ruled it death by misadventure, citing the alcohol (three times the driving limit) and drugs (the sedatives, but also his asthma medication) found in Jones's system. His body was said to be weak, showing signs of liver dysfunction, a dangerously enlarged heart, and incipient pleurisy.

Jones was the first of the big 1960s rock stars to die, and the news made headlines worldwide. Twelve hours after he was pronounced dead, the Stones—with Jones's replacement, Mick Taylor, on guitar—appeared on *Top of the Pops* to promote their new single, "Honky Tonk Women." Two days after his death, on July 5, they went ahead with a planned free concert in Hyde Park, playing to over a quarter of a million people. The gig was now positioned as a tribute to Jones, with Jagger reading part of the Percy Shelley poem "Adonais: An Elegy on the Death of John Keats" in tribute to him, before hundreds of white butterflies were released into the summer air.

Since his passing, theories and rumors about Jones's death have fueled their own mini-industry. There have been countless books and a feature film, *Stoned*, on the subject, with some even alleging that Thorogood murdered Jones, or that the Stones' "minder," Tom Keylock, was somehow involved. In August 2009, Sussex Police decided to review the circumstances of Jones's death after fresh evidence was presented to them by a journalist writing yet another book about the night. They swiftly stated that they would not be reopening the case.

Cotchford House was sold in 1970 and became a Grade II–listed building in 1982. When the new owners modernized the outdoor pool in 2000, the original tiles were sold to fans of Jones for £100 each, netting the new owners £12,000. For many, the place remains something of a shrine. An Italian girl appears every year on the anniversary of Jones's death to lay flowers; Dutch fans float pages of magazines in the pool; other sightseers, from as far afield as Brazil, are content to take pictures. The house was put up for sale in 2012, with an asking price of £2 million, and sold, finally, for a reduced fee of £1,895,000 in October 2017.

JOHNNY CASH

THE HOUSE ON THE LAKE, HENDERSONVILLE, TENNESSEE (HOME FROM 1968 TO 2003)

By Colin Salter

"That's my house!" Johnny Cash is reported to have said when, in 1967, he first saw a remarkable building under construction on the rocky, wooded shore of Old Hickory Lake, near Nashville, Tennessee. Unfortunately, the house was not for sale. Its designer, the idiosyncratic master builder Braxton Dixon, was building it for himself.

What Cash saw was a triangular, three-story central block with its point to the front, flanked by a pair of circular glass towers on stilts. In its use of geometric shapes it echoed Frank Lloyd Wright's approach, and in plan view looked a bit like a reel-to-reel tape machine. But there was no plan—Dixon was an organic, instinctive architect. Set on bedrock foundations, the house was built entirely out of natural materials—stone and wood, much of the timber reused from demolished sites elsewhere. The double front doors, for example, were made from six-inch-thick timbers salvaged from a wharf at Charleston in South Carolina.

Cash was looking for a family home. Both he and the love of his life, June Carter, had been divorced from their previous partners a year earlier, and June had agreed to marry Johnny just as soon as he overcame his addiction to amphetamines. In 1967 he was arrested when, after a car crash, he was found to be in possession of a bag full of prescription drugs. After a night in the cells, the arresting sheriff (presumably a fan) let him off with a warning about the waste of Cash's talent that would ensue from continued drug abuse. Cash took his lucky escape from prosecution as a sign and began to clean up his act. The couple married on March 1, 1968.

Johnny Cash, the former United States Air Force staff sergeant who had pestered his way to a recording contract with Sun Records boss Sam Phillips in 1955, would not take "no" from Braxton Dixon. He just kept raising his offer until he reached $150,000 and Dixon could not refuse. June and Johnny moved in in 1968, and the House on the Lake remained their primary home throughout their married life until death separated them in May 2003.

Johnny and June were music royalty. He was a member of the so-called "Million Dollar Quartet" with fellow rock 'n' roll pioneers Elvis Presley, Jerry Lee Lewis, and Carl Perkins; she was a member of the Carter Family, a groundbreaking country-music group founded in 1927 and still performing in the twenty-first century as Carter Family III, with a third generation of Carter descendants. Their home was a place of pilgrimage for the great and good—not only their peers in the music industry but also leaders in other fields. Evangelist Billy Graham was as regular a guest in the house as Cash was on Graham's TV shows. Al Gore was also welcomed, and several presidents came to call, notably Jimmy Carter, a distant relative of June with whom Johnny became close friends.

Cash was humble about his status as one of rock 'n' roll's founding fathers, and he sometimes struggled to reconcile his Christian faith with his lifestyle. He was equally at home with gospel, rock, folk, and later country

"SO MANY PROMINENT THINGS AND PROMINENT PEOPLE IN AMERICAN HISTORY TOOK PLACE IN THAT HOUSE. IT WAS A SANCTUARY AND A FORTRESS.'

Cash's former son-in-law, Marty Stuart

music, and always interested in the work of younger musicians, duetting with Bob Dylan on the opening track of the latter's 1969 LP *Nashville Skyline*, for example. In his autobiography, he recalls visits to the house by the next generation of singer/songwriters. He used to host what he called "guitar pulls," informal jam sessions at which you might hear Dylan trying out "Lay Lady Lay,"

OPPOSITE: Johnny Cash stands outside his sprawling House on the Lake during a break from taping his television series, *The Johnny Cash Show*, in 1969.

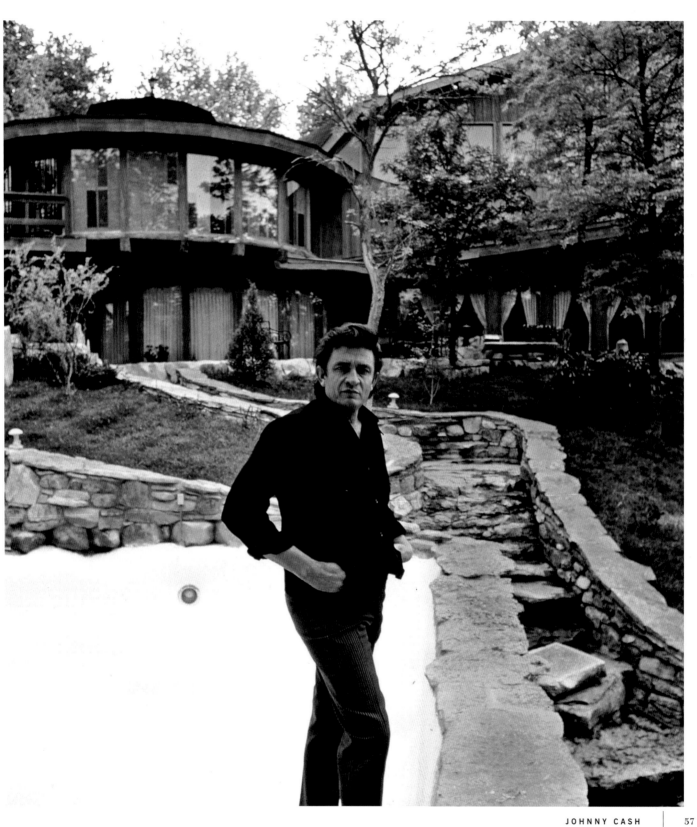

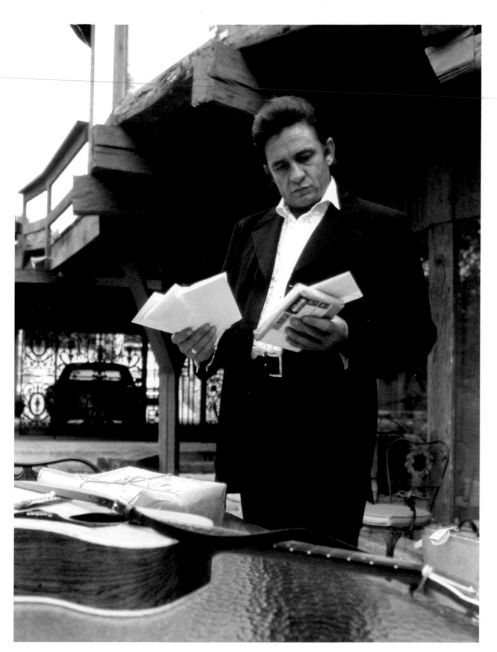

Joni Mitchell singing "Both Sides Now," or Graham Nash unveiling the future Crosby, Stills, and Nash hit "Marrakesh Express."

For their part, musicians of the 1960s had grown up listening to Johnny Cash and looked up to him. Kris Kristofferson was so eager to impress Cash that he once landed a helicopter on the lawn in an effort to play Johnny a song. Some years after Kristofferson premiered his song "Me and Bobby McGee" at Cash's house, he, Cash, Waylon Jennings, and Willie Nelson would later record and perform together as the Highwaymen.

Johnny did most of his writing in the House on the Lake, and much of his recording in a small wooden studio across the street. The studio building was part of a

ranch that he asked Braxton Dixon to build for his elderly parents, and into which he himself moved toward the end of his life, when he began to use a wheelchair. He recorded many of the songs that appeared on his six albums of *American Recordings* in the studio. These were collections of Cash's favorite songs from throughout the twentieth century—a fitting finale to a career that shaped so much of modern American music.

—

"MAYBE IT'S THE GOOD LORD'S WAY TO MAKE SURE THAT IT WAS ONLY JOHNNY'S HOUSE"
Neighbor Richard Sterban, speaking after the fire in 2007

—

From the fourth volume, the single "Hurt" was released in March 2003. The video for it was filmed at the House on the Lake, and in the dilapidated former museum of Johnny Cash memorabilia, the House of Cash, in the ranch across the road. June Carter Cash also appeared in the video, a touching cameo made achingly sad by her death in May, only two months later. Brokenhearted, Cash himself died at home that September. They had been married, and lived in the House on the Lake together, for thirty-five years. Johnny's daughter Rosanne Cash wrote "House on the Lake" in its and their memory, and the house itself featured in the 2006 Johnny and June biopic *Walk the Line*.

Johnny Cash once boasted that he was the only person to be prosecuted by the US Government for starting a forest fire, the result of a careless campfire on a fishing trip in 1965. He might therefore have been amused by what happened next to his former home. It was bought in 2006 by Bee Gee Barry Gibb, who intended to write and record there. But in April the following year, before Gibb could move in, a fire broke out in the house. It quickly took hold, spread by a flammable wood preservative with which workmen had been treating the timbers of the old place. Within a few hours the entire building was reduced to ash.

Gibb, who had bought the property for $2.6 million, sold it on to James Gresham, a property developer, for $2 million in 2014. In the face of local opposition, Gresham abandoned his plans to build a therapy center for eating disorders on the site, and in late 2016 he put it back on the market with an asking price of just under $4 million. In February 2017, the master builder of the House on the Lake, Braxton Dixon passed on, aged ninety-six.

In the immediate aftermath of the 2007 fire, a neighbor remarked, "Maybe it's the Good Lord's way to make sure that it was only Johnny's house." All that remained were the stone chimney breasts from the two glass towers, each carved with a small heart, which was Braxton Dixon's architectural signature. Although the house was in ruins, two hearts still stood.

BELOW LEFT: Cash and his father fish on the lake, August 1969. A keen angler, Cash dueted with Johnny Horton on "I'm a Fishin' Man."

BELOW RIGHT: The smoking wreckage of the House on the Lake after a devastating fire tore through the property in April 2007.

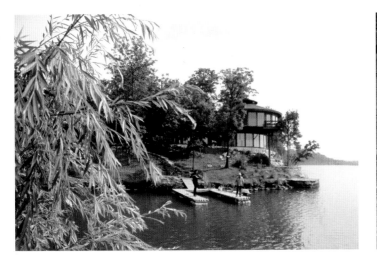

JOHN LENNON & YOKO ONO

TITTENHURST PARK, ASCOT, BERKSHIRE (HOME FROM 1969 TO 1973)
THE DAKOTA, NEW YORK CITY (HOME FROM 1973 TO 1980)

By Eddi Fiegel

If you held a poll to find the most famous John Lennon song, "Imagine" would surely top the list. But since Lennon's murder in 1980, the video that accompanied the song has become almost as famous. The image of John sitting at a white grand piano in a vast, virtually empty white room while Yoko, in a floaty dress and headband, opens the shutters on the floor to ceiling windows, is forever etched in people's minds.

Nearly fifty years after it was made, the room's minimalist sensibility still looks amazingly contemporary, and were it not for John's free-range sideburns and Yoko's slightly Pocahontas-like getup giving away its early '70s origins, the clip could almost have been made yesterday. The film was shot at Tittenhurst Park, a vast seventy-two-acre estate near Ascot in Berkshire, which John had bought and moved into in August 1969. A nineteenth-century stucco-fronted Georgian mansion, the house apparently reminded John of a park he had visited in Liverpool as a child, Calderstones, which had a similarly styled neoclassical house.

Lennon bought Tittenhurst Park from entrepreneur Peter Cadbury, scion of the chocolate-making dynasty, for the princely sum of £145,000, at a time when the average British house price was £3,000–4,000. The estate came complete with a Tudor cottage, servants' buildings, and spectacular grounds, including landscaped gardens. The expansive lawns were dotted with elegant statues and a variety of majestic trees.

Tittenhurst Park was to be John's first home with Yoko after his separation from his first wife, Cynthia, and when it came to the interiors of the main house, the couple set about making them their own. The famous white carpet visible in the "Imagine" video was ordered from Harrods and handmade from unbleached, natural wool on especially large looms in China. Personal assistant Dan Richter sourced other pieces including white marble mantelpieces and a Queen Anne chinoiserie desk for John. In the bedroom, meanwhile, John wanted a bed like a turntable, so a round one was found.

John and Yoko purportedly spent twice the sale price on refurbishing and redecorating the house, hiring various builders and decorators, and the overhaul likewise extended to the gardens. Work began on the installation of a manmade lake, and John and Yoko insisted to the estate's head gardener that they only wanted black and white flowers.

"THEY SLEPT, ATE, HAD SEX, WORKED THE PHONES, READ THE POST, PLANNED THEIR NEXT OUTING, AND WHATEVER ELSE THAT MADE UP THEIR DAY."
John and Yoko's assistant, Dan Richter, on life at Tittenhurst

Even before the "Imagine" video was filmed, Tittenhurst Park was to be immortalized in Beatles history as the backdrop for the group's last ever photo session. On August 22, shortly after Lennon and Ono moved in, a photo shoot was held in the grounds of the house, with John, Paul, George, and Ringo photographed lined up by the pillars underneath one of the terraces and standing and sitting near a wall behind the house. None of them looked especially happy to be there. The pictures

OPPOSITE: Tittenhurst Park, as photographed in 1969, the year John and Yoko moved in. The band portrait used on the cover of the Beatles *Hey Jude* compilation LP was shot on the grounds around the same time.

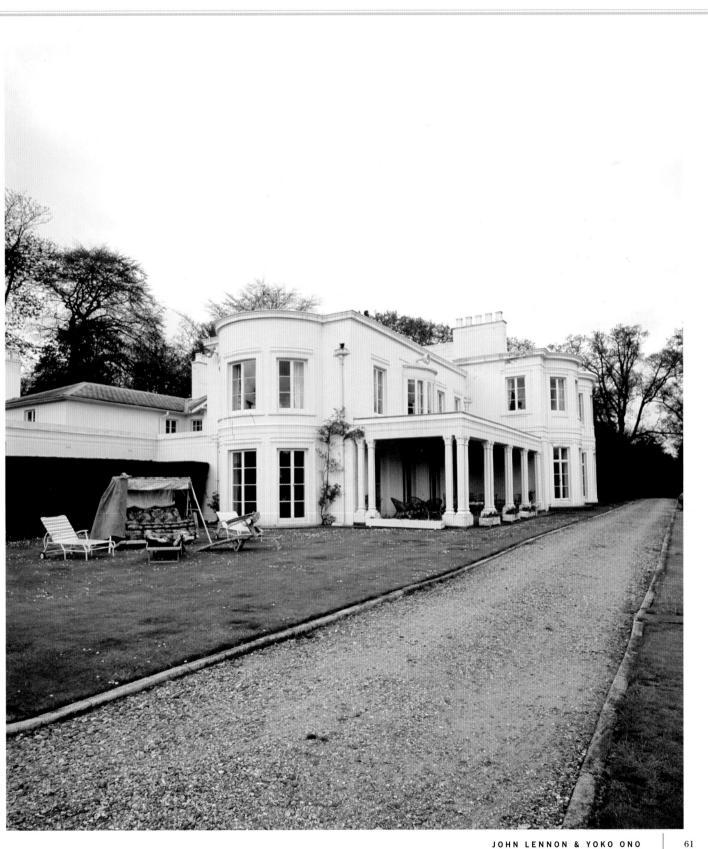

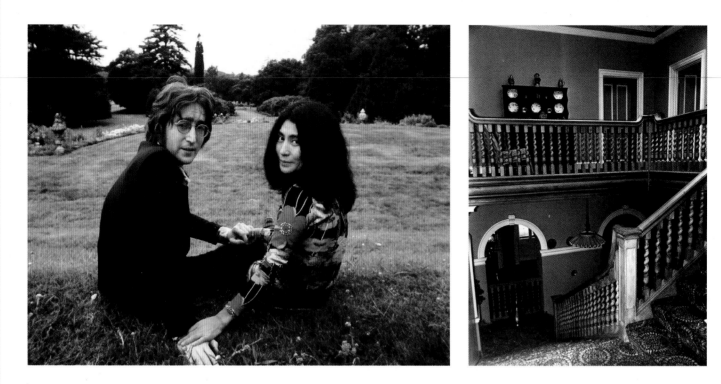

were used for the US *Hey Jude* compilation album; a
month later, on September 20, John told the rest of the
group that he was leaving.

ABOVE LEFT: John and Yoko in one of
Tittenhurst's gardens. They would
later install (without permission) a
manmade lake on the grounds.

ABOVE RIGHT: An interior view of
the main house at Tittenhurst,
showing the entrance hall and
an ornate stairwell.

were used for the US *Hey Jude* compilation album; a
month later, on September 20, John told the rest of the
group that he was leaving.

The band's breakup was officially announced the
following year. In the interim, John had begun building
his own analogue recording studio in Tittenhurst Park's
grounds, soon to be dubbed Ascot Sound Studios. The
facility had an up-to-the-minute, sixteen-channel mixing
console, and both his and Yoko's next few albums were to
be recorded there. In December 1970, they released the
twin John and Yoko *Plastic Ono Band* albums, with covers
featuring mirror images of the couple lying together under
a tree in the gardens in a kind of pastoral country idyll.

The following year, John brought Ringo, George
Harrison, and long-time friend and bass player Klaus
Voormann to Ascot to play on several songs that would
form part of his next album, *Imagine*. As with the Plastic
Ono Band albums, Yoko also recorded a companion
piece, *Fly*, which would also provide the soundtrack to
her art film of the same name.

In August 1969, John and Yoko had gone to see Bob
Dylan at the Isle of Wight Festival, along with George
and Ringo and their wives. John invited Dylan to fly
back to England in Apple's rented helicopter and stay at
Tittenhurst Park, apparently keen for him to play piano
on "Cold Turkey," but this never happened, and Dylan
left soon afterward.

Life at Tittenhurst Park was not all about recording,
of course. Mainly, John and Yoko seemed to spend their
days in bed. As Dan Richter later remembered, "They
slept, ate, had sex, worked the phones, read the post,
planned their next outing, and whatever else that made
up their day."

While they put much time and money into the building
of the studio, much of the rest of the vast mansion
remained in an unfinished state. Large numbers of empty
rooms were filled with piles of cardboard boxes filled with
Beatles paraphernalia, from acetates, tapes, and guitars to
boots, clothes, and books, while elsewhere walls were in
the midst of being torn down and rebuilt.

During the course of 1970, John and Yoko began to
make frequent visits to the USA, partly to undergo Primal

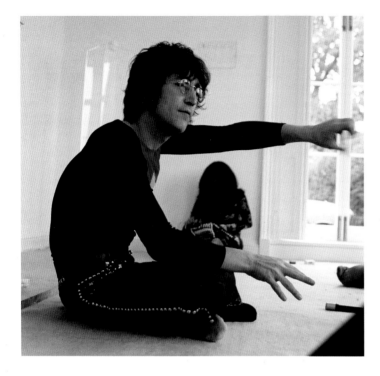

ABOVE: Lennon and Ono in the white room at Tittenhurst, July 1971. The sparsely furnished room can also be seen in the promotional video for John's "Imagine" single, released in October of the same year.

Therapy in California but also because of an ongoing battle between Yoko and her ex-husband, Tony Cox, over custody of their daughter, Kyoko. They would remain in New York for the rest of Lennon's life. Tittenhurst Park, meanwhile, was left empty until September 1973, when John sold the house to Ringo, who would use it as his family home until the late 1980s.

Though Lennon had left the house in 1970, its role as one of rock's most illustrious mansions was not yet over. In 1972, T. Rex's *Born to Boogie* included a "tea party" sequence filmed at Tittenhurst Park, while Ringo would rename Ascot Studio as "Startling Studios," opening it up to various artists, including Judas Priest, who recorded their 1980 album *British Steel* and later mixed their live album *Unleashed in the East* there.

In 1988, Ringo sold the estate to the then–Ruler of Abu Dhabi and President of the United Arab Emirates Sheikh Zayed bin Sultan Al Nahyan for £5 million. The house's décor now apparently features large swathes of

gold. The "Imagine" video may have made Tittenhurst Park one of John's most famous homes, but it was to be his next home which arguably became most closely associated with him.

Occasionally you get a rock star's home which is famous for the wrong reasons. Not because of the gaudiness of its décor nor even because of the star's excesses and carryings-on. In the case of New York's Dakota building, the neo-Gothic, luxury apartment block will forever be associated with Lennon's murder. In 1973, however, when John chose to move there from England, it was just a smart address in the Big Apple. Built in the 1880s, the seven-story Dakota was so named—so the story goes—because at the time of its construction, this part of Manhattan was as sparsely populated as the Midwestern American states of North and South Dakota.

With its imposing Germanic gables, the Dakota was built around a vast central courtyard by the architects who had designed the Plaza Hotel and featured an entrance archway on West 72nd Street broad enough to allow the wealthy first residents space to arrive in their horse-drawn carriages. The arch had a lofty iron gate presided over, twenty-four hours a day, by a white-gloved, security guard,

—

"YOKO BECAME THE BREADWINNER, TAKING CARE OF THE BANKERS AND DEALS. AND I BECAME THE HOUSEWIFE. IT WAS LIKE ONE OF THOSE REVERSAL COMEDIES."
Lennon to *Newsweek*, 1980

—

complete with his own copper sentry box—something which John, at this point, particularly appreciated.

He and Yoko had been living in New York for some months, much of which John had spent undergoing a lengthy battle with US immigration in order to remain in the country, and he had begun to have concerns about privacy, convinced his phones were tapped. Crime in the city was at an all-time high, too, and when the loft he and Yoko had been staying in was burgled, they began looking for somewhere with better security.

When John happened to visit former Beatles assistant Peter Brown at the Langham, a grand apartment building on Central Park West with commanding views across the park, he was immediately impressed. As it turned out,

there were no apartments available for rent there, but something was available in the building next door—the Dakota. US actor Robert Ryan was looking to move out of his apartment at no. 72 following the death of his wife. His four-bedroom home not only had spellbinding views of Central Park, but you could also just about glimpse its lake, a particular passion of John's. Elsewhere, the building had marble staircases, tennis courts, and fourteen-foot-high ceilings, as well as Victorian brass light switches and mahogany paneling, not to mention its own power generator. The building had also become home to an assortment of middle-aged luminaries from the worlds of film, TV, and the arts; other residents at various points included Leonard Bernstein, Lauren Bacall, Judy Garland, Rosemary Clooney, Rudolf Nureyev, Jack Palance, Lillian Gish, and Boris Karloff.

John and Yoko moved into the Dakota in 1973 and soon decorated the apartment with the white walls and carpets that they had famously installed at Tittenhurst Park, creating a similar entirely white room. Furniture was likewise shipped from Ascot, including the white piano used in the "Imagine" film. They also invested in art, buying major works including a painting by Renoir as well as several ancient Egyptian artifacts for their "Pyramid Room," a shrine to Yoko's fascination with all things ancient Egyptian.

John and Yoko would eventually buy five apartments in the Dakota, including the one next door on the seventh floor, which they used as a studio space, and three others:

"IF I'D LIVED IN ROMAN TIMES, I'D HAVE LIVED IN ROME. WHERE ELSE? TODAY AMERICA IS THE ROMAN EMPIRE AND NEW YORK IS ROME ITSELF."

Lennon to *Rolling Stone*, 1980

one on the ground floor for Yoko to work in as an office, one for storage (rumor has it for specialized cold storage of their fur coats), and one as a guest apartment.

The Dakota was to become John's home for the rest of his life, with the exception of his infamous "lost weekend," when he lived in Los Angeles with secretary May Pang during 1973 and 1974 before returning to

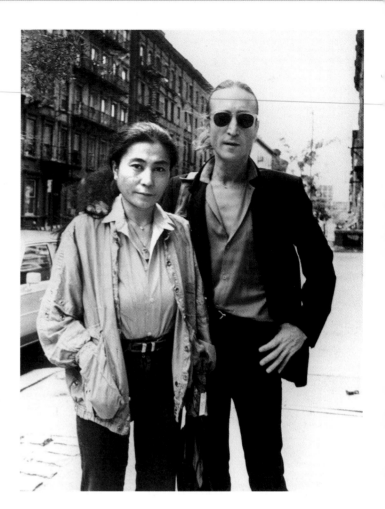

ABOVE: John and Yoko pause for a photograph on the streets of New York City, August 1980. Despite their fame, they found they could often walk undisturbed around the city.

Yoko. John's return to the Dakota marked the start of a new phase in his life, and less than a year later, the couple's son, Sean Ono Lennon, was born on John's thirty-fifth birthday, October 9, 1975.

John would spend the next five years looking after Sean while Yoko managed the couple's business dealings and growing property portfolio. Days were spent taking Sean to the park, baking bread, and preparing macrobiotic lunches. When he wasn't looking after his son, he would spend long hours reading or watching TV, holed up with the couple's cats, mainly in what became known as the "Black Room"—his own den, so named because it was kept in an almost constant state of darkness with the

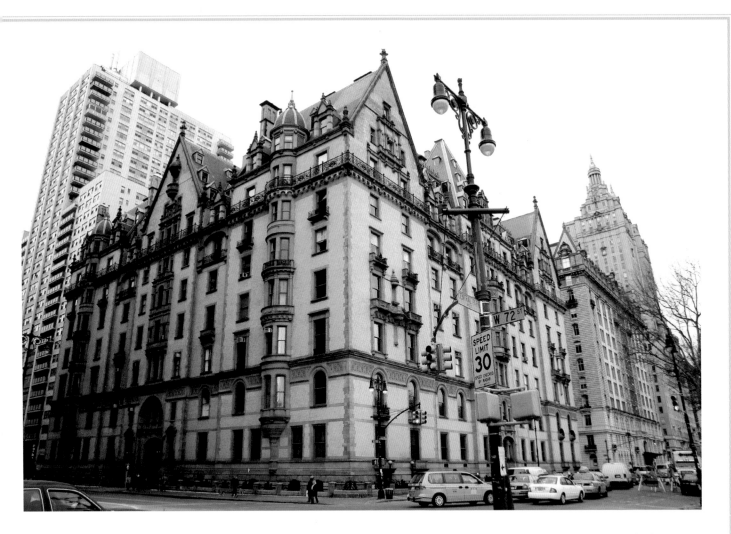

ABOVE: The Dakota apartment building on the corner of 72nd Street and Central Park West, where Lennon lived out his final years in relative seclusion with his wife and son.

curtains closed. The Black Room featured a Yamaha keyboard, which Elton John had given John for his birthday, as well as a vintage "bubble-top" Wurlitzer jukebox complete with a selection of John's favorite '50s hits, such as Elvis's "Hound Dog" and Gene Vincent's "Be-Bop-a-Lula."

Despite having largely taken time out from his musical career, John had nevertheless recorded some home demos during these years, and in August 1980, with the help of producer Jack Douglas, a group of session musicians came to their seventh floor apartment at no. 71 to begin rehearsing for what would become the *Double Fantasy* album. Following sessions at New York's Hit Factory studios, the album, which featured alternate tracks by both John and Yoko, was released on November 17 that year.

A few weeks later, on December 8, John was returning home to the Dakota when deranged fan Mark Chapman fatally shot him as he stood by the building's entrance gate. That same night, a candlelit vigil was held outside the building by thousands of fans—a tradition that has continued every year since, and the Dakota remains Yoko's home.

In 1985, on what would have been John's forty-fifth birthday, a two-and-a-half-acre memorial park named Strawberry Fields was opened in Central Park, just outside the Dakota, by Yoko and New York's then-mayor, Ed Koch. Designed by landscape architect Bruce Kelly, the area's main feature is a circular stone mosaic bearing the word "Imagine."

THE ALLMAN BROTHERS

THE BIG HOUSE, MACON, GEORGIA (HOME FROM 1970 TO 1973)

By Eddi Fiegel

For a relatively small, sleepy town in the heart of America's South, Macon, Georgia, has a lot of rock 'n' roll history. Little Richard was born and raised there, and the town also produced Otis Redding, Randy Crawford, and Mike Mills of R.E.M. But perhaps the group most closely associated with the place is the Allman Brothers. Out amid the green countryside and antebellum villas beyond Macon's Georgian town center sits the Big House—the Allman Brothers' home for several years, and now a museum to the band.

Built in 1900, the spacious, double-fronted Victorian villa on Vineville Avenue is set back from the road behind neatly trimmed lawns, and it is easy to see why the band would have warmed to the house's grandeur. When they moved there in 1970, what they found were light and airy rooms with high ceilings and stained-glass windows as well as ornate fireplaces and French windows. There was even a ballroom on the third floor, while the gardens had ornamental fountains and a fishpond.

Gregg and Duane Allman had spent their early lives in Tennessee and Florida, but Macon was to become a major part of their lives. While he was still a teenager, Duane Allman's prodigious guitar playing on records by the likes of Aretha Franklin, Wilson Pickett, and Percy Sledge had been noticed by Otis Redding's manager, Phil Walden. Consequently Walden, who had recently formed his own Macon-based label, Capricorn Records, not only began managing Allman but encouraged him to form a group with his brother, Gregg.

The Allman Brothers' debut, *The Allman Brothers Band*, was released in 1969, and although record company executives suggested they move to music industry hubs like Los Angeles or New York, the band resisted, insisting that they wanted to stay in the South.

It also made sense for them to be near Capricorn Records' new recording studio. "Everyone told us we'd fall by the wayside down there," Gregg Allman later remembered, but instead, as Alan Paul writes in his 2014 biography of the band, their collaboration with Capricorn had "transformed Macon from this sleepy little town into a very hip, wild and crazy place filled with bikers and rockers."

The group—which now consisted of Duane and Gregg plus songwriter, singer, and guitarist Dickey Betts, bass player Berry Oakley, and drummer Butch Trucks—initially lived in a series of rented apartments in Macon with assorted girlfriends, wives, and children. Eventually, however, Gregg and Duane's girlfriends, Candy and

—

"THE BIG HOUSE WAS A COMFORTABLE PLACE WITH A WONDERFUL SPIRIT OF COMMUNAL LIVING. WE WERE A FAMILY."
Allman Brothers tour manager Willie Perkins

—

Donna, along with Berry Oakley's wife, Linda, decided to look for somewhere large enough to accommodate the three couples and their children together.

They had seen the house on Vineville Avenue and decided that with six of them clubbing together for the rent, they could probably afford the $225 a month for the house. It was just a question of convincing the real estate agents to let them have it. Dressed in her most sedate outfit, Linda took her baby daughter Brittany with her and managed to conjure up a vision

OPPOSITE: The stained-glass windows that surround the main entrance to 2321 Vineville Avenue, a.k.a. the Big House, now home to the Allman Brothers Band Museum.

of tame domestic contentment so believable that the deal was sealed.

In March 1970, the group moved into what would soon become known as "the Big House." Linda in particular

—

"WHAT HAD BEEN BUILT AS THIS PRIM AND PROPER RESIDENCE FOR THE SOUTHERN ELITE HAD BEEN TRANSFORMED INTO AN INFORMAL, COMFORTABLE, WARM AND LOVING HOME."

Willie Perkins

—

took on the house as a project, hanging Indian textiles and prints on the walls and hitchhiking to Atlanta to get a stereo for the music room. Berry's grandmother, meanwhile, chipped in providing some wicker ware as well as an elaborately brocaded Victorian sofa. The band's hectic touring schedule however meant they were often on the road, and while they were away during the early part of 1971 they recorded what would become the hugely successful live album *At Filmore East*. The album was to transform the band's fortunes radically, and a celebratory mood was consequently very much in order when the band returned to the Big House. The couples would be in honeymoon mode, and the house became the scene of nightly jam sessions in the music room—a large sunroom on the first floor that Duane had soundproofed by covering the walls with cotton wadding. The kitchen was also a major hub, especially for Gregg and Duane, who would write songs and chat there.

Guitarist Dickey Betts wrote two of the band's key songs—"Blue Sky" and "Ramblin' Man" at the house—

BELOW: Duane Allman relaxes by a lake in Macon, Georgia, October 1970. Bass fishing remained a favorite pastime of his throughout his time with the band. He is pictured on the cover of the 1972 *Anthology* LP fishing in Florida.

and Berry Oakley would later remember organizing parties where everyone would get together and, as he put it, "hit the note." But the band's bonhomie and contentment at the Big House was not to last.

By autumn 1971, Duane had moved out and was living with his new girlfriend, Dixie, across town. Nevertheless, on October 29 he came over to the house to help with preparations for a birthday party for Linda. They were busy making Halloween lanterns, and Linda later remembered that Duane was keen to "do the eyes and the mouth," and so offered to go and fetch some extra materials. At a nearby intersection, his Harley-Davidson was hit by a truck, and despite attempts to save him at a nearby hospital, he died a few hours later from the internal injuries he had suffered.

Just over a year later, in November 1972, Berry was also killed in a motorcycle accident, just three blocks from where Duane had been hit. They were both only twenty-four years old. Linda spent that Christmas with family and friends in Florida, and when she returned in January 1973, she discovered an eviction notice had been posted on the house. Word had it that the negative publicity around the deaths of the two band members had not been well received by the house's owners.

The Big House went through several different pairs of hands over the next few years and fell into a state of disrepair before being bought in the late 1990s by tour manager Kirk West and his wife Kirsten, who then began a lengthy process of renovation. Now, more than forty years later, the Big House is open to the public, under the stewardship of the Big House Foundation. Filled with Allman Brothers guitars and memorabilia, it is one of the key attractions in Macon's musical heritage trail.

ROCK 'N' ROLL HOTELS

FROM BED-IN TO CHECKOUT

By Colin Salter

There are those who feel that rock 'n' roll in the twenty-first century has lost some of its bite, some of the rebellious qualities of its youth. How different it was from the 1960s to the 1980s, when it was a brave hotel manager who accepted a booking from a touring rock 'n' roll band; when, pumped up after a successful performance, or frustrated by a poor one, some bands would return to their hotel with energy to burn and a reputation for nonconformity to maintain.

For some musicians that might mean no more than a rowdy, late-night bar bill, or a naked streak through the restaurant. But as a rule of thumb, the bigger the rock star, the greater the after-gig excess. In Bangkok, the management of the Mandarin Oriental had to call in the army to sedate Billy Idol with tranquilizer guns. The "White Wedding" star, out of his head on drugs, had destroyed the furniture and fittings of his room, leaving a group of prostitutes he had hired for the night cowering in a corner. Troops eventually carried him out on a stretcher.

Tales are told at several hotels, including the Chateau Marmont and Andaz West Hollywood in Los Angeles, of members of Led Zeppelin riding Harley-Davidsons through the corridors. At the West Hollywood, six floors of the building were occupied by the Zeppelin entourage, who may not have objected to a little late-night traffic outside their doors. Elvis Presley, too, had his hangers-on—his booking at Swingo's Celebrity Inn in Cleveland, Ohio, was for a hundred rooms. Swingo's became something of a legend among rock musicians; as Ian Hunter of Mott the Hoople put it, it was somewhere where "you remember checking in and out, but you can't remember anything in between."

Keith Moon, drummer with the Who, was the epitome of the rock 'n' roll bad boy. He once arrived at Swingo's dressed as a policeman and handcuffed two guests together, but his party piece was throwing television sets out of hotel windows. It became something of a trademark, to the extent that once, on the way to the airport, he ordered his driver to turn around and return to the hotel because he had forgotten to do so.

Although Moon could not drive and never held a driver's license, it's claimed that he once managed to run himself over with his own vehicle. On another occasion, in 1966, when police came to break up his twentieth birthday party at the Holiday Inn in Flint, Michigan, he tried to escape in a Lincoln Continental, but he was so drunk that all he could do was release the brake. Moon sat at the wheel, amused and bemused, as the car began to roll backward, crashing through a fence and continuing on into the hotel swimming pool. The Who's vocalist, Roger Daltrey, would later say that the bill for this episode alone was $50,000. Moon's delight in setting off cherry bombs (powerful firecrackers) is estimated to have caused upward of $500,000 of damage to hotel toilet

—

"KEITH MOON, GOD REST HIS SOUL, ONCE DROVE HIS CAR THROUGH THE GLASS DOORS OF A HOTEL, DROVE ALL THE WAY UP TO THE RECEPTION DESK, GOT OUT, AND ASKED FOR THE KEY TO HIS ROOM."

Pete Townshend

—

systems over the years, and resulted in lifetime bans from Hilton, Holiday Inn, and Sheraton hotels.

What might be unwelcome for a hotel manager is often a magnet for fans. In 1964, the struggling Edgewater Hotel in Seattle accepted a risky booking from the Beatles—then undertaking their second US tour—when no other hotel in town would touch them. The Edgewater's insurance provider promptly canceled the band's policy, and the hotel had to erect barriers to hold back the screaming

OPPOSITE: Janis Joplin checks in at the front desk of the Chelsea Hotel in New York City, March 1969.

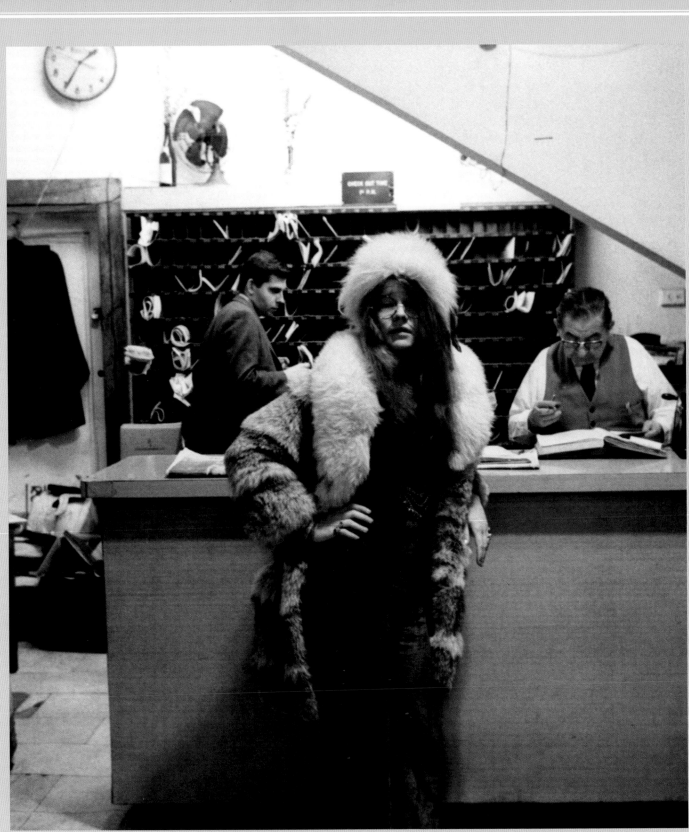

hordes of fans. But the gamble paid off: the Edgewater, originally built as a temporary structure for the 1962 Seattle World's Fair, and due for demolition at the time, is still in business today. The Beatles were the first of many groups to stay there, and the hotel still gets an inquiry every week about Suite 272, which the Fab Four, the Rolling Stones, Led Zeppelin, and others have occupied. The orange carpet from the suite—the one on which the Beatles stood—was sold off to fans in twelve-inch squares the day after their visit.

Many other hotels have felt the "Beatles Effect," none more so than the Amsterdam Hilton and the Queen Elizabeth Hotel in Montreal. Following their marriage in March 1969, John Lennon and Yoko Ono took advantage of the attention of the world's press to plead for world peace. They staged two weeklong "bed-ins" during which they held court from the bed of their hotel for twelve hours a day in front of journalists and cameras.

The first week, in March, was also their honeymoon. The second, in May, was planned to take place in New York but switched to Montreal after Lennon was barred from entry to the USA because of a drug conviction. At the end of their week in Montreal, Lennon and Ono recorded "Give Peace a Chance" from their bed, with Timothy Leary, Allen Ginsberg, and other celebrity visitors on backing vocals. Suite 1742 in the Fairmont Queen Elizabeth is now known as the John Lennon and Yoko Ono Suite, and an anonymous fan still leaves two dozen roses outside its door every year on the anniversary of Lennon's death.

Some rock stars have so much fun in hotels on tour that they choose to live in one even when they are not on the road. Gravel-throated poet of American life Tom Waits lived in the legendary Tropicana Motel in Los Angeles for three years in the 1970s. The cheap rooms there were as popular with local prostitutes and drug dealers as they were with touring musicians. Everyone from Janis Joplin to Blondie, Alice Cooper to the New

BELOW: John Lennon and Yoko Ono stage their second "Bed-In for Peace" at the Queen Elizabeth Hotel, Montreal, Canada, May 1969. A few days later, on June 1, they recorded the single "Give Peace a Chance" live in their hotel room there.

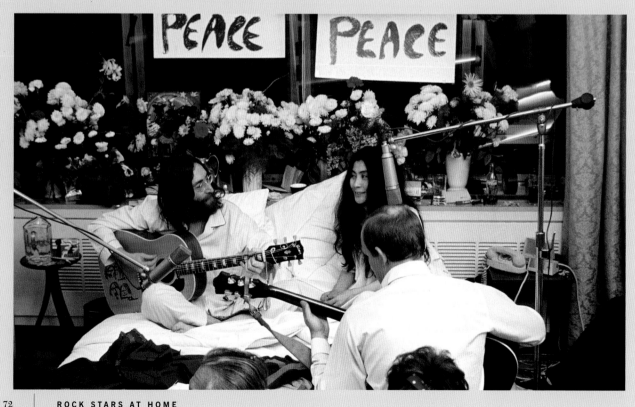

ABOVE LEFT: Sid Vicious receives a police escort from the Chelsea Hotel shortly before being charged with the murder of his girlfriend, Nancy Spungen, October 1978.

ABOVE RIGHT: Led Zeppelin front man Robert Plant surveys the scene on the Sunset Strip from his balcony at the "Riot House" Hyatt, Los Angeles, 1975.

York Dolls passed through the Tropicana, but Waits took up full-time residency there precisely to observe the transient population. Sadly, the Tropicana was demolished in 1987 to make way for a new Ramada Inn, whose owner was not so tolerant of rock stars' bad behavior: "The idea that you can walk in and break things, the way they used to . . . they won't be able to do it anymore."

The most notorious long-stay rock residence is the Chelsea Hotel in New York. The Chelsea opened as a grand hotel in 1905, famed for its twelve-story central staircase and its agonizingly slow lifts. After World War II, when demand for such places fell off, it rented rooms to an increasingly diverse group of occupants. The grand suites were confined to the upper floors, and below them rooms were taken by tourists, writers, artists, musicians, and—on the floors nearest reception—prostitutes, drug dealers, and other troublemakers.

The Chelsea became something akin to a commune, the atmosphere of intense creativity in so many artistic disciplines inspiring its population to great things. Bob Dylan wrote many songs about his new wife during his time there in the mid-1960s, including "Sara" and the epic "Sad Eyed Lady of the Lowlands." Leonard Cohen and Janis Joplin became neighbors on the fourth floor in 1968

and embarked on a brief affair, which Cohen described in two songs, "Chelsea Hotel" and "Chelsea Hotel #2." Rock poet Patti Smith lived there from 1969 with her boyfriend, the photographer Robert Mapplethorpe, who shot the covers for her albums.

Some guests checked in purely to check out—the height of the building made it the setting for several suicides. One victim landed on the sidewalk from the ninth floor, right at the feet of Dee Dee Ramone, who was one day sober after hiding out at the Chelsea to go cold turkey. The most famous death, and a low point in the Chelsea's history, was that of Nancy Spungen. The girlfriend of Sid Vicious was found in room no. 100 with a single stab wound. Vicious, accused of her murder, died a few months later of a heroin overdose in what some claim was a suicide pact with Spungen.

Madonna lived at the Chelsea in the early 1980s, and in 1992 used room 882 to photograph some scenes for her book *Sex*. Her disco celebrity seemed at odds with the Chelsea's bohemian ethos—the hotel would describe itself, in an understated way, as "a rest stop for rare individuals." By the end of the century it was in disrepair and had become little more than a tourist destination for fans of its present and former residents. In 2007, under new ownership, it stopped taking new bookings. It is expected to reopen in 2018 as a boutique hotel, amid fear that its colorful history and character will be lost forever. It would be a sad loss: rock needs places like the Chelsea, where its stars can let down their hair and misbehave.

GEORGE HARRISON

FRIAR PARK, HENLEY-ON-THAMES, OXFORDSHIRE (HOME FROM 1970 TO 2001)

By Eddi Fiegel

George Harrison is remembered for many things, not least as the brilliant Beatle guitarist and songwriter with a passion for all things Indian and mystic. But one of the most striking images of "the quiet Beatle" is perhaps of George Harrison—the gardener.

The front cover of his most successful solo album, *All Things Must Pass*, shows a long-haired, bearded, and mustachioed George sitting in the midst of an expansive garden lawn, dressed in anorak and wellington boots, surrounded by fallen garden gnomes. He looks every inch the hippie gardener, about to do some mooching in the potting shed with some exotic plants. But the gardening garb was in fact indicative of a new phase in George's life. In the spring of 1970 he had moved to Friar Park, a vast Gothic folly with grounds near the sedate town of Henley-on-Thames, some forty miles west of London, and sedate was exactly what George Harrison was looking for.

Since 1964, George had been living at Kinfauns, a rambling bungalow in Esher in the Surrey stockbroker belt, but fans had quickly rumbled his whereabouts, and peace and privacy were at a premium. George consequently wanted somewhere secluded enough to keep the fans out, and with enough space to build a recording studio. "I am also insisting on a private lake," he said at the time, "because water is very peaceful for the mind."

After looking at various properties, his wife Pattie happened to see an announcement in the *Sunday Times*: a coterie of nuns—the Salesians of Don Bosco—was looking for a buyer for their school building in Henley-on-Thames. Since the school had closed, the building was due to be demolished, unless it was sold.

With an estate covering some sixty-two acres, Friar Park had been created by eminent Victorian lawyer and botanist Sir Frank Crisp in 1898. The three-story mansion, awash with towers, turrets, and gargoyles, had twenty-five bedrooms, various reception rooms, a library, and a ballroom. As Graeme Thomson writes in his biography of Harrison, *Behind the Locked Door*, "Inside, the double doors led to a marble vestibule and then a huge hall with a grand staircase and a minstrel's gallery above. The fireplace was vast, flanked on each side by a panel showing the Tree of Life and the Tree of Destiny. The dining room had stained glass windows and the ballroom ceiling was dotted with cherubs."

Elsewhere, mantelpieces and walls were peppered with puns and proverbs, while the light switches were in the form of monk's faces, activated by clicking their noses. The extensive gardens, meanwhile, were no less a masterpiece of English eccentricity, with an array of statues, outlandish topiary, water features, underground passages, and garden gnomes. Not to mention a maze and an Alpine rock garden with a sandstone scale replica of the Matterhorn.

George and Pattie were instantly enthralled, and in January 1970 paid £140,000 for the property. A couple

—

"I AM SEEKING THE ABSOLUTE PEACE OF COMPLETE PRIVACY. I AM ALSO INSISTING ON A PRIVATE LAKE, BECAUSE WATER IS VERY PEACEFUL FOR THE MIND."

George Harrison

—

of months later they moved in, but rather than settling into Lord and Lady of the Manor–style splendor, they suddenly found themselves living more akin to squatters in a hippie commune. Over the years, the nuns had let the house fall into a state of disrepair, with no heating to speak of, crumbling walls, and weeds creeping through the floorboards. The ornate gardens had been used as a dumping ground, the lakes had run dry, and brambles had begun encroaching, Triffid-like, across the lawns.

OPPOSITE: George Harrison at one in the grounds of Friar Park, Henley-on-Thames, 1975. The gardens and water features were designed by the noted landscape architect Henry Ernest Milner in the mid-nineteenth century.

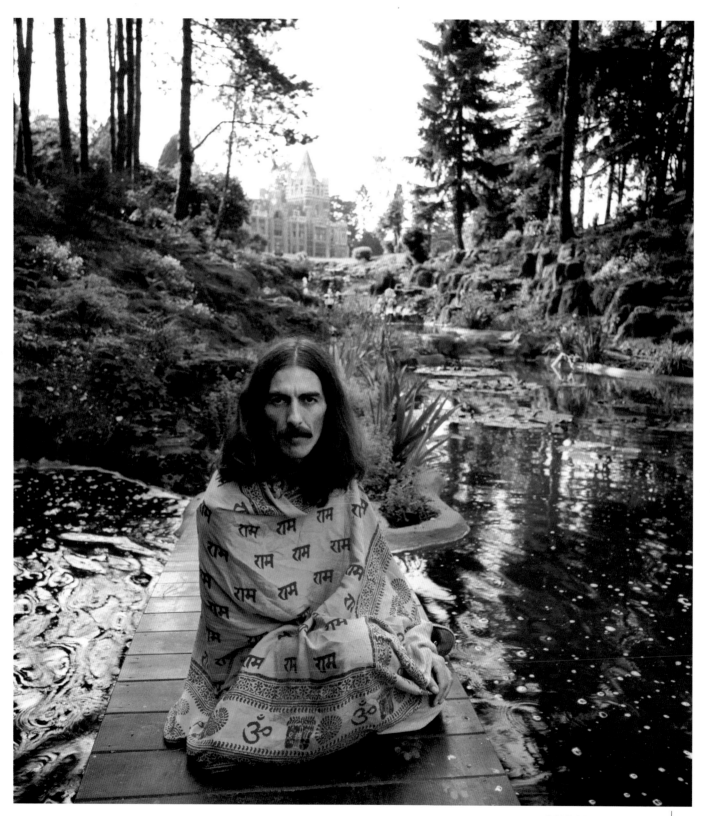

With only the fire in the vast, Henry VIII–style grate to keep them warm, George and Pattie slept on a mattress in the hall, huddling together in layers of coats, scarves, and sleeping bags. George, however, was passionate about restoring the house and would spend hours reading about architectural details. His fascination with the house would also inspire several of his songs over the next few years. *All Things Must Pass*, recorded between May and October of 1970, includes "The Ballad of Sir Frankie Crisp (Let It Roll)"; "Crackerbox Palace," from his 1976 album *33 1/3*, was George's nickname for the house.

Gradually, the couple began the epic task of restoring Friar Park to its former glory, enthusiastically playing decorators and gardeners, and they soon had a growing posse of friends and acquaintances—including John Lennon—all happy to don boots and anoraks and lend a hand, while roughing it in sleeping bags. Other visitors to the house over the coming years would include Eric Clapton, Ron Wood, Bob Dylan, and Peter Sellers.

By 1972, Friar Park was beginning to take shape, and George had also fulfilled his dream of building a recording studio on the top floor of the house, complete with what was then a state-of-the-art sixteen-track desk. The studio offered spectacular views of the grounds and would come to be known as FPSHOT (Friar Park Studios Henley-on-Thames). The following year, George recorded *Living in the Material World* partly at FPSHOT and partly in London; the follow-up album, *Dark Horse*, was his first to be recorded almost entirely at Friar Park.

Dark Horse ended up chronicling what were by then turbulent times for George both professionally and personally. George, John, and Ringo were suing business manager Allen Klein while also suing Paul McCartney. George's marriage to Pattie Boyd was similarly in meltdown amid numerous infidelities, including, most notably, George's liaison with Maureen Starkey and Pattie's with Eric Clapton.

George's love for Friar Park remained unchanged nevertheless, and the house is referenced at several points throughout the album. The track "Ding Dong" was written as a New Year's Eve sing-along, but several of its lyrics were lifted directly from verses carved around the house.

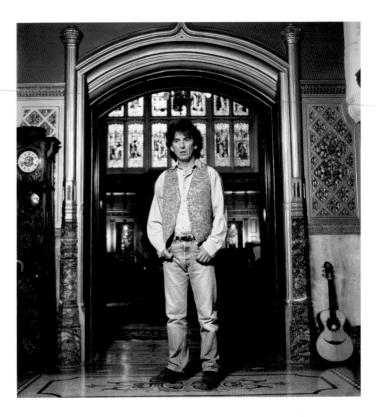

George also used FPSHOT to record two acts on his own newly established Dark Horse label: Splinter's 1974 album *The Place I Love*, and longtime friend Ravi Shankar's 1976 LP *Ravi Shankar's Music Festival from India*. Similarly, he later loaned the studio to ex-Bananarama singer Siobhan Fahey, then married to Dave Stewart, for her 1992 Shakespears Sister album *Hormonally Yours*.

Over the years, FPSHOT was updated to allow for twenty-four-track recording, and George's later solo albums were all made there, as was the 1988 debut album by the Traveling Wilburys, the supergroup he formed with Roy Orbison, Bob Dylan, Jeff Lynne, and Tom Petty. He had also gradually expanded the garage to house his extensive collection of Porsches, as well as a McLaren F1 sports car worth half a million pounds.

In 1978, despite his enormous love for Friar Park, George gambled its future. As a huge fan of the "Monty Python" sketches, George had come to the comedy team's rescue when he heard that the backers for their film *Life of Brian* had pulled out. Wanting to see the film himself, George put up Friar Park as collateral in order to fund it. The

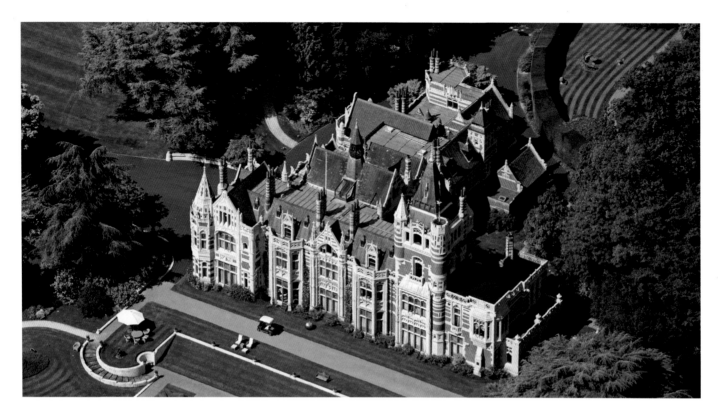

OPPOSITE: A thoughtful Harrison pauses for a moment in the gilded entrance hall at Friar Park in around 1990.

ABOVE: An aerial view of the main house at Friar Park, where Olivia Harrison still lives today.

gamble paid off: *Life of Brian* went on to take over $21 million at the US box office alone, and Friar Park was safe.

In between producing films, recording albums, and collecting cars, Harrison spent a large part of the '80s and '90s with his new family. After his separation from Pattie in 1974, he began a relationship with the Mexican-born Dark Horse label secretary Olivia Arias, and they were married in 1978, the year their son, Dhani, was born.

The couple shared a love for Friar Park's gardens, and soon they embarked on a mission to fully restore them. Until his death in November 2001, George spent much of his time tending to them, assisted not only by Olivia but also by his older brothers, Peter and Harry, who were by this time working as groundskeepers at Friar Park.

"He'd garden at nighttime until midnight," Dhani would later recall. "He'd be out there squinting because he could see, at midnight, the moonlight and shadows, and that was his way of not seeing the weeds or imperfections that would plague him during the day."

George had always been especially fond of the large stones in one of the gardens' many waterways and grottos, and would sometimes perform his "walking on water" trick for visitors, stepping over them as he does in the video for "True Love," the Cole Porter standard featured on his 1976 album *33 1/3*.

George and Olivia opened the gardens to the public in the '70s, and they remained open until 1980, when, following John Lennon's murder, George understandably decided to lock the gates and install high-security fences. Despite these measures, in 1999 an intruder managed to break into the house in the early hours of the morning, attacking both George and Olivia and leaving George with five stab wounds and a punctured lung.

George recovered from the attack but died of cancer in 2001. In order to avoid a media circus, he had planned for his death to take place in the USA, away from potential paparazzi, and his ashes were sprinkled over the River Ganges in India. Olivia Harrison still lives at Friar Park and continues their work on the gardens.

NEIL YOUNG

BROKEN ARROW RANCH, REDWOOD CITY, CALIFORNIA (HOME FROM 1970 TO 2016)

By Colin Salter

Broken Arrow Ranch sits high in the hills between Palo Alto and the Pacific Ocean, framed by ridges crowned with Californian redwoods. The ranch is a mixture of woodland and pasture, well watered by a lake at the high end of the spread. It was from this vantage point in 1970 that the twenty-four-year-old Neil Young was shown the lay of the land by the ranch's foreman, Louis Avila. Avila literally came with the territory—he had worked on the ranch, man and boy, for over forty years. Young had just bought the spread for $350,000. The way he tells it, Avila turned to him at the lake and asked, "How does a young fellow like you get the money to buy a place like this?"

"Just lucky, I guess," Young answered.

For "lucky," read, "Having my most successful year yet." The Canadian country-rock singer was riding high. He'd made a name for himself with folk-rock group Buffalo Springfield and two solo albums; then, as part of the supergroup Crosby, Stills, Nash, and Young, he had recorded one of the seminal LPs of the late hippie period, *Déjà Vu*, whose lead single, "Woodstock," reached no. 11 in the charts in March 1970. In June, the group released Young's "Ohio," one of the greatest protest songs of the era, which got to no. 14 despite being banned from many AM-radio playlists. Later that year, his third solo LP, *After the Gold Rush*, peaked at no. 8.

Although Neil Young had been pursuing a rock 'n' roll career since he formed his first serious band, the Squires, at the age of eighteen, this rapid rise to celebrity was dizzying. He needed a safe place, and he found it in Broken Arrow. It offered Young not only seclusion but also a reminder of his earliest days growing up in the rural community of Omemee, Ontario. There, in a similar rolling, wooded landscape, he learned to swim and play his first instrument, a plastic ukulele. As he sings in his 1967 song "Helpless," "There's a town in North Ontario / All my changes were there." Here in California he found the same comfort, security, and space to grow.

The ranch (named after one of his songs for Buffalo Springfield, but also a Native American symbol for peace) lies halfway along the twists and turns of Bear Gulch Road, which goes from nowhere to nowhere across the northern arm of the Santa Cruz Mountains. Amid traditional timber barns, the ranch house is a mixture of settler style and Gothic detail, all in unpainted wood apart from the stone chimneys. It is enclosed in a deep veranda, and its two stories are crowned with a steep-roofed turret whose narrow balcony offers long views to the south.

The ranch is a working one, with livestock, and it would become a place of work for Young, too. He wrote many songs there, and in time installed recording facilities in one of the barns. Such is the tranquility of the place that there was no need for soundproofing. Young has recorded some twenty albums there, including, soon after his arrival at Broken Arrow, tracks for his fourth solo work,

—

"HOW'D A YOUNG FELLOW LIKE YOU GET THE MONEY TO BUY A PLACE LIKE THIS?"
Ranch foreman Louis Avila to Neil Young, 1970

—

Harvest. The album includes one of the first songs Young composed there, "Old Man," which was inspired by that first remark by Louis Avila when he showed Young around. We all need the same peace and love, the song argues, regardless of age.

Another song from *Harvest*, "A Man Needs a Maid," reflects more personal changes in his life. In 1970, after his first marriage failed, Young had fallen in love with the actor Carrie Snodgress after seeing her debut movie, *Diary of a Mad Housewife*. He arranged to meet her, and

OPPOSITE: Neil Young sits on the hood of a 1959 Lincoln Continental—the main frame of which forms the basis for his LincVolt hybrid vehicle concept—at Broken Arrow Ranch, 1994.

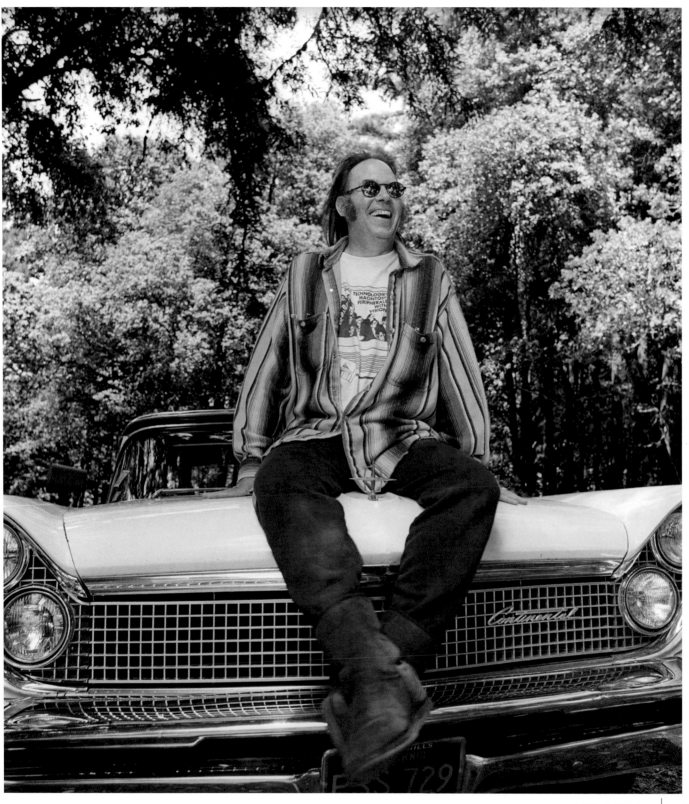

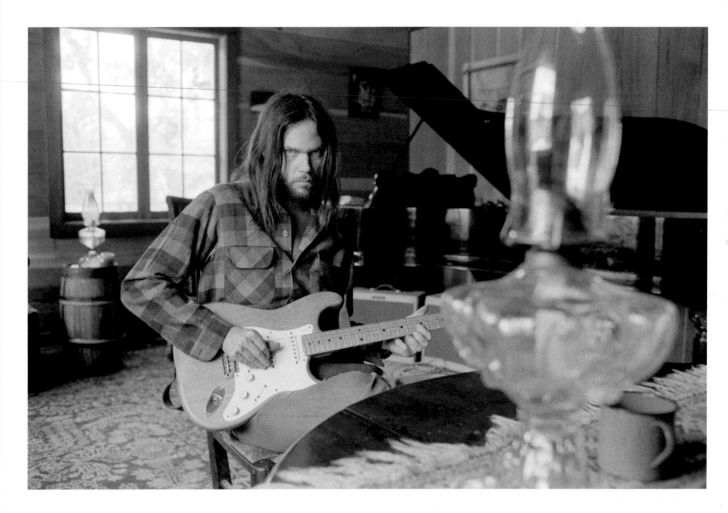

they began a long-term relationship in the year he bought Broken Arrow. They lived together on the ranch, and Carrie gave birth to their son, Zeke, in 1972. A German

—

"FOR WHATEVER YOU'RE DOING, FOR YOUR CREATIVE JUICES, YOUR GEOGRAPHY'S GOT A HELL OF A LOT TO DO WITH IT. YOU REALLY HAVE TO BE IN A GOOD PLACE, AND THEN YOU HAVE TO BE EITHER ON YOUR WAY THERE OR ON YOUR WAY FROM THERE."

Neil Young to the *New York Times*, 2012

—

TV documentary shot at the ranch in 1972 showed just how happy Neil Young was at this time and place, lazing in the sun and working on another *Harvest* song, "Out on the Weekend."

In 1974, Neil met Pegi Morton, a waitress in a diner near Broken Arrow. His relationship with Carrie fell apart the following year, and in 1978 he and Pegi were married. They had two children together, Ben (born 1979) and Amber (1984). Both Ben and Zeke were born with cerebral palsy, and between 1978 and 1982 Neil stopped touring to devote more time to his family at Broken Arrow. To the ranch's existing herd of cattle he added peacocks and llamas for Ben's amusement.

The medical problems that affected his children—Amber, like Neil, was diagnosed with epilepsy—made the privacy of the Broken Arrow Ranch all the more important for Young. Although the recording barn was pictured on the cover of *Harvest*, journalists visiting the ranch were generally forbidden from taking photographs.

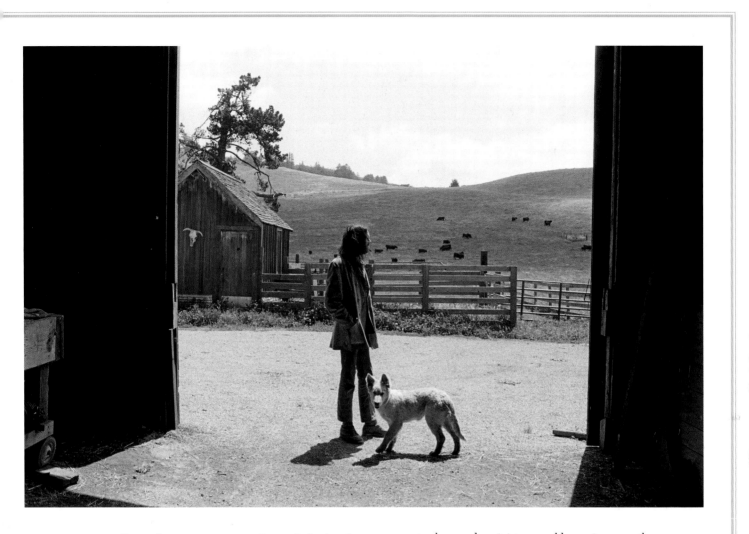

OPPOSITE: Young in the music room at Broken Arrow in 1973. He has recorded dozens of albums at his Redwood Studio on the ranch.

ABOVE: Young and a four-legged friend survey the land from the door of a barn on the grounds of his sprawling home, 1971.

An occasional exception was made for the contents of another barn that housed one of Neil's main off-duty passions. From childhood, he has loved toy trains, and at Broken Arrow he devoted an entire barn to his Lionel Trains layout. When Ben came along, the layout helped forge an important bond between father and son. Though severely disabled and unable to speak, Ben could share with his father the pleasure of the trains, especially after Neil devised electronic systems that allowed Ben to operate them. In addition to his many musical successes, Young now has seven model railroad patents to his name. The trains at Broken Arrow run across 750 feet of O gauge track around a miniature world covering more than two thousand square feet. Among the other nonmusical pursuits Young has explored in recent decades is the development of his hybrid electric car, the Lincvolt, built from his 1959 Lincoln Continental Mark IV, his "favorite of the craziest and most out-there designs that American automobile manufacturers had come up with. I thought it would be a good poster child for the latest in technology."

Sadly, history repeated itself in 2015 when Neil and Pegi Young's marriage collapsed. Neil had begun a new relationship with the actor and activist Daryl Hannah a year earlier. Young, in his seventies, and Hannah, fifteen years his junior, now live together in Los Angeles, a far cry from the rural paradise of Broken Arrow. Young moved out of his home of forty-four years and left it to Pegi, who continues to lives there with Ben to this day.

KEITH MOON

TARA HOUSE, CHERTSEY, SURREY (HOME FROM 1971 TO 1975)

By Chris Charlesworth

The domestic arrangements of the Who were never a mystery to journalists. Alone among acts of their stature during the early 1970s, they welcomed music writers into their homes for interviews, so it was no secret that Roger Daltrey owned a manor house near the village of Burwash on the Kent/Sussex border, that John Entwistle lived in a relatively modest semi-detached house in Ealing, or that after staying in a series of rented flats in central London Pete Townshend had moved his growing family into a large house next to the River Thames in Twickenham, a stone's throw from Eel Pie Island, where, on October 30, 1968, the Who had performed in the dance hall of the island's small hotel.

As might be expected, Keith Moon was less settled than his three colleagues, moving from his birthplace in Wembley to a flat in St. John's Wood, then to the top half of a house in Maida Vale, then to a flat above a garage in Highgate, and then to a substantial house in North London's Winchmore Hill. Along the way he had married a model named Kim Kerrigan and fathered a daughter, but while at Winchmore Hill his marriage to Kim faltered, and she went back to live with her parents in Bournemouth, taking their daughter, Mandy, with her.

Keith promptly abandoned the North London house for a bachelor flat in Chelsea, and around the same time invested some of his income from *Tommy* in a share in a pub, the Crown and Cushion at Chipping Norton in West Oxfordshire. A former coaching inn dating back to 1497, it had since fallen on hard times, and though Keith's share cost him only £16,000, it was a wise investment—not only financially but also as a refuge when things got fraught at home.

Toward the end of 1969, Kim decided to give Keith another chance, and in early 1971 they bought a property off St. Ann's Hill Road, on the outskirts of Chertsey in Surrey. Tara House, as it was called, soon became notorious as Moon's ultra-modern pleasure

dome, a futuristic fantasy home consisting of five pyramids—four at each corner and a giant one in the center. It was set in its own grounds but not too far away from a pub, the Golden Grove, conveniently located at the end of a three-hundred-yard lane that led to *chez* Moon and, unhappily for its occupants, one other property.

Keith and Kim bought the house for £65,000 (approximately £925,000 in today's money) and moved in during summer of 1971. On two of its corners were bedrooms, each with an adjoining bathroom; another housed a "den," its walls decorated with murals of superhero comic characters; and the fourth held the kitchen, which led to a guest bedroom and thence to the garage. The strange layout of Tara was one of rooms within rooms; the main bedroom housed a bathroom within it, and you could walk all the way around it. The

> ### "MOST PEOPLE SEE CARS AS TRANSPORT, AS A MEANS OF GETTING FROM A TO B, BUT FOR KEITH THEY WERE THINGS TO PLAY WITH, USUALLY LATE AT NIGHT."
> **Moon's chauffeur, Peter "Dougal" Butler**

bedhead was up against the outer bathroom wall, facing a huge, wall-sized window, and there was a spherical TV suspended from the ceiling. The loo was within the bathroom, and John Lennon's gold disc for "She Loves You" was mounted on the wall next to a mirror above the basin. Keith had evidently swapped it for his gold disc for "My Generation."

In the center of the huge main room was a sunken "conversation pit" with seating on three sides, a brass chimney pipe descending from the apex of the pyramid

OPPOSITE: Keith Moon in the grounds of Tara, his "pleasure dome" on the outskirts of Chertsey, Surrey. Guests were wise to stay indoors whenever he shouldered a rifle.

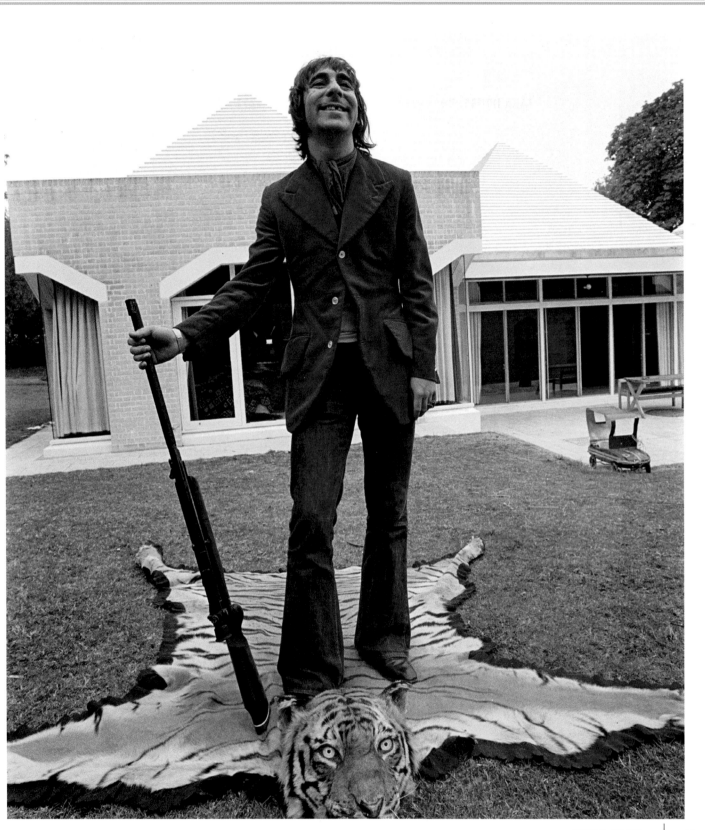

to an open fire next to a built-in TV. Around the pit was a spacious raised area on all four sides, three of which boasted glass walls to a height of about six feet—a rash choice, since the master of the household had a habit of walking into them, sober or otherwise.

The Moons announced their acquisition to the world by opening up the grounds for a housewarming party in July that doubled as a celebration for the release of

—

"MOON CAME INTO A ROOM AND HE WANTED TO BE THE ONE WHO WAS THE LIGHTBULB. HE WAS AN ATTENTION-SEEKER AND HE HAD TO HAVE IT."
Who manager Bill Curbishley to *Mojo*, 1998

—

Who's Next. Members of the press were bussed in from London, the Who were photographed in the grounds, and the evening concluded with a firework display that climaxed with the words "Long Live the

Who" illuminated in the sky. Predictably, there were complaints from neighbors and the police were called, in a taster of things to come.

The likelihood that Keith Moon would settle into quiet domesticity in his new home was remote. The household consisted of Keith and Kim; their daughter, Mandy; Kim's mother, Joan, who was separated from Kim's father; and Joan's son, Dermot. Despite the presence of two young children, the atmosphere at Tara was constantly chaotic. Keith had a habit of playing Beach Boys music extremely loudly, often the same song—"Don't Worry Baby"—over and over again on the jukebox in the den.

Such was the regularity of police visits that he and they became affably acquainted, largely because Keith was invariably genial toward the long arm of the law. "Come in, chaps," he'd say. "Have a brandy. Let's listen to some music while we discuss what seems to be troubling you.

BELOW: Moon rarely stopped laughing, at least in public. Here he obliges with a toothless grin from Tara's "conversation pit."

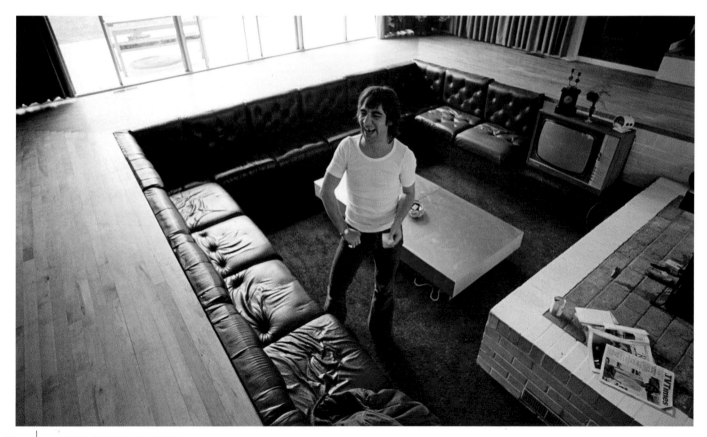

ABOVE: Moon inspects his fleet of vehicles on horseback in the gardens of Tara, 1972. In the foreground is his hovercraft, behind which is his Rolls-Royce Silver Cloud III, which he had sprayed lilac. The TV antenna was purely for show.

I'm sure we can work things out." In the fullness of time, a relationship developed between ma-in-law Joan and a member of the Chertsey constabulary that further reinforced the unlikely but convivial rapport between the drummer of the Who—rock's wildest extrovert—and the forces of law and order in this deeply conservative corner of rural Surrey.

In the spring of 1973, Keith commissioned a swimming pool, complete with wave machine, and bought two tiny motorbikes on which he'd ride around the grounds. During his occupation of Tara House he acquired many expensive cars that were parked outside: two Rolls-Royces, one a lilac Silver Cloud III, the other a white two-door Corniche; a white Mercedes coupé; a red Ferrari Dino 246 that bit the dust on a nearby road; and a silver AC Cobra that once belonged to Led Zeppelin

drummer John Bonham. Then there were his "fun" vehicles: a milk float (a vehicle for delivering fresh milk), an "Al Capone"–style car with running boards at the sides, a hot rod, and a hovercraft, not to mention the "ordinary" cars for other members of the household.

"Cars were simply toys for Keith," says Peter "Dougal" Butler, Moon's long-suffering personal assistant and chauffeur. "Most people see cars as transport, as a means of getting from A to B, but for Keith they were things to play with, usually late at night when he was in the mood for a fast drive. He didn't even have a driving license."

Keith's bar bills from the Golden Grove were outrageous. He invariably took several bottles home with him at closing time—usually vodka and Courvoisier—along with several of the customers. Eventually, Kim decided enough was enough. She left Keith for the second and final time in the autumn of 1973, taking Mandy and Dermot and moving in with Ian McLagan of the Faces, with whom she would eventually marry and settle down in Austin, Texas. Keith remained at Tara for a

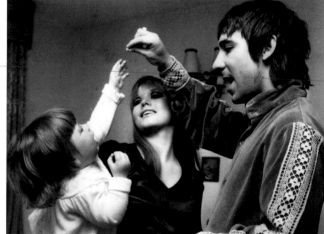

few more months, hopelessly adrift in his ocean of disorder, and one night invited Jeff Beck, whom he had bumped into at the Speakeasy club in London, back to his home, ostensibly to sell him the hot rod.

"I realised that he was a bachelor in the true sense of the word although there was this girl lurking about [a girlfriend from Staines]," Beck told Tony Fletcher, author of *Dear Boy: The Life of Keith Moon*. "He showed me around the house and it was covered in dog shit. I'd never seen such a mess in my life. He hadn't made the slightest attempt to clean it up. He was like, 'Mind the dog shit,' like it had been there and it was

—

**"HE DIDN'T [DESIGN TARA HOUSE].
AND THAT'S WHAT WORRIES ME. IT MEANS
THAT THERE'S ANOTHER CREATURE WITH
A MIND LIKE MOON'S WALKING THIS EARTH."**
Roger Daltrey to *NME*, 1971

—

going to be there. I mean, everyone has accidents, but this was in every room. [He hadn't] any idea how to look after a dog. He opened up all the closets he had custom made, every single one was a disaster, stuff fell out on the floor and he didn't put it back. It was as if a director had said, 'Action!' and coordinated the most incredible stunt of collapsing things. . . . When we finally drank ourselves into oblivion, [the girl] tapped on the room where I was and said, 'Do you mind if I come in?' and I

said, 'No,' and we wound up sleeping in the same bed even though she was purporting to be with Keith. She said, 'I can't take it any more, he's driving me berserk.'"

Moon sold Tara House in 1975, the proceeds winding up in Kim's bank account. It was bought by Kevin Godley of 10cc, who in 1990 sold it to Vince Clarke of Erasure. Clarke demolished the house and built a new one on the same site, complete with a commercial recording studio called Ammonite. Moon found a new partner, Swedish model Annette Walter-Lax, and relocated to California, where he lived in hotels and a series of rented homes until he settled down in the Trancas area of exclusive Malibu. There, on the shores of the Pacific Ocean, he became the Beach Boy of his dreams. The actor Steve McQueen and his wife Ali MacGraw were his next-door neighbors, but the relationship was not cordial.

Keith would remain in Malibu until September 1977, when, tired of America and virtually penniless, he returned to the UK, eventually moving into flat no. 12 at 9 Curzon Square in the Mayfair district of London. It was here, on September 7, 1978, that Annette found his lifeless body, and the rock world mourned one of its best-loved sons.

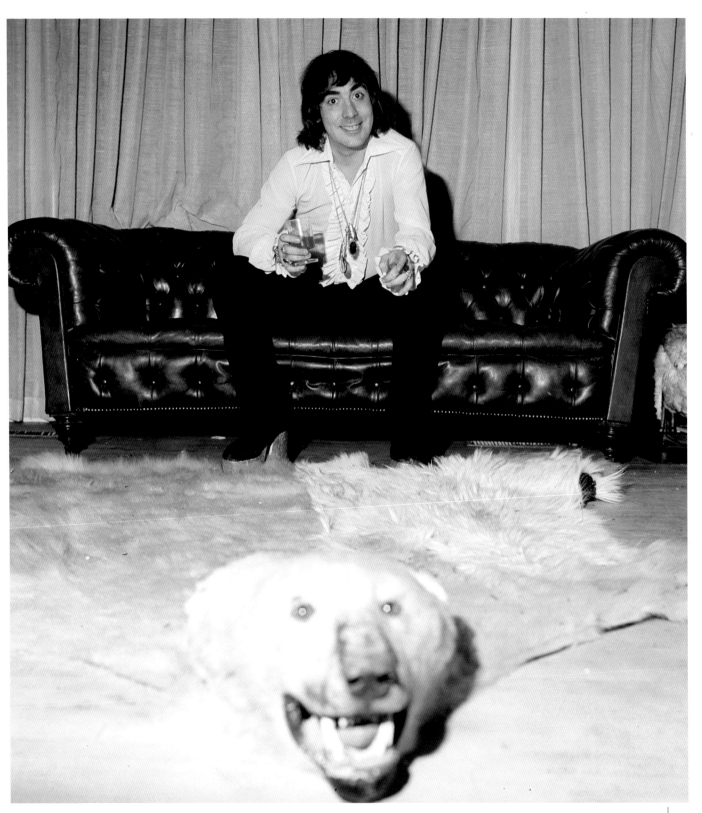

THE JACKSONS

HAYVENHURST AVENUE, ENCINO, CALIFORNIA (HOME FROM 1971 TO PRESENT)

By Daryl Easlea

For the Jackson family, there was something hugely significant about the house on Hayvenhurst Avenue in Encino, California. Scholars of the group's history are fully aware of the resonance and importance of this house to their legend, and especially to that of their exceptionally gifted child, Michael. Although much is made of his opulence and decline at the Neverland Ranch, to which he moved in 1988, it was here in Encino that the magic really happened. It was here that Michael rode his first wave of superstardom. It was here that he wrote both *Off the Wall* and *Thriller*.

As with many African-American families of their generation, it had taken much grit and determination for Joseph and Katherine Jackson to reach such lofty heights. Hayvenhurst was a long way from their modest first home in the Midwest. In the late 1940s, the newlywed couple had settled in Gary, Indiana, a satellite town twenty-five miles from the center of Chicago, where they lived in a small white-frame house at—coincidentally—2300 Jackson Street. It was here that their remarkable brood was born, from the eldest, Rebbie, in 1950, through to baby Janet in 1966. There were eight other children in between, including Brandon, Marlon's twin, who died at birth.

Life in Gary was crowded, typical of many families in the suburbs at that juncture. The entire family shared two rooms. They left Gary in 1969, as fame beckoned, and relocated to Los Angeles. Initially, some of the brothers stayed with their mentor, Diana Ross, before the family reunited and moved through a succession of rented properties. Then, in May 1971, as they were coming to terms with their fame, the family found a home they all could live in on Hayvenhurst Avenue. Comprising five bedrooms and seven bathrooms, the 10,746-square-foot property was set in two acres of land.

The Jackson family was frozen in time on the cover of *LIFE* magazine on September 24, 1971, in an article entitled "Life with Rock Stars . . . and Their Parents."

The accompanying picture [*opposite*] shows Joe and Katherine awkwardly standing by their brood, the five atop a spiral staircase, surrounded by gold discs. They were also photographed by the swimming pool, riding on mini-motorbikes.

When they completed their punishing work schedule, the brothers would swim and shoot hoops in the grounds, pretty much as many other young adults would do, but that was where similarities with conventional youth ended. It was at Hayvenhurst that Michael started fooling around with the tune that was to change his life. "Don't Stop 'Til You Get Enough" was conceived there; the melody entered Jackson's head and he simply couldn't shake it off, enlisting brother Randy to play the piano and percussion, at his direction, on a demo recorded at their home studio.

In the early '80s, at the height of his solo fame, Michael Jackson bought the Hayvenhurst home from his father and began adorning it in the style to which the world would later become accustomed at Neverland. Michael's renovations brought a Japanese koi pond, a movie theater, and six-foot-tall statues from *Snow White and the Seven Dwarfs*. Bubbles the Chimpanzee came to live there, too.

In 1988, Michael moved to Neverland. His father, Joe, moved out of Hayvenhurst in 1994, following the earthquake in nearby Northridge; Jermaine was the last resident, but he too moved away during the 2000s. The property stayed in the family, however, and after Michael's death in 2009, his children—Paris, Prince, and Blanket—returned to live there. In 2013, La Toya Jackson returned to the property and was amazed to find quite how little had changed; the brick-clad feature fireplace was still very much intact, as were the gaudy gift shops in the grounds. At the time of writing, plans were being laid to offer the still Michael Jackson–hungry public an opportunity to visit the house as part of the popular Hollywood bus tours.

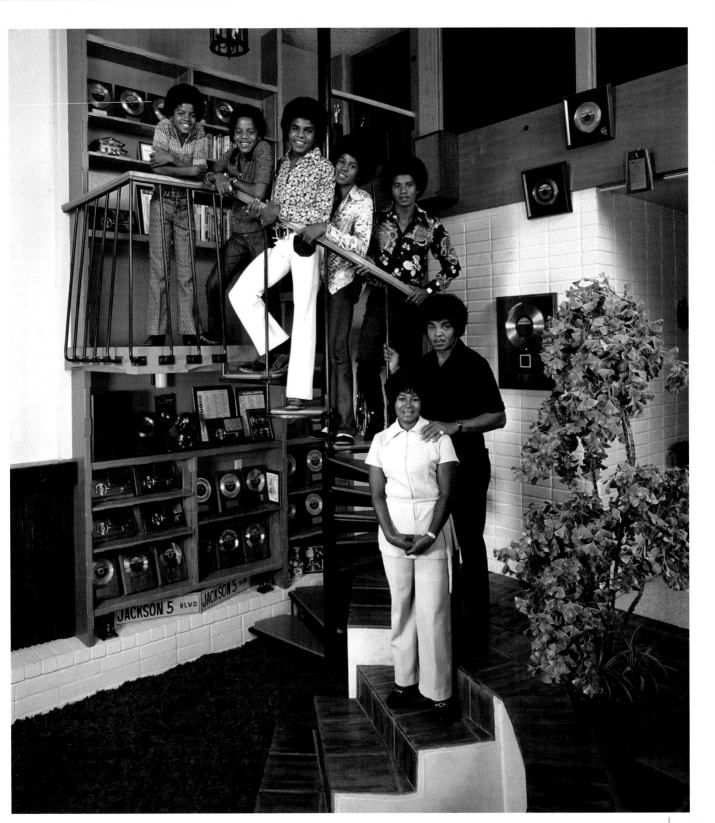

SONNY & CHER

CAROLWOOD (A.K.A. OWLWOOD), HOLLYWOOD, CALIFORNIA (HOME FROM 1972 TO 1976)

By Eddi Fiegel

In 1967, two years after "I Got You Babe" made Sonny and Cher world-class superstars, they were invited to a lavish party at actor Tony Curtis's Hollywood mansion. Cher would later note that they had no idea how they came to be there, as neither of them had ever met Curtis before, but the evening was to make a significant impression on Cher. "Some day, we're going to live right here," she told Sonny.

The palatial Italianate Renaissance villa at 141 South Carolwood Drive was one of the most extravagant in Hollywood. Built in 1936, the house included ten bedrooms and a dozen bathrooms and sat at the end of a long, gated driveway, within some ten acres of impeccably manicured lawns and grounds between Hollywood Boulevard and the Los Angeles Country Club. Previous owners had included Engelbert Humperdinck and Esther Williams, and there was also a guesthouse, which, according to Hollywood lore, had been home to Marilyn Monroe in the 1940s.

> **"I GUESS WE WERE TRYING TO APPEAR ESTABLISHED. WE WERE NOUVEAU RICHE, BUT BETTER NOUVEAU THAN NEVER."**
> **Cher, *The First Time***

The house was awash with wood paneling, ornate ceiling cornices, and elaborate chandeliers. Sprawling over some twelve thousand square feet, it was so large that Curtis's then-wife Leslie Allen later quipped, "You could starve to death getting to the kitchen."

Five years later, in 1972, Curtis offered Sonny and Cher the house for $1 million. After some haggling, the pair—who were at this point basking in the success of their CBS TV show, *The Sonny and Cher Comedy Hour*, which ran from 1971 to 1974—paid $750,000 for the property (around $4 million today).

Cher immediately set about redecorating, but in sharp contrast to the couple's image as the bell-bottomed, long-haired poster couple for the hippie generation, the look she created couldn't have been more traditional, and her decorator was sent on buying trips to Europe, returning home with eighteenth-century antiques and Louis XIV chairs. "I guess we were trying to appear established," she later recalled. "We were nouveau riche, but better nouveau than never."

Sonny and Cher's marriage, however, was in its dying stages, and although they soon began divorce proceedings, TV network CBS threatened to cancel the show if either one of them moved out of the house. Fortunately, the house's epic scale meant they could comfortably spend the next year living in separate wings, rarely crossing paths.

The divorce agreement eventually granted Cher the rights to Carolwood, as it was then known, and over the next few years Cher moved in first her new beau, music mogul David Geffen, and then her new husband, Gregg Allman. But Allman's friends were not always welcome; Cher would later remember her fury when they began snorting cocaine off her antique table. Their tumultuous relationship was not to last; Cher first filed for divorce within days of their marriage in 1975, and they separated for good in 1978.

In 1976, Cher sold the house to carpet mogul Ralph Mishkin, who renamed it "Owlwood" after the owls in the grounds. Cher would go on to earn a reputation as one of the canniest property developers in Hollywood, buying and selling a succession of lavish homes in landmark deals. Owlwood, meanwhile, was on the market in 2017 for $180 million.

OPPOSITE: "Better nouveau than never": Sonny and Cher, pictured at the height of their success in the mid-1970s, looking out across the grounds of their sprawling home in the exclusive Holmby Hills neighborhood of Los Angeles.

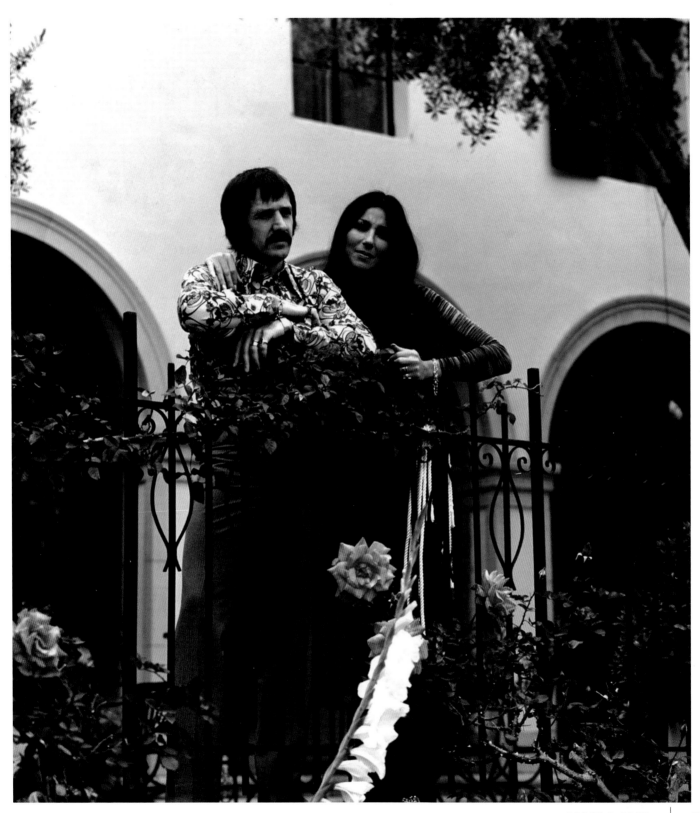

JIMMY PAGE

PLUMPTON PLACE, NEAR LEWES, EAST SUSSEX (HOME FROM 1971 TO 1985)
TOWER HOUSE, HOLLAND PARK, LONDON (HOME FROM 1972 TO PRESENT)
DEANERY GARDEN, SONNING, BERKSHIRE (HOME FROM 2008 TO PRESENT)

By Chris Charlesworth

Few British rock stars have been as meticulous with regard to their property portfolio as guitarist Jimmy Page, the mastermind behind Led Zeppelin. From his Thames-side boathouse in Pangbourne to Deanery Garden in Sonning via Tower House in London's Holland Park, the multimillionaire Page has shown exquisite taste, his keen appreciation for historic architecture rivaled only by George Harrison's acquisition and restoration of the magnificent Friar Park in Henley. The only blip on Page's residential landscape seems to have been Boleskine House on the shores of Loch Ness, which he purchased more with an eye for the notoriety of a former owner than any aesthetic appeal.

Born in Heston on the outskirts of London in 1944, Page spent his formative years in Epsom, the family moving to 34 Miles Road when their only child, James Patrick, was eight. Page lived here until 1967, by which time he had accumulated enough funds from his session work to put down the deposit on the £6,000 house in Pangbourne on the banks of the River Thames. "The dwelling was all windy passages and mysterious, angular rooms, leading to a quite beautiful lower level where a boat was moored, ready for instant takeoff," writes Martin Power in his Page biography *No Quarter: The Three Lives of Jimmy Page*. It was here, in July 1968, that Page would play host to a young singer from the Midlands by the name of Robert Plant, whose three-day stay led to him becoming the singer in Led Zeppelin.

With the revenues from the first two Led Zeppelin albums now sitting in his bank account, Page acquired Boleskine House on the southeast side of Loch Ness in 1970. Once the home of Aleister Crowley, the slightly sinister mystic, painter, and writer, it was situated near Foyers Bay and in poor condition. "It was in such a state of decay that nobody wanted it," Page later told Led Zeppelin archivist Howard Mylett. "It's an interesting house and a perfect place to go when one starts getting wound up by the clock."

By the time Page acquired Boleskine, he had already become fascinated by Crowley, buying up related ephemera that included private manuscripts, first editions of books, artwork, items of clothing, and ceremonial vessels. Allegedly built on the site of a tenth-century Kirk (or church) that according to legend "had been burnt down with its congregation," the house was shunned by locals, as was the nearby graveyard. Crowley bought the Manor of Boleskine and Abertarff in 1899, believing that its secluded location was eminently suitable for the staging of magical rituals, some of them erotic in nature. In the fullness of time, Page would open a bookshop in

> **"IT WAS IN SUCH A STATE OF DECAY THAT NOBODY WANTED IT. IT'S AN INTERESTING HOUSE AND A PERFECT PLACE TO GO WHEN ONE STARTS GETTING WOUND UP BY THE CLOCK."**
> **Jimmy Page on Boleskine House**

North Kensington called Equinox that was devoted to these interests. "There was not one bookshop in London with a good collection of occult books," he said. "I was so pissed off at not being able to get the books I wanted."

Up in Scotland, Page endeared himself to the locals in 1979 by opening the new Phillip's Harbour at Harrow, near Caithness, which he visited with the unrealized intention of opening a recording studio up there.

OPPOSITE: Jimmy Page in the living room of his Thames-side boathouse in Pangbourne, 1970. It was here in 1968 that he played host to Robert Plant before inviting him to become the singer in Led Zeppelin.

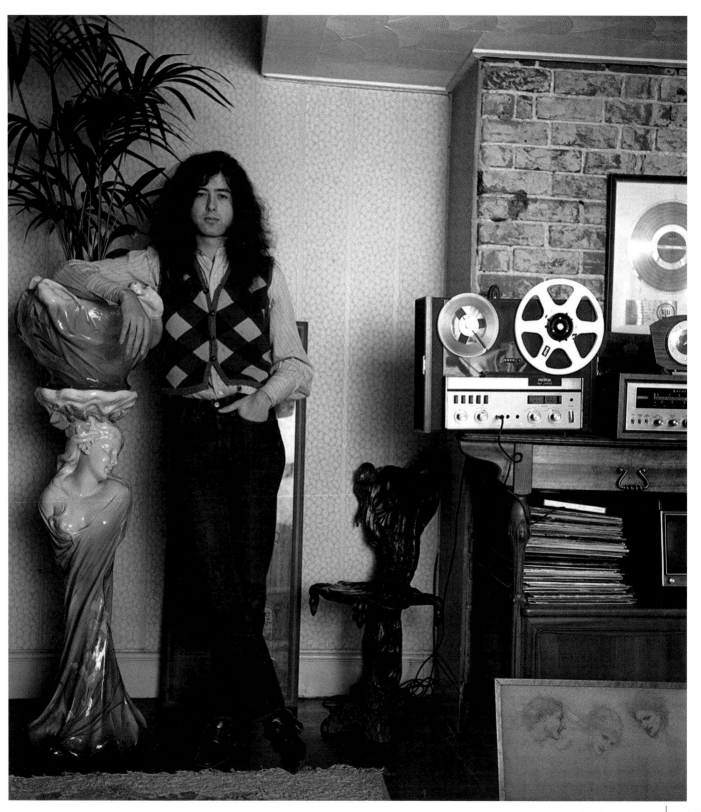

Although he did some restoration work at Boleskine, he sold the house in 1992, largely because he rarely had time to visit. The subsequent owners opened it as a hotel, then resold it in 2002 to a private buyer. In 2015, the house was badly damaged in a fire.

Page's next real home after Pangbourne was Plumpton Place, a Grade II Elizabethan manor house in its own grounds near Lewes in East Sussex. Page acquired the property in 1971, shortly after the birth of his first daughter, Scarlet, and owned it until 1985. With parts of the property dating from the sixteenth century, it benefitted from improvements by renowned British architect Sir Edwin Lutyens and comprised six bedrooms, a large library, and a forty-eight-foot-long sitting room, all surrounded by a moat and lakes, not to mention two

ABOVE: A bedroom at Tower House in Holland Park, showing the ornate Gothic décor, still as it was in William Burges's day.

OPPOSITE: Tower House on Melbury Road, West Kensington, the Grade I–listed building Page bought in 1972.

small cottages close by and a three-bedroom millhouse with its own working waterwheel. Plumpton Place was the setting for the segment in the Led Zeppelin movie *The Song Remains the Same* wherein Page sits with his back to the camera playing a hurdy-gurdy alongside a moat as a pair of black Australian swans swim by. The sequence that follows, in which he climbs a hill in a hooded red robe, was filmed at Boleskine.

With Plumpton Place located sixty-seven miles south of London, Page was always going to need a city base, and this turned out to be the Tower House on Melbury Road

in West London's affluent Holland Park. Designed and built between 1875 and 1881 to the exact specifications of renowned architect William Burges, Tower House—now a Grade I–listed building—was a testament to the French Gothic Revival style that had enjoyed a brief upsurge in popularity throughout Victorian Britain. With its red brick façade, Cumbrian green slate roof, tracery windows, and prominent cylindrical tower marking it out from the surrounding houses, it had enjoyed a rich history of ownership before Page arrived. These included the esteemed archaeologist Richard Popplewell Pullan, two army colonels, and Poet Laureate Sir John Betjeman. "I don't see how anyone can fail to be impressed by its weird beauty," Betjeman once said, "[or] awed into silence from the force of this Victorian dream of the Middle Ages."

After a brief period of neglect, Tower House was given a facelift in the mid-'60s by Lady Jane Turnbull, the daughter of the Ninth Earl of Stamford, whose portrait hung in the National Portrait Gallery. In 1969, Lady Turnbull sold it for £75,000 (around $180,000 at the time) to Irish actor, singer, and *bon vivant* Richard Harris. "I loved the eccentricity of it," Harris said at the

time. "It was built by Burges, who also built Cork Cathedral, and it was the focal point of Kensington for me when I arrived in London."

An astute homeowner who profited from buying, renovating, and then quickly selling properties, Harris nonetheless lingered in the house even though he believed that ghosts of children who previously lived

—

"I DON'T SEE HOW ANYONE CAN FAIL TO BE IMPRESSED BY ITS WEIRD BEAUTY, OR AWED INTO SILENCE."

Poet Laureate Sir John Betjeman on Tower House

—

there inhabited certain rooms. To soothe their restless spirit, he bought them toys. "I love ghosts," he said of his nightly visitors. "I depend on them to guide me through." Harris brought in Burges's original decorators, Campbell Smith and Co., to restore the property's stone and plasterwork, but in 1972 sold it for £350,000 to Page, who outbid David Bowie, another rock star keen to inhabit its peculiar magnificence.

Page's new acquisition boasted unusual inner decorations that mirrored his own particular interests in arcane, Gothic, and Pre-Raphaelite design. Its painted ceilings depicted astrological signs, the sculpted mantelpiece in the library formed the Tower of Babel at its center, and elsewhere could be found murals, detailed woodwork, carvings, and other objects of art, pagan or otherwise. It was built for exploration. "I was still finding things twenty years after being there," Page told BBC News Online in 2012, "a little beetle on the wall or something like that. It's Burges's attention to detail that is so fascinating."

On October 15, 1979, a twenty-three-year-old friend of Page's died at Plumpton Place, and his demise triggered Page's decision to put the house on the market, although it wouldn't actually change hands until the mid-'80s. His next country home, Old Mill House at Clewer near Windsor, would also become the scene of a tragedy, for this was where Led Zeppelin drummer John

"I WAS STILL FINDING THINGS TWENTY YEARS AFTER BEING THERE. A LITTLE BEETLE ON THE WALL OR SOMETHING LIKE THAT."

Jimmy Page on Tower House, 2012

Bonham died on September 25, 1980. Page bought the three-story residence from the British actor Michael Caine for £900,000, largely because it was close to a studio he had acquired at nearby Cookham, and would live there with the American Patricia Ecker, whom he married in 1986, and who would bear him a son, James Patrick III. (Page later married Jimena Gómez-Paratcha, with whom he had two further children, a girl born in 1997 and a boy two years later, but they were divorced in 2008.) Old Mill House was sold in 2008.

In the meantime, Page had purchased another country property that in terms of prestige and architectural splendor was a match for Tower House. This was Deanery Garden, also known as the Deanery, at Sonning near Reading, another Grade I–listed building of significant historical importance and, like Plumpton Place, designed by Sir Edwin Lutyens. Financed by

Edward Hudson, the owner of *Country Life* magazine, it was completed in 1901 and has changed hands several times in the last hundred years. Built in Lutyens's Tudor Arts and Crafts style, it comprises two stories in brick with exposed timbers that surround a courtyard with an archway leading to the extensive grounds. Planted by the noted British horticulturalist Gertrude Jekyll, the gardens incorporate ornate curved steps, elevations, swimming pools, an orchard, herb beds, and a croquet lawn. Although the Deanery is in the center of the village, close to the Bull Inn and St. Andrew's Church, it is surrounded by high brick walls and extremely secluded. Neighbors include George and Amal Clooney and the illusionist Uri Geller; until Page acquired the property, it was open to the public.

The only hitch in Page's enviable property portfolio seems to be an ongoing dispute with his neighbor in Holland Park. The mansion next door to Tower House, Woodland House, was bought in 2013 for £17.5 million by the singer Robbie Williams after the death of its previous owner, film director Michael Winner. Evidently its forty-six rooms were insufficient for Williams's requirements, and the former bad boy of Take That planned to excavate its grounds to create further subterranean rooms and a recording studio. Claiming that such building work might disturb the foundations of Tower House and expose his property to the public, Page recruited architects and structural engineers to support his case and won a partial reprieve that forced Williams to change his specifications. Ironically, considering the volume at which Led Zeppelin used to perform, builders at the site have been fined for making excessive noise.

At the time of writing, construction work appears to have been delayed at Woodland House and the Tower—believed to contain the dazzling dragon suits that Jimmy Page wore onstage—remains intact, as proud and lofty a symbol of Led Zeppelin's stature in the rock world as any rock star mansion anywhere.

OPPOSITE: Page's second Grade I–listed acquisition, Deanery Garden at Sonning, designed by Sir Edward Lutyens. Before Page acquired the property, it was open to the public.

HAUNTED HOUSES & MAGIC MANSIONS

DARK DAYS AND BLACK MAGIC

By Colin Salter

Embracing black magic and the dark arts has certainly been a good eye-catching gimmick for rock acts ever since Birmingham blues band Earth changed their name to Black Sabbath. But all that theatrical devil worship is just an act, isn't it? Horror-rocker Alice Cooper's Haunted Houses, for example, are not homes possessed by poltergeists but a series of temporary fairground attractions giving much-needed employment to actors and suppliers of fake blood at Halloween.

Some rock stars have gone beyond the make-believe, however. Led Zeppelin's guitarist Jimmy Page was a serious collector of the works of Aleister Crowley, the notorious English occultist, and when Crowley's remote former home on the shores of Loch Ness came up for sale in 1970, Page bought it, though he would spend little time there. Page sold the house in 1992, and in 2015 it was irreparably damaged in a fire, only adding to the mystique.

—

"WE TOLD THE PEOPLE ABOUT IT WHO OWNED THE CASTLE—WE THOUGHT THEY'D THINK WE WERE MAD, BUT THEY JUST SAID, 'OH YES, THAT'S THE CASTLE GHOST.'"
Black Sabbath's Tony Iommi to *Guitarist*, 2009

—

In the mid-'70s, David Bowie also became interested in Crowley's ideas, at a time when the former Ziggy Stardust was succumbing to hallucinatory drug addiction. Bowie formed an unlikely friendship with Glenn Hughes, then the bass player with Deep Purple, over their shared love of soul music. Over the summer of 1974, Bowie stayed at Hughes's Beverly Hills home before eventually taking a place of his own on Doheny Drive. Under the influence of Crowley and cocaine, Bowie—who was about to star in Nicolas Roeg's film *The Man Who Fell to Earth*—began to imagine objects and people in the sky above him. He drew them obsessively in crayon on the windows of Hughes's home. On one such occasion, a *Rolling Stone* reporter saw him lighting a black candle and pulling down the blind to reveal a hand-drawn pentagram, as if to ward off some sort of evil. "Don't let me scare the pants off you," he said. "It's only protective. I've been getting a little trouble from . . . the neighbors."

It's not only drugs that produce apparitions. Rock has had more than its share of early deaths, and the troubled ghosts that linger afterward, seeking peace. One of the saddest is that of Alan Wilson, a member of the so-called "27 club" of rock stars—also including Janis Joplin, Kurt Cobain, Amy Winehouse, and many more—who all died at the age of twenty-seven. Wilson, the guitarist with blues-rock outfit Canned Heat, was in the habit of sleeping outdoors to be closer to nature, and he died one night in 1970 under a tree at the home of the band's lead singer, Bob Hite, in Topanga Canyon. The cause of death was an overdose of sleeping tablets, and although suicide was not confirmed, he had been depressed. His ghost is said to haunt the property, and perhaps to have been responsible for the destruction of the Hite home in a flood that washed it away later in the decade.

Perhaps Black Sabbath's imagery is not just fantasy. Geezer Butler, the band's bass guitarist, claims to have woken from a nightmare in 1970 to find a ghostly gentleman in black standing at the end of his bed, watching him. The apparition inspired the line, "A figure in black stands before me," from the song "Black Sabbath."

The band saw a similar figure in 1973, while setting up their equipment in the dungeons of Clearwell Castle in Gloucestershire—a popular venue for rock bands at the

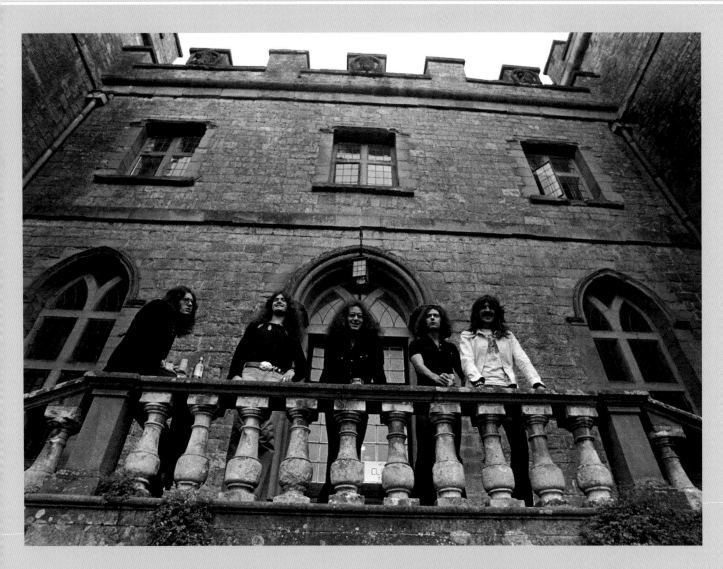

ABOVE: David Coverdale, Glenn Hughes, Ian Paice, Ritchie Blackmore, and Jon Lord of Deep Purple at Clearwell Castle, 1973. The band rehearsed their albums *Burn* and *Stormbringer* at the castle that year.

time, with others, including Led Zeppelin, Deep Purple, and Queen, also using the castle's underground studio facilities for rehearsal and recording sessions during the mid to late '70s. But only Black Sabbath, it seems, encountered a ghost on the premises. According to Butler, it walked past them and through the armory into the next chamber, where it "disappeared into thin air."

Did the figure inspire the band's image? Or has the band's image conjured up the spirits? Perhaps blues guitarist Robert Johnson, or the Devil, has the answer. Rock, or at least its parent genre the blues, has often been called "the Devil's music." The epithet may reach back to Johnson, who famously sold his soul to the devil one night at a Mississippi crossroads in return for the ability to play the blues. His 1936 recordings in Room 414 of the Gunter Hotel in San Antonio, Texas, including "Cross Roads Blues" and "Hellhound on My Trail," are considered the earliest roots of blues and rock 'n' roll. He died only two years later, another member of the "27 club," and presumably went straight to hell.

Perhaps it's true what they say: the Devil has all the best tunes.

JERRY LEE LEWIS

THE LEWIS RANCH, NESBIT, MISSISSIPPI (HOME FROM 1973 TO PRESENT)

By Colin Salter

Malone Road runs straight as an arrow, from south to north, for four miles across DeSoto County in northernmost Mississippi. It's a gentle landscape, and the road is lined with the trees and picket fences of the scattered township of Nesbit. Just beyond it, across the state line, lies Memphis, Tennessee, a city that needs no introduction to music fans. It's the home of Sun Records, the city where Jerry Lee Lewis, "The Killer," cut his teeth and his first recordings.

When Lewis needed somewhere peaceful to relax between rigorous rock 'n' roll tours, the soft countryside of DeSoto County was an obvious choice, and in 1973 he bought thirty acres of it at 1595 Malone Road. On it he built a relatively small brick home, modest in profile and plan apart from the white five-pillared classical colonnade, which gives the building a façade of grandeur.

He called it the Lewis Ranch, and he made the place his refuge and his home, inviting his fellow music stars to share the seclusion of the tranquil estate. That tranquility was sometimes shattered by rock 'n' roll hijinks. Jerry Lee's land includes a small lake, on which he and his friends used to speed up and down on jet skis for fun. Lewis broke a leg when one such race got out of hand in the 1980s.

There's another water feature on the ranch. Jerry Lee—the man credited with making the piano cool for rock 'n' roll—has that essential status symbol: a swimming pool in the shape of a grand piano, shaded by trees on the north side of the house, with the black-and-white keys marked out in ceramic tiles at the deep end. Lest there be any doubt about the Killer's instrument of choice, the three pairs of double gates providing access to the ranch from Malone Road are also decorated with a large wooden grand piano motif.

Inside the house itself there are several pianos, including a handsome black Yamaha Grand and a remarkable survivor of the wild rock 'n' roller's very physical playing style: his first ever piano. It's a battered P.A. Starck upright with worn-out keys; it is said that his father mortgaged the family farm to buy it when the boy was seven or eight. Young Jerry Lee had showed such promise that by the age of twelve his father was driving him and the piano from town to town to perform.

Lewis still lives at the house, more than forty years after he built it, with his seventh wife and his beloved dogs—but not his favorite chihuahua, which died in 1997, and whose painted portrait still hangs by the fireplace where the dog used to lie. Elsewhere, there is a bobcat-skin rug, and it's become a standing joke in the Lewis household that it is actually one of Jerry Lee's ex-wives.

In 1994, faced with an IRS bill for $4 million in unpaid taxes, Jerry Lee Lewis opened up the Lewis Ranch to the public, charging visitors $15 a head. The cover of his 1995 LP was shot there, too. When his sixth marriage failed in 2005, Lewis stopped receiving visitors, but in 2017, he and his seventh wife reopened for business—this time at $30 per person—with tours led by his son, Jerry Lee Lewis III.

Paying guests can once again stroll in the grounds around that swimming pool and see Lewis's collection of classic vehicles in the Killer Kar Museum. Inside the house, the Killer's pianos are on display, surrounded by a priceless collection of memorabilia from a lifetime spent in the company of other rock 'n' roll pioneers—Elvis Presley, Roy Orbison, Carl Perkins, Johnny Cash, Little Richard—all of whom acknowledged that no one could follow Jerry Lee Lewis on a bill.

OPPOSITE TOP: Jerry Lee Lewis marries his fifth wife, Shawn Michelle Stevens, at the ranch, June 7, 1983. She died of a drug overdose only a few weeks later.

OPPOSITE BOTTOM: The Graceland-like gates to the Lewis Ranch, adorned with an image of its owner's piano, as seen from Malone Road on the outskirts of Nesbit, Mississippi.

ELTON JOHN

WOODSIDE, OLD WINDSOR, BERKSHIRE (HOME FROM 1975 TO PRESENT)

By Colin Salter

Starting with his first hit, "Your Song," in 1970, Elton John ruled the pop charts around the world in the first half of the 1970s. By the end of 1975 he had had seven successive Top 5 singles in the USA, including four no. 1s. The same year had seen his first appearance in an acting role, as a character called Local Lad singing the song "Pinball Wizard" in the movie version of the Who's rock opera *Tommy*. But success was followed by stress. He was developing bulimia, and in October 1975 he overdosed on drugs during a series of concerts at Dodger Stadium in Los Angeles, which had declared a citywide "Elton John Week."

Elton needed a place of sanctuary, and he found it at Woodside, the mansion in Berkshire that he bought in 1975 and still owns today. Woodside is an imposing home set on the edge of Windsor Great Park; the park was once the private hunting grounds of the kings and queens of England during their residencies at Windsor Castle.

The Woodside estate has a genuine royal connection. It was originally a gift from Richard III to his valet Thomas Walton in the fourteenth century, and until the house was remodeled in its present form during the reign of Queen Anne, it was known as Walton's. Hidden from public roads, it is approached along a neat, tree-lined avenue, past a modest granite slab carved only with the name of the house. One hundred and fifty yards in, a security checkpoint is the first sign that you are visiting pop royalty.

Since Elton bought Woodside, it has understandably also become one of the most heavily guarded estates in the area, protected by dogs and high fences. This is a private home. In its thirty-seven acres of grounds there is ample room for a heated swimming pool, a squash court, a stable block, two lakes, woodlands, formal gardens, and an orangery. There are also two tennis courts, which added to the house's attraction for Elton. He was an enthusiastic player of the sport in his younger years, and his 1974 single "Philadelphia Freedom" was written in

honor of the team for which tennis legend Billie Jean King played at the time.

Inside the elegant house itself—behind its early eighteenth-century brick façade and rows of graceful white sash windows—are a range of grand public rooms and six large bedrooms. At the height of his fame and notoriously extravagant spending, Elton filled it with his art collection and with floral displays. "I like flowers," he once remarked, when it emerged that in one twenty-month period he had spent nearly £300,000 on them.

The purchase of Woodside seemed to mark a tipping point in Elton John's life. In the years immediately following it, much changed in his life. In 1976, he became chairman of his beloved Watford Football Club, the team he had followed in his youth. He had his first UK no. 1, "Don't Go Breaking My Heart," a duet with Kiki Dee. But it marked the end of his chart success for a

"I GREW UP AT MY GRANDMOTHER'S HOUSE, AND SHE HAD A BEAUTIFUL GARDEN. I USED TO HATE MOWING THE LAWN AND WEEDING, WHICH IS WHAT YOU DO WHEN YOU'RE A KID. I LOATHE GARDENING, BUT I LOVE GARDENS, AND I HAVE TWO BEAUTIFUL GARDENS."

Elton John

time. Although he had occasional hits in individual countries, global smashes were few and far between. In 1977, he parted company with his lyricist, Bernie Taupin, and announced his retirement from live performance. His recorded output fell, too—having released ten studio albums during the period 1969–1975, he was now issuing only one a year. It was as if the seclusion of Woodside

OPPOSITE: Elton John shows off some of his art collection, including a portrait of the singer by Bryan Organ, as well as a pair of stuffed leopards gifted to him by friend and fan Princess Margaret.

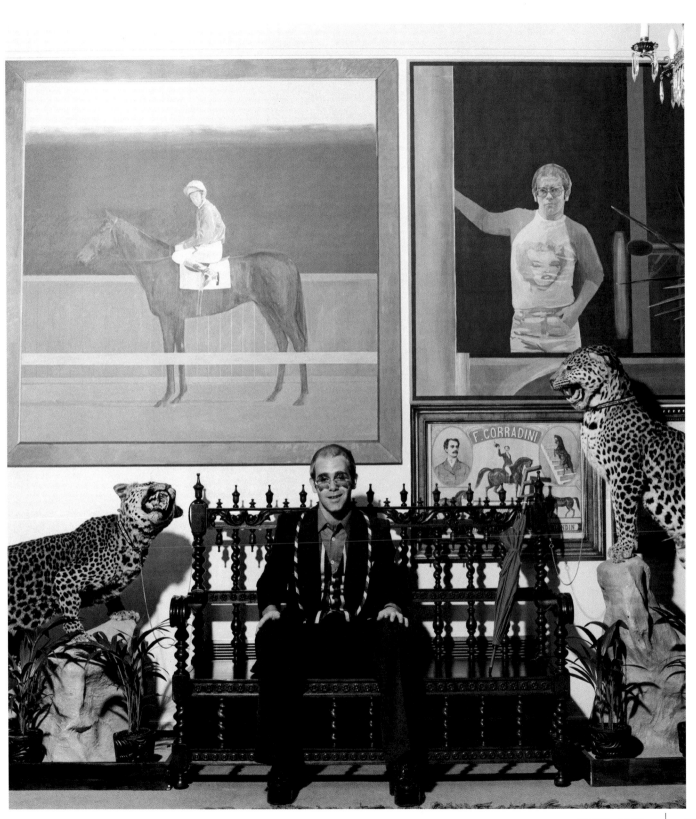

gave him the space and time to pause and reflect. In 1979, Elton began to work with Taupin again, and to return to performing around the world. In 1990, the single "Sacrifice" returned him to Top 10s around the

—

"IT'S NOT A SHOWBIZ LIFE AS SUCH. WE GO TO PIZZA HUT, WE GO TO WATERSTONES, WE GO TO THE CINEMA. THEY'RE NOT STUCK BEHIND THE GATES OF A MANSION."

Elton John on family life

—

world and gave him, at last, a UK solo no. 1. In 1992 he created the Elton John AIDS Foundation, which the following year hosted the first of his now-legendary annual Academy Awards parties. In 1993, it raised $300,000 for the foundation; in 2017, the figure was $7 million. In the 1990s, having reined in his impulse buying, he sold off many of Woodside's valuable artworks

at auction, raising millions more pounds for his charity. These days, his collector's instinct is employed in buying masterpieces of early photography.

From 1998 to 2013, Elton also hosted the annual White Tie and Tiara Ball in the grounds of Woodside, raising in total over £50 million for the foundation. Often there was a theme for the gala event, for example "Surfin' USA" in 2008, when the Beach Boys themselves headlined the ball's entertainment.

The early '90s included landmarks in Elton's personal life, too: 1991 was the year he gave up alcohol and drugs for good, and in 1993 he began his relationship with his future husband, David Furnish. As soon as the law changed, in 2005, they entered into a civil partnership. A

ABOVE: A view from the grounds of Woodside, Elton's main home since 1975. The vast estate spans some thirty acres, while the main home is reportedly larger than nearby Windsor Castle, where the British sovereign lives.

simple ceremony at Windsor Guildhall was followed by a typically extravagant party at Woodside costing (some say) $1 million. The arrival of guests caused traffic jams in the area. Nine years later, in 2014, when British law changed once again to allow full same-gender marriage, they were among the first to wed, and in 2018 they celebrate twenty-five years together.

Sir Elton John has other homes around the world, too, for those occasions when it is not convenient to return to rural Berkshire. There are apartments in Nice, Venice, central London, and Atlanta. The address of the latter home gave its name to his twenty-seventh studio album, *Peachtree Road*, released in 2004. A great supporter of emerging musicians and their work, Elton keeps in close

touch with new releases; but he no longer buys, as he did at his most spendthrift, separate copies of each new CD for each of his homes.

Wherever he may lay his hat on tour, Woodside is the house he and David call home. It's also home to their two sons, Zachary and Elijah, who were born two years apart to a surrogate mother in California. They'll be teenagers when Elton enters his eighties, but he relishes his role as a father. "I'm their dad, I'm famous, they live an extraordinary life," he admitted in an interview with the *Guardian* newspaper. But despite their privileged lifestyle, he is careful to pass on his own strict values. Of their pocket money (reportedly just £3 each per week in 2016) they may spend £1, but must save another and give the third to a charity of their choice. "It's not a showbiz life as such," Elton added. "We go to Pizza Hut, we go to Waterstones, we go to the cinema. They're not stuck behind the gates of a mansion."

ALL ABOARD THE STARSHIP

TAKING TO THE SKIES

By Chris Charlesworth

The more famous rock stars become, the less inclined they are to fly on commercial airlines—unless, of course, it's a long-haul flight on a plane with a restricted first-class cabin, where they can avoid contact with the public. Nowadays, the top acts of the day lease small private jets with fewer than a dozen seats to whisk them from city to city, but back in the 1970s, such planes weren't as widespread as they are today—and, in any case, this was an era when extravagance was rampant. A brash display of opulence was the measure of one's stature in the hierarchy in the rock world, and the ultimate in grandeur in private planes was the Starship, the celebrated customized Boeing 720 that many rock bands—most notably Led Zeppelin—leased during the first half of the 1970s.

The Starship, the first Boeing 720 ever built, was delivered to United Airlines in October 1960, then purchased for $750,000 in 1973 by Contemporary Entertainment, a company owned by teen-idol singer Bobby Sherman and his manager Ward Sylvester, who spent $200,000 customizing it in ways they thought might appeal to luxury-seeking rock bands. This involved reducing the seating capacity to forty-two and installing a fully stocked bar in the main cabin, as well as armchairs, swivel seats and tables, and a thirty-foot couch that, facing aft, ran along the right-hand side, opposite the bar, on the end of which was an electric organ. Wall-mounted TV sets showed an endless supply of videos, some of them pornographic.

Toward the rear of the plane was what today would be called a "chill-out room," with pillows on which to recline, and behind that a bedroom with a double bed and shower. A couple of attractive stewardesses were thrown in for good measure, and to appeal to the vanity of its passengers, the owners took to painting their name on the side of the fuselage.

Led Zeppelin were the Starship's first customers, the upshot of an uncomfortable flight between San Francisco and Los Angeles in 1973 when, to their horror, turbulence tossed their small private jet around in the sky. Manager Peter Grant decided to hire the far more sturdy Starship after that, and did so for the group's ten-week 1975 US tour as well. One advantage of the Starship—or any private plane—was that it enabled the group to base themselves in one large US city from which they could fly out to shows within a three-hundred-mile area and return the same night, thus avoiding the need to check in and out of a different hotel every day. Another

—

"IT WAS AN EXTREMELY USEFUL TOOL BECAUSE INVITING A JOURNALIST ONTO THE PLANE, THE STORY KIND OF WROTE ITSELF. THE NOVELTY VALUE WAS SIGNIFICANT."
Led Zeppelin publicist Danny Goldberg

—

was that they could bring along whoever they liked without having to obtain tickets for them, so Led Zeppelin's friends—many of them of the fairer sex—could hop on board and off at their whim.

"The Starship was only $14,000 more [than the small private jet]," said Peter Grant, "because Boeing wanted the publicity and that kind of thing—and we thought, 'Well why not? We'll have a 720!' The first day, in Chicago, they parked it next to Hugh Hefner's plane. All the press were there, and somebody said to me. 'Well how do you think it compares to Mr. Hefner's plane.' I said, 'It makes his look a Dinky Toy.'" Led Zeppelin singer Robert Plant has gone on record as saying that his

ABOVE: Led Zeppelin on the runway with the Starship in the background, 1973. Left to right: John Paul Jones, John Bonham, Jimmy Page, and Robert Plant.

favorite memory of the plane was "oral sex during turbulence," and Zeppelin PR Danny Goldberg recalls that Grant would disappear into the bedroom with girls and not reappear until the plane was coming in to land.

Another less well-known benefit was that the pilots were happy to allow passengers to sit alongside them in the cockpit and even demonstrate the workings of the controls. "Bonzo [John Bonham] once flew us all the way

from New York to Los Angeles," Peter Grant told me during Led Zeppelin's 1975 tour, when I flew with the group aboard the Starship from Chicago to Los Angeles, and on to Greensboro two days later, then back to New York the same night.

Zeppelin's road manager, Richard Cole, called the Starship a "flying gin palace," and he wasn't wrong: drink flowed, sumptuous food was served and at once point on my trip we all gathered around the organ while John Paul Jones played a selection of the English music hall songs favored by Grant.

ABOVE: Plant, Jones, and Page relax in the "chill out" room aboard the Starship, a comfort zone between the main cabin and the bedroom.

OPPOSITE: Elton John appears unconvinced by his new glasses as he sits on the bed in the bedroom at the rear of the plane.

Led Zeppelin were famously photographed by Bob Gruen standing alongside the plane at a private airfield near New York. Gruen later told *Billboard* magazine that his picture summed up the excesses and decadence of the 1970s: "Here are these guys who don't have buttons on their shirts, yet they have their own plane. Many musicians have told me that when they saw my picture of Led Zeppelin, that's what they wanted."

In many ways the plane reflected the growing distance between rock stars and their audience, a situation that Zeppelin epitomized, but they were by no means the Starship's only clients. My first trip on it was with the Alice Cooper Band, whose tour manager, Dave Libert, handed out a cocktail of vitamins to the passengers each morning. I was also on board in 1974 with Elton John for a trip around the Midwest, and I recall that Elton rejected the haute cuisine on offer and requested instead that the stewardesses pick up a plentiful supply of Kentucky Fried Chicken—several buckets worth, in fact. The more sophisticated Elton of today no doubt cringes at the memory.

Other Starship clients included Deep Purple, Bob Dylan and the Band, the Allman Brothers, Frank Sinatra, and Peter Frampton, who in 1976 was the last rock act to

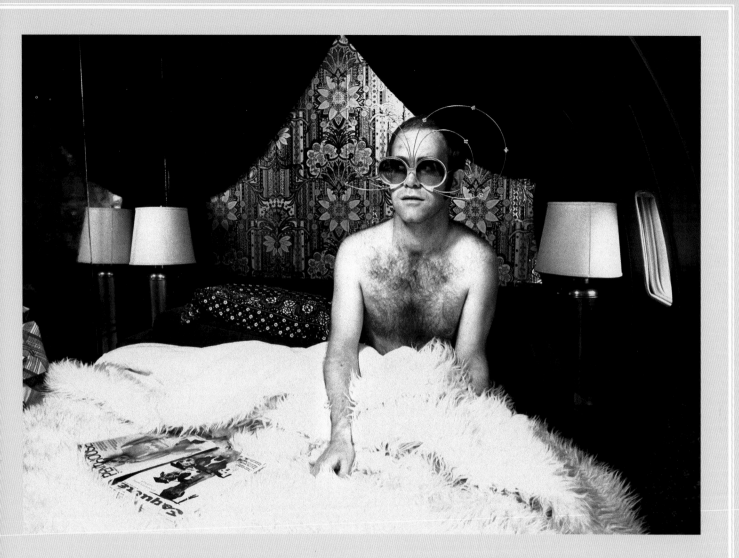

charter it. "It was definitely a show of where you were in your career," said Frampton. "It was a statement of how well you were doing. 'Whoopee! We must be big—we've got the Starship.' It was pretty much a party plane."

In the end, the Starship was a victim of the fuel shortage that gripped the USA in the mid-'70s, its four greedy engines bringing an era to a close after only four years.

"The fact that there was a fuel shortage and we were flying this plane, we thought was a cool thing. It fit in with Alice's extravagant image," Libert said.

"It was headed for the scrap heap," Frampton added.

The Starship went through several changes in ownership between 1977 and 1979, eventually ending its life in storage at Luton Airport, thirty miles north of London—a rather prosaic ending for the career of this most iconic of rock chariots. It was broken up for parts in 1982, and today lingers on only in the memory of the

—

"IT WAS A STATEMENT OF HOW WELL YOU WERE DOING. 'WHOOPEE! WE MUST BE BIG—WE'VE GOT THE STARSHIP.' IT WAS PRETTY MUCH A PARTY PLANE!"
Peter Frampton

—

few—probably not much more than one hundred—passengers fortunate enough to have experienced its dubious charms.

DEBBIE HARRY & CHRIS STEIN

266 BOWERY, NEW YORK CITY (HOME FROM 1973 TO 1978)

By Colin Salter

The Bowery is the oldest street in Manhattan. It follows part of a preexisting Native American walkway that runs the length of the island from north to south. Its name harks back to New York's roots as New Amsterdam when, having displaced the local population, the Dutch settlers cleared the land for agriculture: "bouwerij" is the Dutch word for farm.

As New York grew, the farmland was bought up for the mansions of the wealthy, and Bowery Lane became a grand boulevard. As the city continued to expand, the rich and powerful moved away from the Bowery and the district began a steady decline. By the end of the nineteenth century it was a haunt of sailors, prostitutes, and New York's hidden gay community. Between the wars its fortunes fell further, and being "on the Bowery" meant being down on your luck. The drunks and the dispossessed were known collectively as Bowery Bums, and the street was lined with many flophouses where such bums could find a bed for the night.

In the 1970s, the city took the first steps toward regenerating the area of the Bowery by moving out some of its vagrant population. In their place, attracted by low rent and a high degree of bohemian squalor, artists and musicians moved in. Among them, in 1973, were lovers Debbie Harry and Chris Stein, then vocalist and guitarist in a group called the Stilettos, who moved into an apartment at 266 Bowery.

Theirs was a far cry from the glamorous, eclectic loft apartments of movies and sitcoms. No. 266 is a narrow plot, and the couple squeezed into a couple of rooms barely large enough for a double mattress. They were not natural homemakers. Chris Stein has said that they were both hoarders; with no room for furniture in the apartment, the floor and mattress soon disappeared beneath mounds of clothing, books and newspapers, food cartons, and musical equipment. The kitchen doubled as Stein's makeshift darkroom. A Communist Party poster on one wall reflected their admiration for its graphic qualities rather than the party's politics.

There were cockroaches. "We were messy little children back then," Harry recalled in an interview with Mark Jacobson in 2011. Perhaps it was not all Debbie and Chris's fault. They regularly heard knocking noises in the walls, and pictures would fall from their hooks for no reason. The couple became convinced that the apartment had its own poltergeist.

—

"NEW YORK HAS ALWAYS BEEN A CITY OF CHANGE AND A CITY ABOUT CHANGE. NOBODY'S GOING TO WANT TO COME TO HERE IF IT LOOKS LIKE ANOTHER STRIP MALL."
Debbie Harry

—

"There was a glamour in the decay that we were all in," Stein later told the *Los Angeles Times*. "You look back at the rot and decay with a sort of envy." In his book, *Chris Stein/Negative: Me, Blondie, and the Advent of Punk*, he notes, "Even then, I was aware of the contrast between the environment and the attempt at glamour that was going on there."

Music was their focus, and in 1974 the Stilettos began to play at a new venue just a couple of blocks north of Chris and Debbie's apartment. At the end of 1973, Hilly's Bar at 315 Bowery renamed itself CBGB (Country,

OPPOSITE TOP: Debbie Harry and Chris Stein on the roof of their apartment building in New York City, 1980.

OPPOSITE BOTTOM: Harry, Stein, and a fetching pair of polka-dot oven gloves in the kitchen of their apartment, circa 1980.

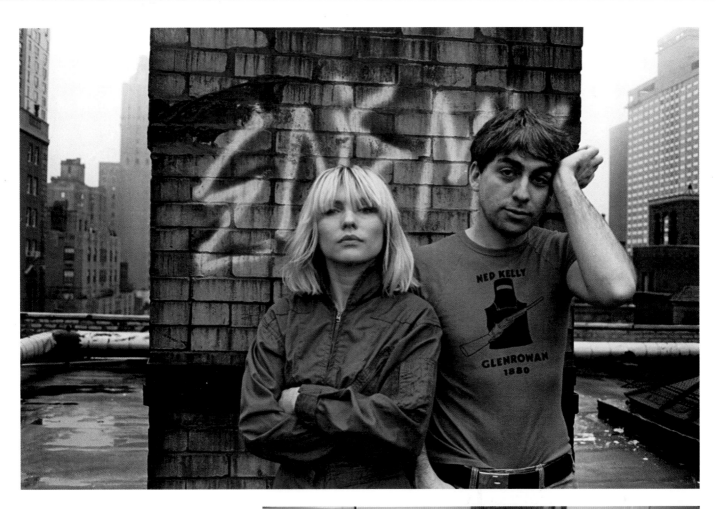

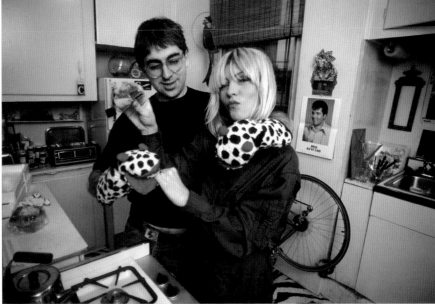

DEBBIE HARRY & CHRIS STEIN

BlueGrass, and Blues) and began to promote live music. Another New York City venue, the Mercer Arts Center, had recently closed its doors, and many of the new wave bands that had found an audience there gravitated to CBGB. The Stilettos played a blend of punk rock with 1960s vocal harmonies, and Debbie and Chris found themselves at the heart of a new musical movement.

Change was in the air in the summer of '74. In the aftermath of the Watergate scandal, President Nixon had been denied executive privilege and was about to resign. Pop music was in the doldrums, somewhere between glam rock and disco. The public sensed the need for something new, in politics and in rock. Debbie and Chris decided to strike out on their own, forming a new band provisionally called Angel and the Snake and debuting at CBGB that August. Debbie was concerned that their name wasn't memorable enough, and it was on the route from CBGB back to the apartment that she hit upon a better one. Waiting for traffic to stop, she was heckled by truckers driving across the busy junction of Houston Street and Bowery: "Hey, BLONDIE!"

In June 1975, a couple of weeks before Debbie's thirtieth birthday, Blondie recorded five demo tracks, which finally saw an official releases in 1994 on *The Platinum Collection*. They rehearsed and performed with a succession of musicians until the band's lineup

—

"THERE WAS A GLAMOUR IN THE DECAY THAT WE WERE ALL IN. YOU LOOK BACK AT THE ROT AND DECAY WITH A SORT OF ENVY."
Chris Stein to the *Los Angeles Times*, 2014

—

stabilized in late 1975. Beside frequent spots at CBGB, the band (and many other CBGB regulars) played another cutting-edge venue, Max's Kansas City, off Union Square, just beyond the northern end of the Bowery. Max's had begun life in the 1960s as a hangout for artists, sculptors, and authors such as Robert Rauschenberg, Allen Ginsberg, and Andy Warhol. They in turn attracted innovative musicians like the Velvet Underground, Iggy Pop, and the New York Dolls. Debbie Harry had worked as a waitress there for a time,

ABOVE: Escaping the hustle, Harry and Stein settle in to watch the original *Godzilla*.

OPPOSITE: Joey Ramone shields his eyes while posing with Harry at her New York apartment, 1977.

but now she was sharing its stage with the Patti Smith Group, Television, and Talking Heads.

In 1976, Blondie recorded their debut LP, *Blondie*, which initially struggled to attract attention but eventually kick-started the group's five-year run of hits, including their US breakthrough, 1979's "Heart of Glass." A mattress on a Bowery floor no longer fit the lifestyle or the image of the band. Debbie and Chris moved out, first to an apartment on 17th and 6th in the city and eventually to a five-story mansion, where they were living when the band broke up in 1982.

The split came as a result of falling sales of both albums and tour tickets, and also of Chris Stein's ill health. He was by now suffering from an autoimmune disease, pemphigus, which caused severe blistering of the skin. Debbie put her solo career on hold to care for him, and eventually had to sell the mansion to pay off historic Blondie debts ("During the two years we were most successful, our accountant didn't pay our taxes," Stein later recalled) and Chris's healthcare bills. In time, they separated as a couple, but their working relationship remains as strong and creative as ever. The band reformed in 1997 and, five albums later, are still touring. Debbie Harry is now in her seventies. Do they miss the carefree days of life before fame in a Bowery flophouse? Perhaps, but not the poltergeist, and definitely not the cockroaches.

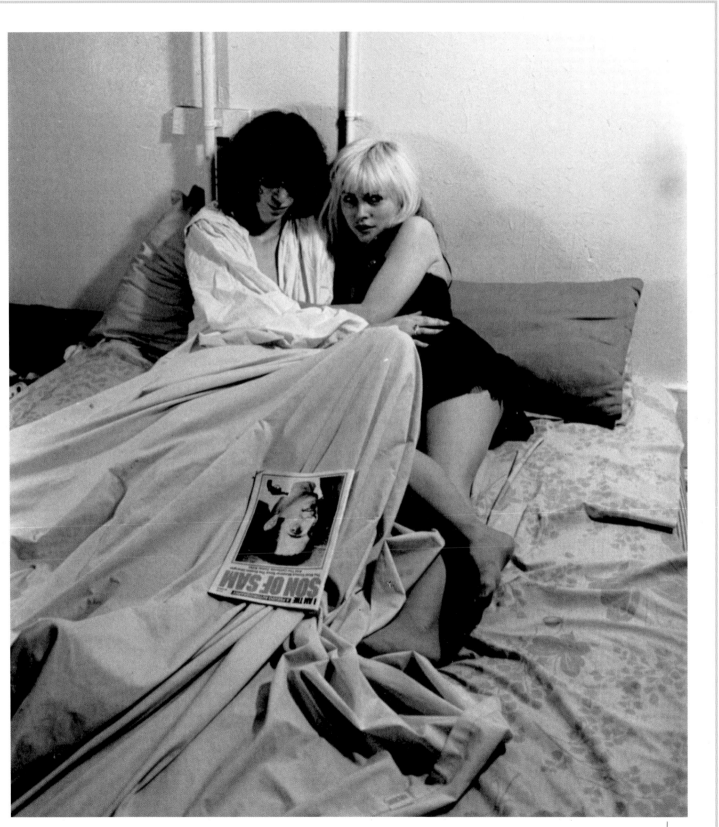

PUNK DIGS & DIVES

SQUATTING AND SQUALOR IN THE '70S

By Colin Salter

Nobody with any sense goes into music to get rich. Few rock musicians are wealthy, especially at the start of their careers. Most enter the business because they're driven to make music, and every spare cent or penny goes to their gear and the bare essentials of life—clothes, food, drugs, and so on. Accommodation is often a large expense they can well do without, and squatting—occupying empty properties without the owner's consent—represents a big saving.

Hippies squatted in the 1960s, and punks from the 1970s onward. The action of squatting was particularly in keeping with the punk ethos. Disregarding laws of ownership was suitably anarchic; and squatting, like punk itself, enabled people with the minimum of resources to get involved in music.

In the UK, nobody represented the anarchic spirit of punk more than the Sex Pistols. In 1975, the band's singer, Johnny Rotten, and bass guitarist, Sid Vicious, shared a squat in a rundown apartment block called

"WE WERE ALL SCRATCHING AROUND THE STREETS. WE HAD NOTHING TO DO. THERE WAS NOTHING ON TV FOR YOUTH. THERE WAS NO YOUTH CULTURE. NO ONE HAD EVEN A HOME TELEPHONE. WE LIVED IN SQUATS."
Viv Albertine, 2010

New Court, in the otherwise upmarket London borough of Hampstead. Sid had been kicked out of his parental home by his mother. Neighbors recall the pair throwing kittens from the windows.

Today, the block has recently been refurbished and one-bedroom apartments in it now go for around half a million pounds, but in the Sex Pistols' day their apartment, no. 39, had no electricity or running water. A campaign to place a memorial plaque on the building recording Rotten and Vicious's occupation has so far

been unsuccessful, although it is still possible to see where Vicious carved his name into a brick in one of the outside walls.

A similar call to commemorate Vicious's childhood home in the Kent town of Tunbridge Wells has been resoundingly rejected. As one local resident would later put it, "Sid Vicious and everything associated with him is completely out of step with the genteel folk of Tunbridge Wells."

Joe Strummer of the Clash embarked on his musical career long before punk. In 1973, his path had taken him to South Wales, where he played with local band the Vultures. When his band broke up the following year, he returned to London and squatted, first at 23 Chippenham Road and then nearby in a rundown building at 101 Walterton Road in the area of Maida Vale, where he formed a new band with his fellow squatters. The band took their name from the squat's address and called themselves the 101ers, playing rhythm 'n' blues and rockabilly covers—a far cry from the music of the Clash.

In April 1976, the 101ers were supported at one gig by a new band, the Sex Pistols, whose punk energy astonished Strummer. "Five seconds into their first song, I knew we were like yesterday's paper, we were over," he recalled.

Strummer left the 101ers and joined the Clash, whose first gig was a support slot for the Sex Pistols two months later. By then, the crumbling Walterton Road property had been demolished; a row of modern low-rise apartments now stands in its place.

No memorial plaque adorns the site in Walterton Road, but Strummer is remembered with a plaque at 33 Daventry Street in the Marylebone district of London. Here the Clash guitarist squatted in 1978 and 1979, and here (although it is not recorded on the plaque) other bands of the era would gather to rehearse, including the

Slits, two of whom, Palmolive and Viv Albertine, had previously played in the Flowers of Romance with Sid Vicious and one-time Clash guitarist Keith Levene. It was also here that Vicious filmed the videos for the Sex Pistols singles "Something Else" and "C'mon Everybody," on which he sang lead vocals.

Vicious died before either song was released, and pop was already moving on—"Something Else" was kept off the no. 1 spot in the UK by the disco classics "I Will Survive" and "In the Navy." But there is no doubt that these squats and the punk musicians who thrived in them changed the world of rock forever—even if not all of them committed fully to the squatting lifestyle.

TOP LEFT: Ari Up and Kate Korus of the Slits rehearse at 33 Daventry Street, London, 1977. The squat was home to Clash front man Joe Strummer at the time.

BOTTOM LEFT: Paul Cook, Sid Vicious, and Steve Jones of the Sex Pistols take a break from the rigors of the road, January 1977.

ABOVE: Joe Strummer rehearses with his first band of note, the 101ers, at the property that gave the band their name: no. 101 Walterton Road in Maida Vale, London. Just around the corner was the Elgin pub, where the 101ers played regularly during 1975 and '76.

"I never actually lived in a squat, eating baked beans with Viv Albertine, as is written," Clash guitarist Mick Jones told John Hind of the *Guardian* in 2016. "I just visited, while still living with my gran. Once the Clash were successful, I got my own home."

DAVID BOWIE

HADDON HALL, BECKENHAM, KENT (HOME FROM 1969 TO 1972)
155 HAUPTSTRASSE, BERLIN, GERMANY (HOME FROM 1976 TO 1978)

By Daryl Easlea

Location has always strongly informed the best work of David Bowie, almost as if he had been holding a microphone to the very city in which he was recording, from the London of *Ziggy Stardust* to the Philadelphia of *Young Americans* to the New York of *Let's Dance*. However, the greatest geographic resonance is reserved for Berlin. His three years in the German city produced some of his most stunning and influential material; the accompanying story of how he escaped the madness of the West to regroup and consolidate has become a cornerstone of the Bowie legend.

Bowie was to live at several locations throughout the world, and many would become closely associated with him. He moved to live communally with various artists and performers at Haddon Hall on the Southend Road in Beckenham, South London, in 1969. After his fame accelerated, he had to leave; following a spell at Vale Court in Maida Vale in the summer of 1973, he bought a four-story house in Gilston Road, Chelsea, which had been designed by Jonathan Reed. Bowie barely lived there, though, as fan and press intrusion came too great to bear. He moved first to New York and then Los Angeles, before moving with wife Angie and son Zowie to Clos des Mesanges, a villa near Blonay on the shores of Lake Geneva in Switzerland, where Charlie Chaplin would be his neighbor. He would later own property in Lausanne, Mustique, Sydney, New York, and the Catskill Mountains.

Despite living at Blonay, in early October 1976, Bowie rented a flat in Berlin with his friend and muse Iggy Pop and his long-term personal assistant Corinne "Coco" Schwab. He had been recording at the Château d'Hérouville outside Paris and then in Munich before settling in the former German capital at 155 Hauptstrasse in the Schöneberg district. The three-bedroom flat was on the first floor of a five-story block; Bowie also had a studio, where he kept a bookcase and easel. As his

biographer, David Buckley, later wrote, "Contrary to popular myth, Bowie was not roughing it in Berlin."

Schöneberg was a relatively unremarkable area of the city; part of the appeal of the apartment was that it was near to where the writer Christopher Isherwood had lived in the 1930s. Iggy and Bowie would live anonymously, in a curious mix of local-meeting-tourist behavior, shopping the markets and bookshops that line Nollendorfplatz and Winterfeldtplatz, and visiting the edgy Kreuzberg area, where Turkish immigrants, artists, and punks would congregate. Near his apartment, the pair would hang out at Neues Ufer, a café with a large gay clientele; when in Kreuzberg, they would frequent SO36. Bowie would travel by bicycle along the Hauptstrasse to Hansa Studios for recording sessions with producer Tony Visconti and recording collaborator Brian Eno.

Although still grappling with many demons, notably a newfound love for German lager (drunk frequently at nearby Joe's Beer House), Berlin provided Bowie with

—

"WE HAD THE ENTIRE GROUND FLOOR, WHICH CONSISTED OF A HUGE ENTRANCE AREA WITH FOUR OR FIVE LARGE ROOMS LEADING OFF. I REMEMBER A LONG PERIOD OF SPRAY PAINTING ALL THE CEILINGS SILVER AND GETTING INCREDIBLY HIGH ON THE FUMES."
Bowie on life at Haddon Hall, from *Moonage Daydream*

—

rehab from his L.A.-fueled cocaine addiction. "It was the first time in years that I had felt a joy of life and a great feeling of release and healing," he later said. "It's a city that's so easy to 'get lost' in—and to 'find' oneself, too."

OPPOSITE: "Look out my window and what do I see?" David Bowie at Haddon Hall, Beckenham, During his time living there from 1969 to 1972 he painted the ceilings silver and held wild parties in the garden.

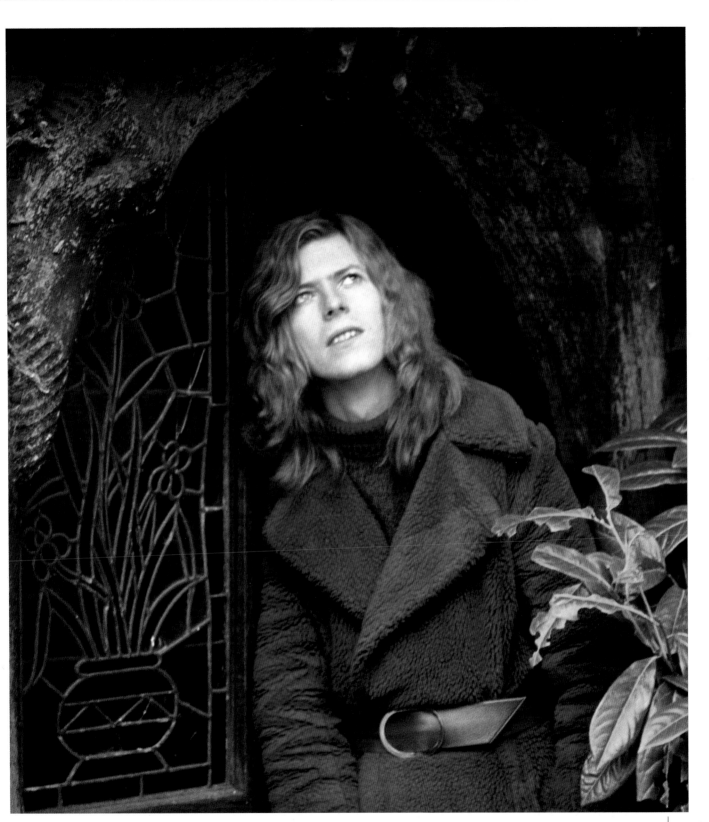

Bowie did both: he escaped the pressure of being Ziggy—a long shadow that was still blocking out light all these years later—and expectations of what an artist should be.

The atmosphere of the city soaked through Bowie's work between 1977 and 1979, known collectively as "The Berlin Trilogy." It can be felt on the Berlin-recorded tracks of *Low*; the two Bowie-produced Iggy Pop LPs of the era (*The Idiot* and *Nightclubbing*); and most importantly on *"Heroes"*, Bowie's only album completely recorded in the city. (*Lodger* was part-written in the city but recorded in Switzerland.)

"On *Low* both of us were totally depressed," Tony Visconti said in 1983. "David was going through a divorce and splitting up with a manager, and my life was all ups and downs. And we both came out of it by *"Heroes"*. It was just the opposite. We were very optimistic, having a lot of fun." It was during recording at Hansa Studios in the city that Bowie saw Visconti sneaking an illicit kiss with his then-girlfriend, Antonia Maass, which provided the track *"Heroes"* with its most memorable lines.

Though he had come to Berlin partly to escape his L.A. lifestyle, Bowie was hardly a recluse during this period. In 1977, he visited Britain to record TV appearances with both Marc Bolan and Bing Crosby; in 1978, he undertook the Isolar II tour, which ran from March to December; in between, he made his second film, the better-forgotten *Just a Gigolo*, while living in the city.

In the spring of 1979, Bowie left the Hauptstrasse apartment for the final time, plumping instead for a place in New York, which was to usher in the next phase of his career, but the mark left on him by Berlin was deep. It had

—

"FIND SOME PEOPLE YOU DON'T UNDERSTAND AND A PLACE YOU DON'T WANT TO BE AND JUST PUT YOURSELF INTO IT. FORCE YOURSELF TO BUY YOUR OWN GROCERIES."
Bowie on moving to Berlin

—

granted him enormous artistic freedom. By emulating the sounds that he had been so influenced by from the German music scene (notably NEU! and Kraftwerk), he had created music that made him impervious to the shocks

ABOVE: Haupstrasse 155, Bowie's unprepossessing home in Berlin during the late 1970s. He and Iggy Pop would often be found in Neues Ufer, the café next door at number 157.

of new wave. It was here, too, that he further developed his visual art, inspired by regular visits to the Brücke Museum and the work of key figures such ás Kirchner and Heckel. And although his marriage to Angie had crumbled once and for all, he was able to extricate himself from a punishing cycle of drug addiction.

Few would have thought at the time that this period in David Bowie's life—his very reinvention as a left-field performer on the run from an America that was bleeding his very spirit dry—would become quite so fabled. In 2013, Bowie himself freely referenced this time on his surprise comeback single "Where Are We Now?," and after his death in 2016, the period was discussed as arguably the most important in his career. In 2017, Saga Holidays, a company that arranges high-end vacations for the over-fifties, was offering a four-day "You Can Be Heroes" weekend, taking in all the key locations from Bowie's sojourn for a substantial sum per person.

RIGHT: Bowie in his Berlin bedroom, February 1978. Hanging behind him is his portrait of the Japanese author Yukio Mishima.

OUT OF VIEW

ROCK 'N' ROLL RECLUSES

By Simon Spence

There are many examples of musicians overheating in the spotlight, the pressure of stardom becoming too much for them to handle. Many of these meltdowns are played out in public, but occasionally an overburdened star will simply disappear off the radar, seeking anonymity and obscurity to do their unraveling and/or soul searching in private. Ironically, this serves almost without exception to make them even more interesting. In their absence, rumors inevitably spring up about their problems (poor health, mental illness, dark secrets), and these often snowball into mythical tales of Howard Hughes–like behavior.

Phil Spector, the acclaimed megalomaniac 1960s record producer, responsible for his famous Wall of Sound and countless classic hits such as "You've Lost That Lovin' Feelin'," went into hiding in his Beverly Hills mansion in 1967, aged just twenty-eight, secreting himself behind security fences and "Keep Out" signs. He reputedly spent his time watching the film *Citizen Kane* endlessly and kept a glass coffin in his basement—reserved for his young wife, Ronnie Spector of the Ronettes, if she should ever leave him. He reputedly only allowed her out on her own after he had installed an inflatable life-size model of himself in the passenger seat of her car.

The stories about Spector grew even stranger when he moved into a 1930s replica of an eighteenth-century Gothic Pyrenean chateau, high on a hill above the Los Angeles suburb of Alhambra. It was where he supposedly walked around in darkness in a "Batman" costume, an insomniac racked by paranoia, and where, ultimately, he shot and killed the forty-one-year-old actress Lana Clarkson. (He was already known for brandishing guns.) Spector was convicted of her murder in 2009 and sentenced to nineteen years in prison.

With less bloody end results, Axl Rose withdrew from public view during the collapse of his band Guns N' Roses and his relationship with Stephanie Seymour,

holing up in his Malibu Canyon mansion compound and avoiding all public appearances from 1994 to 1999. A rock 'n' roll Bigfoot, he became the subject of a string of bizarre rumors, from how he'd lost all of his hair (untrue) to how past-life regression therapy had convinced him he'd been sexually abused by his father at age two (true). It was not until 2008 that Rose re-emerged with a new Guns N' Roses album, *Chinese Democracy*.

Other famous stories of rock disappearance jobs include those of Canadian singer Leonard Cohen, who spent five years in seclusion at a Buddhist monastery in the late '90s; fame-shy Kate Bush, who spent thirty-five years avoiding live performance prior to her run of twenty-two sold-out shows at London's Hammersmith Apollo in 2014; and the sad tale of Sly Stone, who spent much of the late '70s battling drug addiction before falling off the radar in the '80s, only to re-emerge in the 2000s, virtually homeless and living in a van.

Prior to his death in 2010, Captain Beefheart (real name Don Van Vliet) had become more myth than man.

—

"I'VE BOUGHT MYSELF A BEAUTIFUL AND ENCHANTING CASTLE IN A HICK TOWN WHERE THERE IS NO PLACE TO GO THAT YOU SHOULDN'T."

Phil Spector to *Esquire*, 1999

—

The *Trout Mask Replica* star stopped making music in 1982, and for the next twenty-eight years refused virtually all interviews, devoting himself to painting in a small Californian coastal town, just miles from the Oregon border. Although his music was always off-kilter, he lived out his days peacefully with his wife of forty years. Van Vliet had always been ill at ease around people, plagued by oddball fans, and was battling the symptoms of the onset of multiple sclerosis, the disease that would leave him wheelchair bound and finally kill him.

ABOVE LEFT: Don Van Vliet, a.k.a. Captain Beefheart, photographed near his home in the Mojave Desert in the early 1980s.

ABOVE RIGHT: Phil Spector at the piano at the Pyrenees Castle, his home in the Hollywood Hills, in 1978.

Illness was also the reason for David Bowie's swift and sudden disappearance following his 2003–2004 world tour, cut short when he had to undergo emergency heart surgery. Little was seen of the singer from that moment until his death in 2016 as he retired to his luxury penthouse apartment in downtown Manhattan and second home in the Catskills, with his supermodel wife Iman and their young daughter, Alexandria.

There were no tales of crazy behavior this time, however—quite the opposite, in fact. It was said that

Bowie lived a healthy lifestyle, spending his days watching imported DVDs of BBC dramas, helping his daughter do her homework, painting, drawing, and reading. Occasionally there would be snatched paparazzi shots of him walking around New York City, buying his lunch in Soho, going to the park and sitting in cafés, browsing local bookstores and art galleries. Fans continually speculated about his health even after the shock release of a 2013 album, *The Next Day*, which he promoted only with music videos. In January 2016, on his sixty-ninth birthday, he released a final album, *Blackstar*. Two days later, he was dead from cancer, a disease for which he had undergone treatment over the past eighteen months.

ABOVE: Brian Wilson of the Beach Boys looks out from his Bel Air home, April 1977.

OPPOSITE: A peek inside the idiosyncratically painted home of Pink Floyd founder Syd Barrett.

Beach Boy Brian Wilson was an altogether different kind of recluse—one who simply struggled to cope with the pressures of being in one of the world's biggest bands. His was a cautionary tale of fame, drugs, and excess. Strung out on LSD, cocaine, uppers, downers, and

—

"I FIND ISOLATION BETTER BECAUSE OF THE FACT THAT I CAN PAINT. NEW YORK FOR INSTANCE . . . IT'S SO LOUD. THE LAST TIME I WENT THERE IT TOOK ME TWO MONTHS TO GET MY HEARING BACK."

Don Van Vliet to *Copyright*, 1991

—

copious amounts of marijuana, his mental health collapsed following the release of his band's iconic *Pet Sounds* album in 1966. The follow-up, *Smile*, was

canceled, with Wilson's erratic behavior eventually giving way to a hermitic lifestyle as the band cut ties with him. He was rarely seen outside his Bel Air mansion, once owned by Edgar Rice Burroughs, where he binged on food, drugs, cigarettes, and alcohol. It was rumored that he did not get out of bed for three years, refused to wash, and ballooned to three hundred pounds. If he went out, he did so in bathrobe and slippers, and only to attempt to drive his vehicle off a cliff or demand that he be pushed into and buried in a grave he had dug in his backyard. Visitors recall him playing just one note on a piano over and over again at the studio he had assembled in his living room; the piano at one time was situated in a sand

pit he had built there so he could feel the sand on his feet as he played. After years of alarming episodes, which included him being sighted playing the piano for drinks at a gay bar and living as a vagrant in San Diego, the combination of a spell in a psychiatric hospital, shock therapy, and treatment by the controversial therapist Dr. Eugene Landy (who diagnosed Wilson as a paranoid schizophrenic) eventually set his life back on track.

The most famous musical recluse of them all, though, has to be Pink Floyd founder Syd Barrett, who spent more than thirty years avoiding the limelight in truly remarkable circumstances. He had been the photogenic and fabulously gifted lead singer, guitarist, and songwriter of Pink Floyd until he walked away from the band and their success in 1968. While the band went on to even greater fame, writing hit "Shine On You Crazy Diamond," from the massive *Wish You Were Here* album, about him, he was rarely seen outside of no. 6 St. Margarets Square, a three-bedroom, semi-detached 1930s house in a *cul-de-sac* in a quiet part of Cambridge.

Barrett's behavior had been notably odd ever since he quit Pink Floyd. He recorded two offbeat solo records before locking himself away for a large part of the '70s in his upscale Chelsea Cloisters apartment complex. Here he gave away furniture, televisions, guitars, and even session tapes before, in 1978, when he was aged just thirty-two, packing a few belongings into a small shopping bag and walking nearly fifty miles northward to his

mother's house in Cambridge. He made no more public appearances, reverted to using his real name (Roger), and was said to enjoy gardening and painting. He was also purportedly writing a book on art history, which remains unpublished.

Barrett's use of drugs—particularly LSD—in the 1960s is well documented; he is often described as the original "acid casualty," with an image as a doomed genius, the ultimate romantic ideal of a reclusive artist. The truth was more mundane. He shared his home in Cambridge with his mother, Winifred, until she died, and thereafter lived a seemingly poverty-stricken existence, venturing out only rarely to go shopping or pay his newsagent's bill. There were paparazzi shots of an almost unrecognizable balding and overweight Barrett struggling home laden with groceries. His mental health was unstable. He boarded up the windows of the house to keep out the eyes of the press and the fans who regularly visited, hoping to catch a glimpse of the former star. When he could be cajoled into answering the door, he did so half-naked and screaming, "Syd's not home!"

It was only when Barrett died in 2006, aged sixty, from cancer (his mental state by now having deteriorated so much that his will was authorized under the Mental Health Act) that the world was finally allowed into his home. And quite a sight it was, filled with bizarre DIY alterations and makeshift furnishings. Doorknobs were replaced with plastic toy hippos or pieces of square wood, and flimsy plywood shelves lined each room. Furniture was haphazardly and garishly painted, the floor tiles were a hodgepodge of colors. Almost every wall was painted differently—pink, lavender, Seville orange, sunshine yellow—all with boards and doors in clashing colors, purple, turquoise, and green.

Most of his possessions were auctioned off, included the few paintings he did not destroy. A homemade bread bin, crudely constructed from sheets of plywood, netted £1,400, toward a total of £121,000, which the Barrett family (his sister having been his one regular human contact) donated to a scholarship for local art students. The house was sold for £310,000. Most incredibly, when his will was made public, it was revealed Barrett had left £1.7 million to be shared between his four siblings.

BARRY GIBB

MILLIONAIRE'S ROW, MIAMI BEACH, FLORIDA (HOME FROM 1976 TO PRESENT)

By Simon Spence

While Australia (where their professional career began), the Isle of Man (where the three brothers were born), and Manchester, England (where they were raised) can all lay a claim to being important settings in the long and illustrious history of the Bee Gees, it was in Miami that the group, and lead singer Barry Gibb in particular, truly found their own voice and put down roots.

When he first arrived there in 1975, Gibb said he liked the bright sunlight, which reminded him of his sun-drenched late teens in Australia. There was little else to cheer him. The Bee Gee were has-beens, their careers had hit rock bottom, and the album they were making at the city's celebrated Criteria Studios—also used by James Brown, Aretha Franklin, and the Eagles, among others—was a last roll of the dice. Initially, they stayed in a vast white stucco and Cuban barrel tile–roofed mansion with huge entrance hall, grand staircase, and marble floors in Golden Beach, a small, upscale town just north of Miami Beach, on one of the many barrier islands that fringe Miami's Atlantic coast. With its single palm tree out front, the house was famously featured on the cover of Eric Clapton's 1974 no. 1 comeback album, recorded at Criteria, *461 Ocean Boulevard* (the address of the house). It was Clapton who had suggested that the Bee Gees record at Criteria and stay at the house—they shared a manager, Robert Stigwood—figuring a change of atmosphere might save the group.

At the time, Miami rivaled New York as North America's main disco city. Disco ruled the US charts, with huge no. 1 hits such as "The Hustle" and "Kung Fu Fighting" dominating the airwaves. Out of Miami had come "Rock Your Baby," the unstoppable K.C. and the Sunshine Band, and TK Records, the company at the forefront of disco. The Bee Gees breathed it in and recorded their own disco hit, "Jive Talkin'." The following year they cut a second US no. 1 at Criteria and another disco classic, "You Should Be Dancing." The success

allowed Barry to leave his tax haven on the Isle of Man in late 1976 and buy his own mansion in the coastal resort city of Miami Beach, fifteen square miles of natural and manmade barrier islands. He said he had found "a lovely peaceful spot away from showbiz crowd."

This was North Bay Road, overlooking Biscayne Bay, the wide lagoon that sits between the Miami mainland and Miami Beach. The coral-colored, Spanish-style villa cost him $500,000 and boasted a pool and tennis courts, as well as its own dock and cabana. Gibb spent a further $350,000 fixing up the property. It had been built during the early Miami Beach boom years of the 1920s and '30s, when wealthy industrialists invested in grand winter homes along sections of the bay. While the Miami Beach Atlantic oceanfront had since been sacrificed to grand hotels, the sprawling length of the bay remained relatively undeveloped, exclusively for the rich.

Gibb loved his new home and soon his little patch of Miami Beach heaven was teaming with other Gibbs. First he persuaded his parents, Hugh and Barbara, to move to

> ## "I'VE NEVER BEEN INTO PARTIES, PREMIERES, OR NIGHTCLUBBING. I MUCH PREFER STAYING AT HOME WITH THE WIFE AND KIDS, WATCHING TV OR READING A BOOK."
> **Barry Gibb to the *Daily Mirror*, 2001**

a house close by (his wife's parents also moved to Miami Beach, in living quarters attached to the Gibbs' home). As the good times continued to roll for the band, with further no. 1 hits such as "Stayin' Alive" and "Night Fever" featuring on the record-breaking 1977 soundtrack

OPPOSITE: "You can tell from the way I use my walk." Bee Gee in chief Barry Gibb picks out a party shirt at his home on Millionaire's Row, Miami, Florida, at the height of the band's success in the late 1970s.

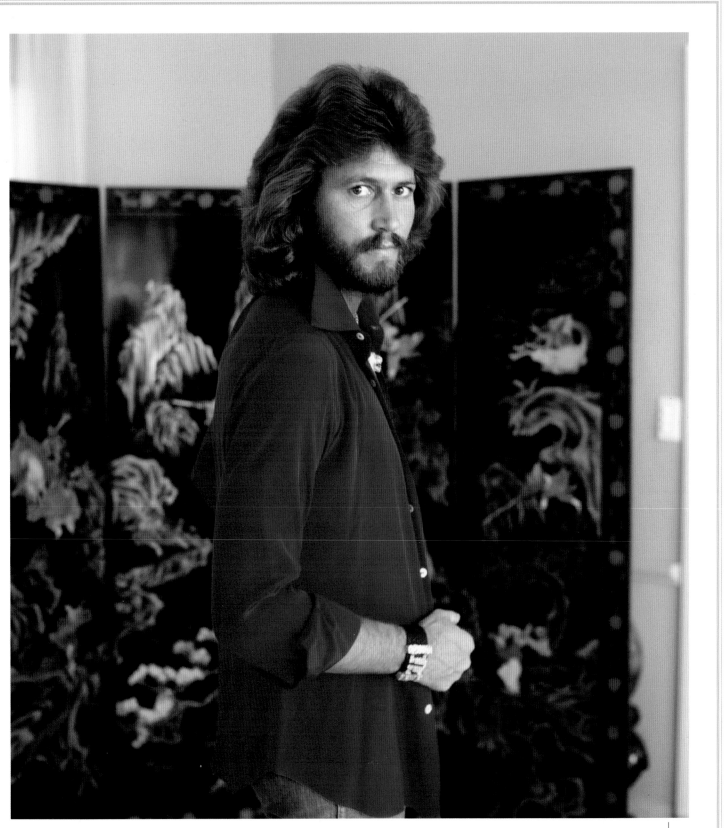

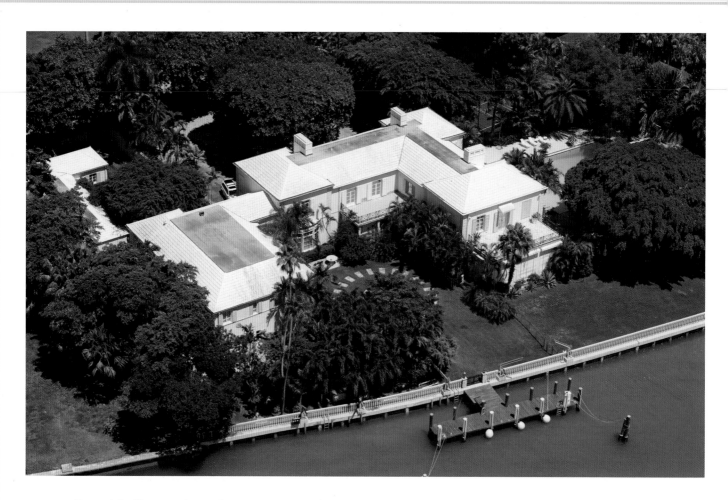

album of the film *Saturday Night Fever* (a US chart-topper for six months, selling twenty-seven million copies within a year of its release), twins Robin and Maurice followed Barry to Miami Beach. Robin bought the house next-door but one and Maurice bought a Georgian-style mansion six blocks away.

Robin's home was a beauty: built in 1948 and split over three levels, with ten bedrooms and nine bathrooms, it featured a large living room with floor-to-ceiling windows overlooking Biscayne Bay, a swimming pool, and its own dock. It was said to have been the location for John F. Kennedy's trysts with Marilyn Monroe, while British Prime Minister Tony Blair famously holidayed there in 2006 as a guest of Robin. The youngest Gibb brother, Andy, also moved to Miami Beach. In the wake of *Saturday Night Fever* mania, with the Bee Gees positioned as kings of the disco era, he became a huge

solo star, with Barry producing and co-writing his first three singles, all US no. 1s, and the newly anointed teen idol spent a fortune on a luxury houseboat that featured three staterooms, three bedrooms, and a grand piano in the main lounge.

Success had its downsides. Tour boats sailed past Barry's home several times a day, with fans on board equipped with cameras and binoculars. There was also a tour bus that regularly drove down North Bay Road. Often fans would drive by playing "Stayin' Alive" at full blast. Gibb reluctantly had his home fortified: nine-foot-high fences were erected; guard dogs, electronic wrought-iron gates, and a security force employed. When not in the studio, he was a homebody, watching TV or playing

snooker in his rec room. While stars such as Willie Nelson and Glen Campbell visited to jam and play snooker, Gibb, a prodigious dope smoker, remained uncomplicated in many ways and insisted on having British home comforts such as baked beans, processed peas, Bovril, and Yorkshire pudding mix sent over.

The Bee Gees cut one final album at Criteria, 1979's *Spirits Having Flown*, spawning three more no. 1 singles, including "Tragedy" (making it six US no. 1s in a row, a feat only ever achieved by one other band, the Beatles), but the Gibbs' commitment to Miami only strengthened. Barry oversaw the purchase of a warehouse from TK Records in the Hialeah area of North Miami and transformed it into the band's own studio, Middle Ear. Here he produced global hits for stars such as Barbra Streisand, Dionne Warwick, Kenny Rogers, and Diana Ross. His work with Ross in the mid-'80s brought him into close contact with Michael Jackson, who often used Gibb's home as a hideout from the press.

If they had not become famous musicians, the Gibb brothers could well have been successful property speculators. Barry's mansion (to which he added features such as a full-size basketball court out back and a giant fountain out front) was valued at $16 million in 2006, and Robin's home two doors away, which he'd bought for just $950,000, was valued at $5.8 million. In the '90s, Maurice had moved even closer to Barry, buying a new property three blocks away for $7.1 million. In 2012, it sold for $13 million.

North Bay Road is now recognized as probably the most desirable street in all of Miami Beach—dubbed Millionaire's Row—with a reputation for exclusivity extending well beyond the city in being compared to Park Avenue or Rodeo Drive. Nondescript from their entrance, the homes that back onto Biscayne Bay, such as Barry's mansion—extravagant even by North Bay Road standards—open out into a whole other beautifully sculpted and landscaped world, with the serene expanse of the lagoon at the foot of the garden.

The "showbiz crowd" Barry had sought to avoid flocked to buy property here, with a string of new mammoth homes built on North Bay Road, all with substantial frontage on the bay and open views of downtown Miami in the distance. Barry's new neighbors included New York Yankees baseball superstar Alex Rodriguez; members of the Miami Heat basketball team, the team Gibb follows fervently; singers Ricky Martin, Shakira, and Lil Wayne; actors Jennifer Lopez and Matt Damon; and designers Calvin Klein and Tommy Hilfiger.

—

"IT'S LIKE LIVING IN A BLOODY GOLDFISH BOWL. THE BOATS COME PAST EVERY HOUR ON A NICE DAY, AND THE PEOPLE ALL HAVE CAMERAS AND BINOCULARS."
Barry to *Rolling Stone*, 1979

—

At one point, Gibb could even count Colombian drug lord Pablo Escobar as a neighbor, while Phil Collins is the latest star to buy a property on the road.

The last surviving Gibb brother (Andy died in 1988, Robin in 2012, and Maurice in 2013), Barry can only smile at the developments that have taken place on North Bay Road in the past forty years. Just as he had taken care of the Bee Gees' business wisely, his property portfolio includes four nearly adjacent plots on Millionaire's Row, as well as a huge country estate in Beaconsfield, Buckinghamshire.

Barry became a US citizen in 2013, and has said he will never sell his North Bay Road home. He is currently worth well in excess of $100 million. Not bad for a kid who grew up poverty-stricken in the postwar slums of inner-city Manchester.

PETER GABRIEL

ASHCOMBE HOUSE, SWAINSWICK, SOMERSET (HOME FROM 1978 TO 1987)

By Daryl Easlea

Just as Genesis were beginning at last to gather a degree of commercial success, singer Peter Gabriel moved west in 1974 with his then-wife, Jill, to Woolley Mill, just outside Bath. Within a year he had left the group he had helped form in 1967. It was here that his first two children, Anna and Melanie, were born; and it was here that he grew cabbages, a fact he was to enshrine in his statement when he left Genesis in 1975: "Even the hidden delights of vegetable growing and community living are beginning to reveal their secrets. I could not expect the band to tie in their schedules with my bondage to cabbages."

It was not until he moved into the nine-bedroom Grade II–listed Ashcombe House in Swainswick in 1978, however, that Gabriel granted himself the freedom of converting a cattle barn into a recording studio, christening the property (which came with twenty-five acres of land) "Shabby Road." It was from here that, while watching his children grown up, he could record at his own pace, which to those who knew him was painstakingly slow.

It was at Ashcombe that Gabriel began to advance the experimentation that was to define his career. Here he wrote and recorded three albums: 1982's *Peter Gabriel*, also known as *Security*; 1985's soundtrack album, *Birdy*; and, most importantly, 1986's *So*, the record that was to change his life forever. Gabriel allowed in TV cameras to capture the work-in-progress recording for *Security*; he and producer David Lord were filmed smashing glass and generally hitting things and recording them on Gabriel's new toy, the Fairlight computer. Meanwhile, in the summer of 1985 various performers used the house as a base to rehearse for the first ever WOMAD (World of Music, Arts, and Dance) festival, staged by Gabriel in nearby Shepton Mallet.

Gabriel first worked with producer Daniel Lanois on *Birdy*. "I first saw Peter at the end of the lane," Lanois told me in 2015. "I'd never met him [before], but when I shook his hand, I thought, I'm with somebody I already know, let's pick up from where we left off. He liked *Birdy* and he asked if I'd stay on to work on his song record." That "song record" was to become *So*. "We didn't even have a telephone when we were recording *So*—I ripped the telephone off the wall and threw it in the ravine." It was in this splendid isolation in the barn that Gabriel created world-conquering material such as "Red Rain," "Sledgehammer," and "Don't Give Up." To counteract Gabriel's legendary reluctance to finish a track, Lanois physically nailed him down in the barn to complete the album's lyrics.

Though Gabriel's primary impulse during his spell at Ashcombe was to work, he made time for other pursuits as well, including a rekindling of his childhood love of croquet, a game he had first played at his parents' place in Surrey (and which is also referenced in the artwork to Genesis's *Nursery Cryme*). With the grounds of his new

"WE DIDN'T EVEN HAVE A TELEPHONE WHEN WE WERE RECORDING—I RIPPED THE TELEPHONE OFF THE WALL AND THREW IT IN THE RAVINE."
***So* producer Daniel Lanois, 2015**

home offering a well-manicured croquet lawn, the game became an "obsession" for Gabriel and his collaborators during the making of *So*. "We'd set up either car lights or some vague attempt at nightlights so we could play at night as well as in the daytime," he later recalled. "Whenever there was a break we'd get out there and this stayed with us on tour. We traveled with a mobile croquet set."

The enormous success of *So* meant that Gabriel moved his operation away from Shabby Road to a purpose-built studio at Real World in nearby Box in the late '80s, while he also later bought a property in London's Notting Hill. But Ashcombe House, nestling in the Lam Valley, remains central to Peter Gabriel's legend.

Peter Gabriel poses for a portrait by an outbuilding on the grounds of his home at Ashcombe House, 1984.

ISLANDS & EXILES

GETTING AWAY FROM IT ALL

By Simon Spence

In the late '60s, Marlon Brando became pop culture's first and most famous castaway, making headlines when he bought a remote island off Tahiti, boasting of preserving the ecology and archaeology and building a home there to use as a getaway from his pressurized Hollywood life. Many since have followed his lead, and nowadays an island is seen as a superstar's ultimate must-have accessory. What has changed is the motivation behind such purchases. Few still cling to the nature-loving ideals Brando espoused, and while the romantic desire to escape to a private utopia remains powerful, stronger still is the need to hang on to one's cash, or as much of it as possible.

In this respect, Mick Jagger led the way, becoming the most famous rock exile of his era when, in 1971, faced with a crippling tax bill from the British government, he left his home country for the South of France, where the Rolling Stones would record *Exile on Main St.*, a double album routinely voted among the best of all time. Jagger and bandmate Keith Richards turned tax exile and tax dodging into an act of rebellion, casting themselves as modern-day pirates. Behind the scenes, however, there was less swashbuckling and more paper pushing. In 1972, Jagger oversaw a restructuring of the band's finances, setting up offices in the tax havens of the Netherlands and Caribbean, and he and his bandmates have been tax exiles ever since, meaning they can no longer use Britain as their main residences. The Stones have reputedly paid just 1.6 percent in tax on their total earnings since 1972.

Jagger set something of a template for rock musicians looking to hoard their treasure, combining hard-headed business sense with the idyllic, escapist dream of owning a piece of tropical paradise. He may not have had Brando's lofty ideals, but Jagger came to encapsulate the image of decadent romanticism when, in the late 70s, he set up home on the private island of Mustique in the West Indies. Although he didn't own the island—the

British aristocrat Lord Glenconner did—Jagger made the place a byword for celebrity seclusion and luxury. Before his arrival, it had been used as the discreet escape for British royals, notably Princess Margaret, sister of Queen Elizabeth II, who'd owned a home there since the 1960s.

There are now around one hundred private villas on the island, which is famed for its beautiful beaches and exclusivity, with musicians such as Shania Twain, Bryan Adams, and David Bowie, plus fashion designer Tommy Hilfiger, all following Jagger to set up home there. Bowie sold Mandalay, his Balinese-style fantasy villa with infinity pool overlooking the ocean, to magazine publisher Felix Dennis in 1995, claiming the house was so tranquil and peaceful that he found it hard to get any work done there. Jagger called his Japanese-inspired villa Stargroves—the same name as the manor house in the English countryside he owned in the '70s—and recently put it up for lease. He also owns a smaller beachfront villa next door, Pelican Beach.

—

"THE HOUSE IS SUCH A TRANQUIL PLACE THAT I HAVE ABSOLUTELY NO MOTIVATION TO WRITE THINGS WHEN I'M THERE."

David Bowie to *Architectural Digest*, 1992

—

Other islands are available: Johnny Depp owns a forty-five-acre one in the Caribbean. Colombian pop star Shakira has teamed up with Pink Floyd co-founder Roger Waters to buy an island in the Bahamas. Leonardo DiCaprio has one located off the coast of Belize. Film director Steven Spielberg owns another off the coast of Portugal, while British businessman Sir Richard Branson owns Necker Island in the Caribbean. Ricky Martin has his off the coast of Brazil, while Diana Ross's island is in French Polynesia. Actors Mel Gibson, Julia Roberts, and Nicholas Cage, as well as musicians Céline Dion, Lenny

Kravitz, and Tim McGraw and his wife Faith Hill, all own islands in the Bahamas, which ranks at no. 2 as the best location for tax avoidance, just behind Monaco.

Less glamorously, John Lennon purchased the windswept Dorinish Island in Clew Bay in County Mayo, Ireland. The island became known as "Beatles Island," but Lennon visited rarely, staying in a psychedelic caravan when he did. Yoko Ono sold it for $40,000 in 1980 after Lennon's death and donated the money to an Irish orphanage.

The equally idiosyncratic American rocker and record producer Todd Rundgren now lives on the Hawaiian island of Kauai. He relocated there in the 1990s after complaining that Marin County, California, was being overrun with investment bankers, and that artists were being pushed out. He had lived in Sausalito, across the Golden Gate Strait from San Francisco, for ten years after his first home in Woodstock was violently robbed (Rundgren and girlfriend, who was pregnant at the time, were tied up by a group of armed men during the raid). On Kauai, Rundgren oversaw the building of a custom-designed home, a pagoda-like structure set amid lush tropical ambience, and lived close to nature, posing for pictures in a sarong, roasting a pig. Like Brando, he

seems to have retained a sense of idealism to his island life, and has become immersed in Hawaiian and Tiki history. He built an authentic Hawaiian Tiki bar called Tiki Iniki, and in 2008, for his sixtieth birthday, invited fans to camp out on his property.

—

"I REMEMBER GETTING LETTERS FROM NURSES SAYING, 'THAT'S IT, I'M NOT BUYING ANY MORE OF YOUR RECORDS.' I DIDN'T MEAN IT THE WAY IT CAME OUT."
Phil Collins to the *Guardian*, 2016

—

If Mick Jagger managed to make being a tax exile seem cool, then others have been less fortunate, and have instead come to be seen as cold-hearted, selfish, and money-grabbing. The drummer Dave Clark, whose eponymous five-piece band led the charge of the British musical invasion of 1960s America, was ahead of Jagger

in fleeing Britain for tax purposes and promptly saw his musical career, if not his bank balance, disappear.

In the 1970s, there was an exodus from Britain to avoid income tax for highest-rate earners, which at that time had reached a whopping 83 percent. There was no romance to the Bee Gees' decision to move to the Isle of Man to avoid tax; and after David Bowie quietly left for Switzerland in 1976, his reputation as a businessman would soon equal his musical status. Tina Turner, with whom Bowie had duetted on "Tonight" in the '80s, became another famous tax exile when she too moved to Switzerland in 1994. She has continued to live there for the past two decades, renouncing her US citizenship in 2013. Sir Sean Connery, the former James Bond, was another to leave the UK in

BELOW: David Bowie's hideaway on the island of Mustique, which he eventually sold after deciding it was much too peaceful there.

OPPOSITE: Phil Collins at work in his home studio in Surrey, 1984, a few years prior to his permanent relocation to Switzerland.

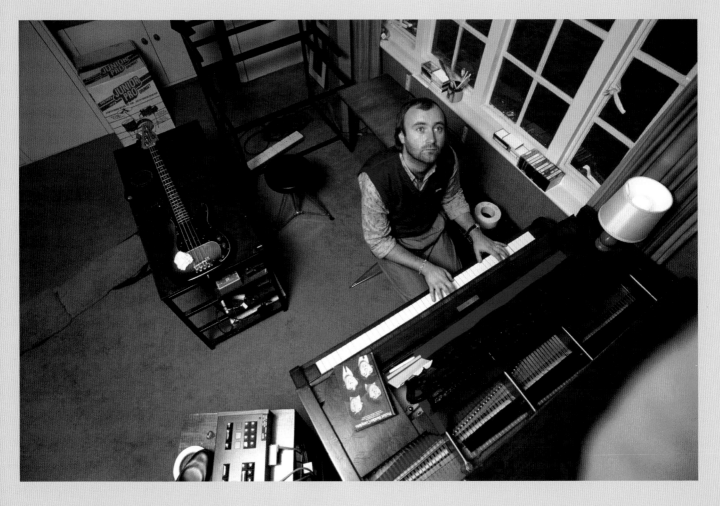

the '70s, as was ex-Beatle Ringo Starr, with both attracting degrees of scorn for their decision.

No one, however, quite embodies the image of greedy, self-serving, tax-dodging rock star like Phil Collins, the singer, actor, and former Genesis drummer. Like Bowie and Turner, he had sought refuge in the so-called "pop-star paradise" tax system of Switzerland. The country grants generous privileges to rich expatriates, with tax deals based on the rental value of their property rather than their actual income or wealth, on the condition that they do not work in the country. Unlike his fellow superstars, though, Collins became hated for making the calculated move. It all seemed to stem from a quote Collins gave on the day before the 1992 general election in Britain, when he vowed to leave the country if the center-left Labour Party won power. "If they put up taxes, I'd consider going abroad," he said. It was not a popular sentiment among his working-class fans. "I remember getting letters from nurses saying, 'That's it, I'm not buying any more of your records,'" he added.

Collins was cast as a heartless right-winger only concerned with himself (an image cemented by the urban myth that he divorced his wife by fax). When Labour won the 1997 general election by a landslide, he was bid good riddance. He maintains it was all a misunderstanding. There's not doubt, though, that he remains a tax exile, with seven bank accounts listed on file in Switzerland. "He continues to live and bank" there, according to his manager. "It is entirely appropriate for him to have a bank account where he lives." There is, however, a growing voice among the Swiss population to end tax breaks for wealthy foreigners. Maybe he should buy an island?

BOB MARLEY

TUFF GONG HOUSE, KINGSTON, JAMAICA (HOME FROM 1976 TO 1980)

By Colin Salter

Hope Road brings traffic and trade into Kingston from the east of the island. It's one of the oldest roads in Jamaica's capital, lined with some of the city's finest buildings: institutions of government, places of entertainment, historic homes. Jamaica House, the office of Jamaica's prime minister, sits at its midpoint, not far from King's House, the official residence of the island's British governor. Near the western end of Hope Road stands Devon House, erected in 1881. It's a true symbol of hope, the first grand house built by a former slave, self-made millionaire George Stiebel, after emancipation in 1838.

Just east of Jamaica House, at 56 Hope Road, is the former Odnil House, one owned by Cecil Lindo, a nineteenth-century member of one of the preeminent plantation-owning families of Jamaica's colonial era, and a great-great-uncle of Island Records founder Chris Blackwell. Blackwell inherited the house in the early 1960s and made it the headquarters of his expanding record label, which had just had its first international hit with Millie Small's "My Boy Lollipop."

The building became a sort of clubhouse for local musicians, especially after the Tuff Gong recording studio moved its operations to what was now called Island House, in 1970. Tuff Gong was founded in 1965 by rising local star Robert Nesta Marley—Bob Marley to his fans, Tuff Gong to his friends. Tuff Gong ran its studios, a record label, a record shop, and a vinyl pressing plant from buildings on the premises. By the early '70s, several members of Marley's band, the Wailers, were also at least part-time residents of the property, including Bunny Wailer and Marley himself.

Chris Blackwell was determined to take reggae to a global audience, and he saw in two bands—Toots and the Maytals, and Bob Marley and the Wailers—the charismatic musicians through which he could achieve his goal. He jumped at the chance of signing the Wailers

in 1972, and his faith was well placed. Their first release for Island, *Catch a Fire*, is regarded as one of the greatest reggae albums of all time.

With successive album releases, Marley spread reggae around the world, becoming its iconic embodiment. Island's operations also expanded, moving into other genres, including folk, art-pop, and progressive rock. In 1975, after moving his headquarters to London to be nearer to the mainstream music industry, Blackwell sold Island House to Marley in 1975. The property was now the heart of the Marley universe, as his home, the base for his Tuff Gong brand, and an open house to his friends and fellow Rastafarians.

It was a relaxed, creative atmosphere. A typical day at the house might begin with a breakfast of fresh food freshly cooked, in keeping with Rastafarianism: fish from the beach, milk from the cow, green bananas from the palm. After 10 a.m., when the Tuff Gong shop opened up, the place would fill up with local youth. Now known as Tuff Gong House, 56 Hope Road was

—

"I HAVE A BMW. BUT ONLY BECAUSE BMW STANDS FOR BOB MARLEY AND THE WAILERS, AND NOT BECAUSE I NEED AN EXPENSIVE CAR."
Bob Marley, 1977

—

one of the few places that they could idle away the day without attracting the attention of the police.

Some took advantage of this place of safety to conduct illegal business, but by and large the grounds of Marley's home served as a sort of community center for the less fortunate of Kingston society. Marley took his role as

OPPOSITE TOP: An exterior view of the Bob Marley Museum at 56 Hope Road, Kingston, Jamaica, the singer's former home.

OPPOSITE BOTTOM: Marley (*left*) and percussionist Alvin Patterson (*right*) chat with friends after playing soccer in Trench Town, 1974.

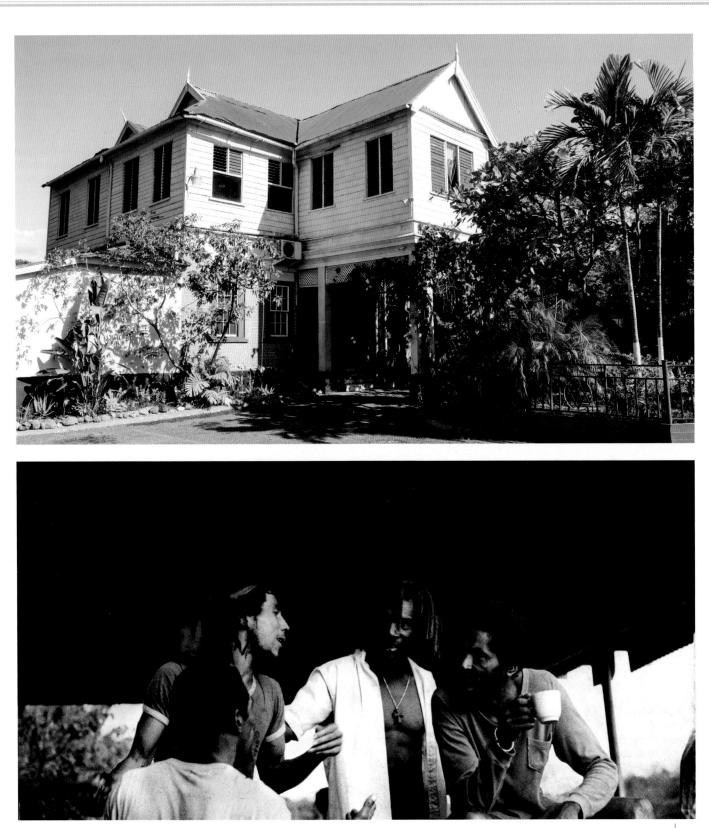

community leader seriously: sitting under an awning on the front steps of his home, he would hold "reasonings"— conversations of ideas with the doers and thinkers, the ranters and ravers. There were always queues of people asking for money from the local boy made good, and he often gave it—help with rent, or school uniforms, or some other desperate need. Some reports say he would give away as much as $40,000 on days when he was at home.

At any time of the day, there could be a soccer game or a simple kick-about in progress in the yard. Bob Marley, a man of profound spiritual and musical devotion, was fanatical about the sport. He once said, "Football is part of I. When I play, the world wakes up around me."

As visitors drifted away from Tuff Gong House at the end of each day, evenings were the time for music. Marley and friends would get together for long jam sessions, playing new songs and old, smoking and reaping the benefit of the day's goodness.

Bob's political influence extended beyond his immediate ghetto constituency. As someone who had raised not only reggae's but Jamaica's global profile, he

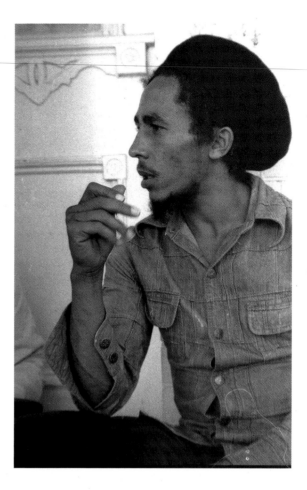

—

"WHAT IMPORTANT IS MAN SHOULD LIVE IN RIGHTEOUSNESS, IN NATURAL LOVE FOR MANKIND."
Bob Marley to *Melody Maker*, 1975

—

was a figure whose favor Jamaican politicians courted. It is said that even the prime minister of the day, Michael Manley, would pop around from Jamaica House to 56 Hope Road on occasion. Marley was in general a supporter of Manley's People's National Party (PNP), although taking sides could be dangerous in the antagonistic atmosphere of Jamaican politics in the '70s. In 1976, he agreed to play a concert called "Smile Jamaica," with the aim of promoting national unity. It was very nearly the end of him.

Because of Marley's association with the PNP, and because all such concerts had to be arranged with and approved by government offices, and because Michael Manley shrewdly called a general election within days of the announcement of the concert, it appeared as if

Bob Marley was holding a rally for the PNP's election campaign. He received death threats, and security guards were posted at the entrance to Tuff Gong House. But they were absent from their posts when, at 8:30 p.m. on the evening of December 3, 1976, a carload of heavily armed gunmen drove into the Tuff Gong yard, leaped out, and started moving through the house from room to room, firing indiscriminately.

The Wailers were rehearsing "I Shot the Sherriff" when they heard the first shots, and took refuge in the washroom; Marley had stepped out to talk with his manager Don Taylor. When one of the gunmen found them, he shot Taylor five times but fired carelessly in Marley's direction, injuring him only slightly in the chest and arm. It seems that Bob Marley was too great a national treasure to assassinate, but his wife Rita Marley was shot in the head elsewhere in the building.

OPPOSITE: Marley poses for a portrait session at 56 Hope Road, a few months prior to the attempt on his life at the property in 1976.

ABOVE: The house where Marley grew up in Trench Town, the birthplace of rocksteady and reggae music.

None of the gunmen were ever found. All three victims eventually recovered from their injuries. Bob was taken to another of Chris Blackwell's properties on the island to recuperate, and the rest of the Wailers went into hiding, fearing for their lives. Remarkably, Marley went ahead with the Smile Jamaica concert on December 5, just two days later, using members of local band Zap Pow in the absence of the Wailers. Michael Manley won the 1976 election.

Marley left Jamaica soon afterward and spent the next two years living in London. He moved back to 56 Hope Road in 1978 and gave another concert of reconciliation, this one dubbed "One Love Peace," during which he insisted that Manley and opposition leader Edward Seaga join him onstage and shake hands.

By then, Marley had already been diagnosed with the malignant cancer that would eventually end his life. He continued to play live until 1980, and after eight months of unsuccessful treatment at a clinic in Germany he determined to fly back to Hope Road to die. His condition deteriorated while he was midway across the Atlantic, however, and the plane landed in Miami, where on May 11, 1981, he died. He was given a state funeral in Kingston and buried with full Rasta ceremony at the church in Nine Mile, the shantytown where he was born.

Today, Nine Mile is a place of pilgrimage for fans and Rastafarians, while 56 Hope Road houses the Bob Marley Museum, a red, yellow, and green shrine to the man who turned the world on to reggae music, and who sang what he believed: "Let's get together and feel all right."

RIOT ON SUNSET

HEAVY METAL LIVING IN HOLLYWOOD IN THE '80S

By Bryan Reesman

Few rock groups can (or should) match the infamy of Sunset Strip rockers Mötley Crüe. From their humble, discombobulated beginnings, the rambunctious foursome was defined by debauchery, hedonism, and aggression. They wanted to fight and fuck their way through life, and their brothers-in-arms mentality kept them going when times were tough. And they were certainly rough financially when the quartet occupied the infamous "Motley House" apartment on the second floor of 1124 North Clark Street in West Hollywood, a place financed by then their manager, Allan Coffman, and located right up the street from the Whisky a Go-Go. They were at ground zero for the burgeoning Sunset Strip rock scene of the early '80s, with Gazzarri's, the Roxy, the Troubadour, Tower Records, and the famous Rainbow Bar and Grill all located within reasonable walking distance.

Originally sporting a glammy biker look that completely cut against the punk and new wave grain of the time, the four members of the Crüe—vocalist Vince Neil, bassist Nikki Sixx, guitarist Mick Mars, and drummer Tommy Lee—offered L.A. rock fans a badass alternative to the popular synth-driven sounds of the day. Their raucous music and incendiary live shows began attracting a following, and their after-parties at their rundown pad were notorious for their chaotic nature. Members of other hard rock and metal upstarts like Ratt and W.A.S.P., not mention Van Halen front man David Lee Roth, often joined the pack, and the boys in the band were going through girls fast and furious.

Based on Vince Neil recollections in the band's autobiography, *The Dirt*, it is clear that the Motley House was not a rock palace but a literal roach motel. There was a toilet they never cleaned, a refrigerator often filled with expired food, a sink with only two drinking glasses and a plate, a living room carpet stained with blood, booze, and cigarette burns, and rats crawling on the patio. Despite their rank surroundings, however, they lured people to their place the way their roach roommates scurried to any food that was immediately left out. (They used to light up the bugs with hairspray and a lighter.)

"People would pour into the house . . . for after-hours parties, either through the broken window or the warped, rotting brown front door, which would only stay closed if we folded a piece of cardboard and wedged it underneath," Neil explains in *The Dirt*. They lasted in that hellhole nine months between 1981 and 1982 before being ejected by their landlords for their destructiveness and neglect of the place. How so many women allegedly passed through its doors without being grossed out is impressive. Or maybe they just didn't care.

If this all sounds a bit far-fetched, this writer can attest that the L.A. rock scene years later was still a frenzy of hedonistic activity. I lived in a complex at the northeast corner of North Fuller Avenue and Hollywood Boulevard during the summer of 1990. My fellow longhairs were everywhere. It was common to hear

—

"PEOPLE WOULD POUR INTO THE HOUSE FOR AFTER-HOURS PARTIES, EITHER THROUGH THE BROKEN WINDOW OR THE WARPED, ROTTING BROWN FRONT DOOR."

Vince Neil, *The Dirt*

—

cranked music, weekend parties, and occasionally sex through the walls. (You didn't want to get into the public Jacuzzi.) A lot of the residents were rocker wannabes likely living on someone else's dime, while the "Rock and Roll Ralph's" supermarket two blocks down at Sunset Boulevard was frequented by senior citizens by day and rockers by night.

OPPOSITE TOP: Nikki Sixx, Mick Mars, Vince Neil, and Tommy Lee of Mötley Crüe mug for the camera in Hollywood in mid-1981.

OPPOSITE BOTTOM: A pre-fame Guns N' Roses at one of their regular Hollywood hangouts, Canter's Deli, June 1985.

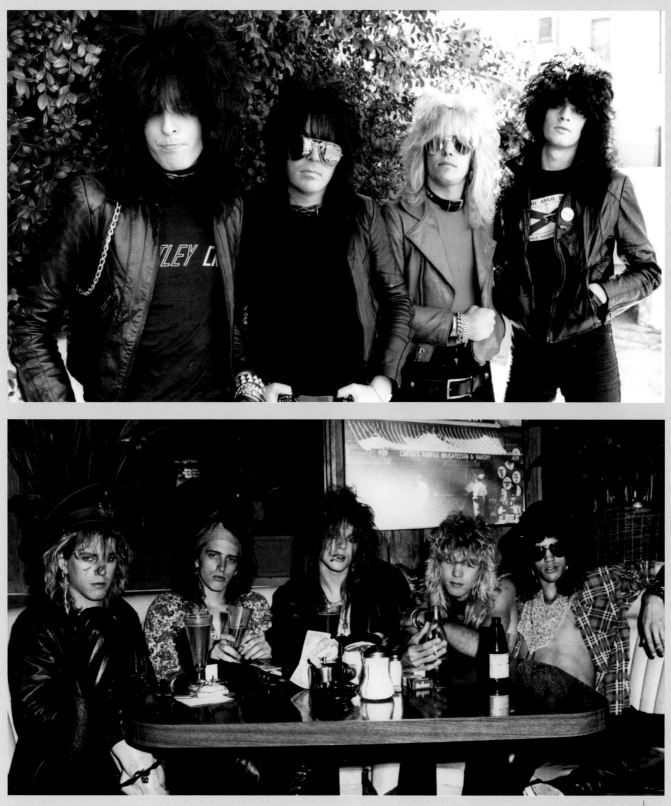

If you wanted to drive down and cruise the Strip from the Whisky to the Rainbow, you'd have to crawl through forty-five minutes of traffic, because everyone else had the same idea—to gawk at the leather- and spandex-clad dudes with towering hair escorting around their rocker girlfriends strutting along in miniskirts and stilettos. Later on, police cracked down on cruising the Strip because the traffic was overbearing. And we all know about the libidinous craziness that transpired in the clubs, particularly backstage.

Now imagine a young, hungry band like Mötley Crüe and their hyper-rock brethren invading their two-bedroom place to let loose for the night. It's no wonder the ceilings had dents from the band's use of a broom to bang back at the neighbors whose floor-thumping expressed their displeasure with their antics.

A party-hearty band that the Crüe had a solid relationship with was Ratt, who lived in a one-bedroom apartment called Ratt Mansion West in the Palms area of Culver City, south of West Hollywood. "It was close enough to the Strip because we were always there," vocalist Stephen Pearcy told me during a 2009 interview about his band's early history. "The Crüe lived there and stayed in our living room. We had parties after shows and

—

"WHEN THEY FINALLY GOT KICKED OUT, THERE WASN'T ONE THING LEFT INTACT. IT LOOKED LIKE SOMEBODY WAS REMODELING AND HAD KNOCKED DOWN THE WALLS."
Guns N' Roses producer Mike Clink on the Hell House

—

would bring 100 or 200 people back to the apartment building and piss everybody off. But nobody bothered us. If Mötley had a gig we would go see them and end up at their apartment near the Whisky. They had our camp, we had our camp, and we would meet in the middle."

Pearcy adds that the two bands would support each other at their gigs. "We were helping each other out constantly, as much as we could," he recalls. "Doug Weston at the Troubadour didn't like the name Ratt, so we had to change the name to the Gladiators, which was the name of a gang [Ratt guitarist] Robbin [Crosby], Nikki, myself, Tommy, Vince, and Mick put together when we

hung out on the Strip. We were called the Gladiators. That's how Robbin became King. I was Ratt Patrol Leader, Vince was Field Marshal, and Nikki was Nikki 'Leader' Sixx. We would trip around and raise hell. Anything went."

For those nine months at the Mötley House—and let's face it, way beyond—anything did go. The band members' antics became part of their own legend. (Although Sixx's lamenting confession that he and Tommy essentially raped a drunk friend in a closet will make you wince.) In fact, some people argue that *The Dirt* helped revive Mötley Crüe's career more than their music, especially as it came out in 2002, at a time when rock 'n' roll was sanitized and safe again.

The '80s were a hedonistic, self-absorbed time fueled by kids living in a post–sexual revolution world, and at a time when conservative forces wanted to roll back the clock to old-fashioned, judgmental morality. The loud and proud lifestyle of these Sunset Strip rockers offered a rebellious rebuttal to that notion. It's a time that may never come to pass again, and in some aspects (particularly the exploitation of women) that is a good thing. But rock 'n' roll could use some craziness and free-spirited fun again.

Likely no musical group has been more self-destructive than Guns N' Roses, the hard rock hellions with the bad attitude whose aptly titled debut, *Appetite for Destruction*, became a multi-platinum musical manifesto. Like their L.A. predecessors, Mötley Crüe, they clawed their way to the top any way possible; in GN'R's case, this meant trading in drugs and booze, using women, and escaping scrapes with the law as they chased their big break.

They were bucking the trend of the pop-slanted glam scene in Hollywood. Guns N' Roses were a darker, grittier band with an ugly side that turned the hair band circuit on its head and captivated a huge global audience. Before breaking big, the rambunctious boys of GN'R, all of whom came from outside L.A., struggled to even find housing. Slash's friend Vicky Hamilton was a booking agent interested in managing the band—she initially booked Slash and Axl Rose's bands separately before introducing them in 1984, leading the guitarist to joining Axl's pre-GN'R band Hollywood Rose—and was willing to help them out any way she could.

ABOVE: Gun N' Roses guitarist Slash with his anaconda, Clyde, in 1984. *Reptile* magazine's Phillip Samuelson would later describe Slash as "someone who had a thorough knowledge of numerous species [of snake] and their proper husbandry."

In 1985, the members of the newly formed Guns N' Roses acquired a sixteen-by-ten-foot rented space where they rehearsed, wrote songs, got trashed, and crashed. "They sold drugs and stole lumber to build a tiny loft that slept three," Paul Elliott wrote in a November 2003 *Q* magazine feature. "Somehow they existed on less than $4 per day, eating gravy and biscuits at a local Denny's and drinking potent fortified wine: tramps' choice Night Train was a particular favorite. When they threw parties, they would sometimes ransack a girl's handbag while she was in bed with one of the guys."

Slash told *Kerrang!* in June 1987 that the place had no showers and no food and likened it to a terrible prison cell. "But God, did we sound *good* in there!" he declared. "We're a really loud band and we don't compromise the volume for anything! We'd bash away with a couple of Marshalls in this tiny room, and it was cool because all the losers from Sunset and all the bands would come over and hang out there every night. We used to rehearse in there and sleep in there. It got hectic. But at least we didn't get fat and lazy. Basically, it's just down to a poverty thing—that's where that kind of 'fuck you' attitude comes from, because you're not showering, you're not getting food or nothing, you do what you have to, to *survive*."

Hamilton's loyalty was tested in mid-1985. She had been booking gigs for GN'R for a while when Slash asked if Rose could crash on her couch for a few days while he evaded the police on a rape charge that was later dropped. A few days of harboring this short-term fugitive turned into six months of craziness, with three other members (Slash, guitarist Izzy Stradlin, and drummer Steven Adler) also crashing at the place in sleeping bags and bringing with them a maelstrom of booze, drugs, girlfriends, and visits from police officers. (Bassist Duff McKagan lived elsewhere with his girlfriend.)

RIOT ON SUNSET | 141

Hamilton's willingness to help out when Axl needed it cemented her new role as the band's manager, but the one-bedroom apartment she shared with roommate Jennifer Perry was turned topsy-turvy as the boys laid

—

"OVER WHERE THEY WERE REHEARSING THEY HAD BUILT THIS LOFT AND ABOUT THREE PEOPLE COULD SLEEP THERE. APPARENTLY THEY WERE HAVING BONFIRES AT NIGHT IN THE PARKING LOT."
Former Guns N' Roses manager Vicky Hamilton

—

waste to the place. As she recounted to Matt Parry and Emma Foster of the *Daily Mail* in April 2015, "The table was always littered with drugs paraphernalia, cigarette burns. The bathroom was the worst, with black-blue hair dye all over the walls from Izzy and Slash. There was some unidentifiable slime on the bathtub. I would take a bag in the shower as I didn't want to stand there."

Hamilton served as the band's booking agent, manager, and den mother, and would drink Jack Daniels and smoke pot with them. If the guys wanted to do heroin or coke, they had to go to the roof of her building. She also had to deal with Rose's volatile temper, and had reportedly stopped him from inexplicably trying to kill Adler a day before a major music-industry showcase.

Hamilton's address, incidentally, was 1114 North Clark Street in West Hollywood—a stone's throw from the famed Whisky a Go-Go, and literally two doors down from 1124 North Clark Street, the address of the infamous Mötley House. Some areas just attract trouble.

BELOW: The marquee of the Roxy in Los Angeles, advertising an early show by Guns N' Roses in January 1986.

OPPOSITE: Axl Rose and Slash during a performance at a UCLA frat party in July 1985. The band's fee was $30 and a crate of beer.

Following a major label bidding war for the group, Hamilton landed GN'R a deal with Geffen Records in March 1986. She reportedly made little to no money from her work with the band, but was at least rewarded for her work by the label's A&R guru, Tom Zutaut, who moved her into an A&R position there after she agreed to let Geffen find the fledgling group a larger management team. Meanwhile, the band were set up with producer Mike Clink, who made a hard and fast rule of no drugs in the studio.

Naturally, the perpetually wired rockers went haywire on their own time. Clink found them a small house at 1137 North Fuller Avenue in Hollywood, which they inhabited for a few months in 1987 while they recorded their debut album, and which would become known, infamously, as "The Hell House." They ultimately left the place a shambles. "One night they locked themselves out, so they put a boulder through a window," Clink told

Elliott for his *Q* feature. "They thought it would look like somebody had robbed the place. When they finally got kicked out, there wasn't one thing left intact. It looked like somebody was remodeling and had knocked down the walls." The band's craziness with women, drugs, and partying allegedly continued at the Hell House, so the end result is not surprising.

All of that aggressive energy and creative inspiration gelled in the songwriting that led to their snarling debut album, *Appetite for Destruction*, which skyrocketed globally and transformed them into rock icons. To arrive at that place, the members of GN'R, like many of their Sunset Strip brethren, had leached off of women, created mayhem at other people's expense, and ignored the consequences of their bad behavior. It all makes for a great rock 'n' roll legend today, but few people would have ever wanted to deal with that young band in a domestic situation, as these stories grimly attest.

FREDDIE MERCURY

GARDEN LODGE, KENSINGTON, LONDON (HOME FROM 1985 TO 1991)

By Colin Salter

The house at 1 Logan Place would be unremarkable in another setting. Garden Lodge is surrounded by a small garden that would not be out of place in a well-to-do suburb of southern England. An immaculate lawn, a couple of flower beds edged in box hedging, paved paths leading to a small trellised walkway in one corner, a pond of koi carp in another, and a covered area for barbecues in the unpredictable British summer. There's a tall ash tree, a couple of ornamental cherry trees, and a fine mature wisteria along the garden wall. All very English, very middle-class, very ordinary. Can this really have been the London home of flamboyant singer Freddie Mercury?

Garden Lodge is a two-story detached Georgian brick building with white sash windows. A large bay window on the ground floor at one end of the L-shaped plan provides a balcony for the room above, from which French windows crowned with a fanlight give access. Another fanlight graces the solid-paneled front door. It's an elegant house, but there must be hundreds like it. The setting is what makes it remarkable: a detached house in its own quarter-acre of garden, in the eye-wateringly expensive heart of London's wealthy Kensington district. It's surprising that it survives at all; that it hasn't been

> **"HE SAID, 'IF THINGS HAD BEEN DIFFERENT, YOU WOULD HAVE BEEN MY WIFE AND THIS WOULD HAVE BEEN YOURS ANYWAY.'"**
> **Mary Austin to the *Daily Mail*, 2013**

demolished to make way for a high-rise condominium. Indeed, the little house is surrounded on all sides by tall Victorian apartment blocks. It's worth a fortune.

Mercury bought the house in 1985, the year of Queen's triumphant appearance at Wembley Stadium as part of the Live Aid charity concert. Queen's headlining slot at the Knebworth Festival the following year would prove to

be his last public performance, because in late 1986 or early 1987 he was diagnosed with HIV. As his health declined he gradually withdrew from public life, although he continued to record new songs with increasing urgency. In June 1991, after the filming of his last video, for "These Are the Days of Our Lives," he retreated to the security of Garden Lodge.

The Lodge was not just a London *pied à terre* for the singer, but a home. He filled it with Japanese furniture and art, of which he was a passionate collector; the koi carp in the garden were another aspect of his enthusiasm for all things Japan. He loved cats, too, and by the end of his life half a dozen of them shared Garden Lodge with him. His favorite, Delilah, was immortalized in the song of the same name on his last album, *Innuendo*.

Although Garden Lodge is overlooked by neighboring apartments, Freddie did his best to preserve his privacy. The garden wall is a towering twelve feet high—seven feet of brickwork, completely surrounding the property, extended upward a further five feet by a palisade of sharp-toothed fencing, with rotating anti-climb blades. The ugly security measures are disguised from inside by wooden panels; from outside it was clear that intruders were unwelcome. Here, Freddie Mercury spent his last days in peace; and here, on November 24, 1991, he died.

The story of Garden Lodge would not be complete without reference to the one great love of Mercury's life, his former girlfriend, Mary Austin. Although they broke up when Mercury came out to her in 1976, they remained close. Freddie bought Mary an apartment when they separated, and it was Mary who found Garden Lodge for Freddie in 1985. She was a frequent guest at Garden Lodge throughout Mercury's time there and attended him regularly during his final weeks. It was she who broke the news of his death to his family. In his will, Mercury left the bulk of his fortune, his future recording royalties, and Garden Lodge itself, to Austin. She lives there to this day.

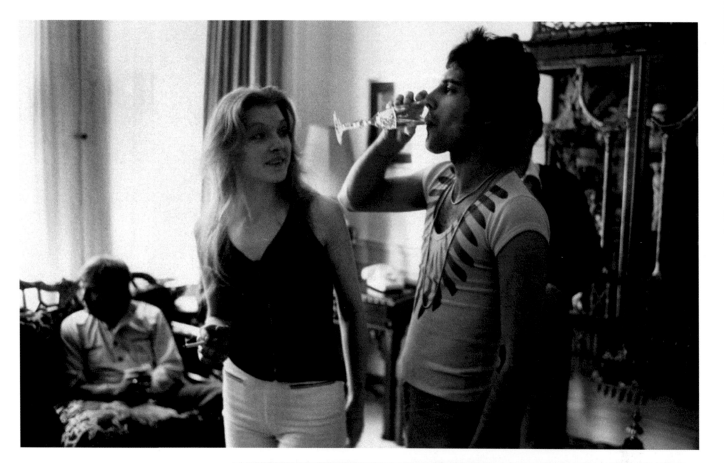

ABOVE: Freddie Mercury drinks a glass of champagne while girlfriend Mary Austin looks on during a dinner party at his London home, 1977.

RIGHT: The exterior wall of Garden Lodge today, decorated with tributes to the singer.

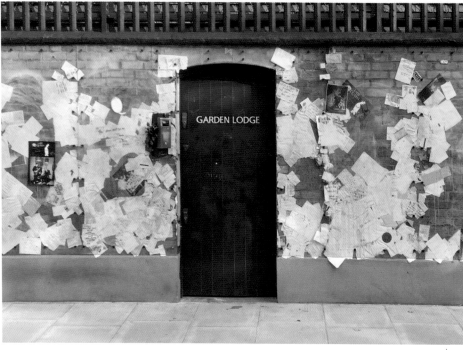

PRINCE

PAISLEY PARK, CHANHASSEN, MINNESOTA (HOME FROM 1987 TO 2016)

By Daryl Easlea

With his phenomenal, obsessive work rate, Prince needed a studio that he could use whenever the muse struck him—which, frankly, seemed to be most hours of the day, every day. With this in mind, he created a live/work/play space that would be ready for him morning, noon, and night. Whereas most artists built homes with studios in them, Prince built a studio with a home in it. Paisley Park was the bricks-and-mortar embodiment of Prince, as fabled as Graceland to Presley and Neverland to Jackson. As private estates and production complexes go, Paisley Park is unrivaled.

Unlike many global superstars, Prince chose primarily to remain in the area in which he grew up. He traveled and had great success around the globe, yet he returned to the culturally vibrant twin cities of Minneapolis and St. Paul. It was here that he was born at Mount Sinai Hospital on June 7, 1958, and here that he died in 2016, and his connection with the area courses through his work.

As the writer Nate Patrin put it in a blog post for the Red Bull Music Academy, written in the wake of the singer's death, "There's a certain deep-rooted feeling about Prince that you only know if you grew up in the same place he did: He WAS Minnesota as much as he was from Minnesota. For more than forty years, he was a lingering omnipresent part of the atmosphere in local studios and clubs—in the background or the sidelines at first, always there to fill in (and, given the opportunity, show off) with his guitar or piano or voice. He was Minnesota's permanent Artist in Residence, even at his most otherworldly."

In many respects, Prince remained unknown to the outside world, but he was very much the local megastar in his area. The city of Minneapolis is full of Prince landmarks, from Electric Fetus, the record shop he would frequent, to First Avenue, the nightclub that features heavily in *Purple Rain*, and the Capri Theater, where he played his early gigs.

Prince grew up in various properties around north Minneapolis, including a home on 8th Avenue, before moving to the house he lived in with his father after his parents' divorce, a modest clapboard property at 539 Newton Avenue. In 1977, at the age of nineteen, he moved to an apartment in Sausalito, California, to finish recording his first album, For You, but by the start of the '80s he was back on home turf, having found a house on the shores of Lake Riley in Chanhassen. The property, at 9401 Kiowa Trail, was painted purple, and it was here that Prince enjoyed the phenomenal bout of creativity that resulted in *Purple Rain*. His father moved in after he left, and would live there until his death in 2001. Prince subsequently had the building demolished; all that remains are the gates, resplendent with a "love and peace" sign.

Prince's main home through his years of fame was 7141 Galpin Boulevard, a large yellow house on a considerable patch of land near Lake Lucy and Lake Ann. Large sections of *Sign of the Times* and *The Black Album* were

—

"WHEN I OPENED PAISLEY PARK, I WAS SO EXCITED TO HAVE MY OWN STUDIO THAT I JUST STARTED RECORDING AND DIDN'T COME OUT FOR TWENTY YEARS."
Prince to MSN Music Central, 1996

—

recorded in the home studio there, with its high stained-glass window. Prince also owned a large house in the Coldwater Canyon area of Beverly Hills during this period, which he would eventually sell in 1997.

Prince's audience became aware of the name "Paisley Park" in May 1985 when it appeared as one of the key tracks on *Around the World in a Day*, his problematic

OPPOSITE: Prince and his first wife, dancer and actress Mayte Garcia, curled up together at the singer's luxury holiday home in Marbella, southern Spain, November 1999.

second album with the Revolution. With fans expecting another "black rock" opus in the style of the preceding *Purple Rain*, what they were treated to instead was an eccentric, psychedelic release that effectively quelled his superstar status. Prince established a label of the same name that year as a home for his many side productions, and it was clear by then that he also wanted to build a studio where all his dreams could be realized.

In 1983, Prince purchased land on the 8000 block of Aztec Drive in Eden Prairie, near Chanhassen. The rehearsal space he used there was the prototype for Paisley Park, but after neighbors raised concern about potential noise issues, further plans to build on the land (which Prince retained) were curtailed.

—

"HERE THERE IS SOLITUDE, SILENCE. I LIKE TO STAY IN THIS CONTROLLED ENVIRONMENT."
Prince to *Details*, 1989

—

Soon after that, Prince found a cornfield adjacent to Highway 5, west of Chanhassen, at 7801 Audubon Road. Construction began on the site in March 1986, with Bret Theony of BOTO Design brought in to work on the project. A year and $10 million later, the Paisley Park complex would incorporate windowless forty-eight-track recording and mixing studios on the main floor, where Prince recorded, produced, and mixed some of his biggest hits; a massive 12,400-square-foot soundstage and concert hall, where he rehearsed for concert tours and held exclusive, private events and concerts; and, so that he didn't have to leave the place where he lived and worked, his own private discotheque, the one-thousand-capacity NPG Music Club.

On the second floor, Prince kept a private apartment, as well as the fabled "Vault"—home to all of his myriad recordings. The front lobby of the complex resembled a Vegas shopping mall, with second floor balconies looking down, pyramid-shaped skylights, and Prince's "Love symbol" glyph painted on the floor.

The studios officially opened on September 11, 1987, although they had in fact begun operations in April of

that year. One of the first projects to make use of the soundstage was the *Sign of the Times* film, which captures the final days of the legendary tour; the studio segments were shot at Paisley Park. Over the next three decades, Prince would record (or part-record) all of his albums at the studio. It was here that he hunkered down against the world when he got into a dispute with his record company, Warner Bros., and began painting the word "Slave" on his face, and it was here too that he recorded with soul, funk, and R&B legends such as George Clinton and Mavis Staples. The compound also provided the headquarters for his NPG label, which replaced the Paisley Park imprint.

It was at Paisley Park, too, that a succession of his girlfriends took up temporary residence. When Kim Basinger walked out on Prince, he allegedly told staff not to mention her name again. She had reportedly departed in such a hurry that she left her car in his parking lot. Prince had it towed away.

Prince's life was full of spontaneous, random acts and sadly failed relationships. He would meet fans and take them for a drive around the city; he would throw impromptu parties with jams that would last well into the night. On Valentine's Day, 1996, he married backing singer Mayte Garcia, but their marriage disintegrated after they lost their child, Amiir. In 2001, he married Manuela Testolini in a private ceremony, but their union too was only to last only a handful of years.

Alongside Paisley Park, Prince maintained a sizable property portfolio. According to a 2016 report in *Variety*, he also owned several "well-maintained although hardly luxurious" homes in quiet areas of downtown Minneapolis, as well as parcels of land across the expressway from

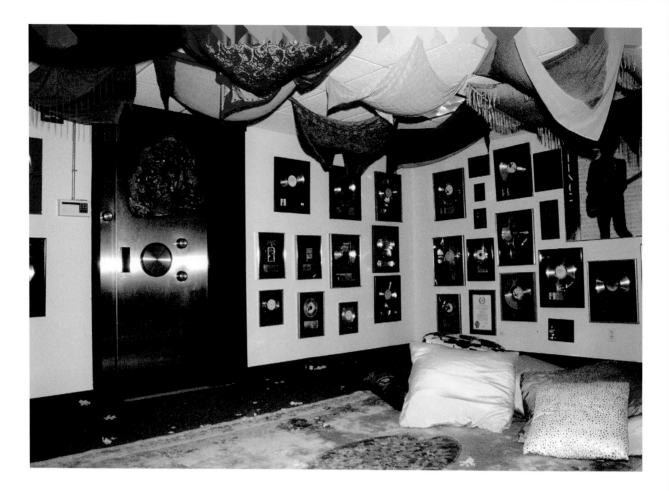

OPPOSITE: The unprepossessing exterior of Paisley Park, as seen from Highway 5, the main road through Chanhassen.

ABOVE: Prince's "Foo Foo Room," decorated with dozens of gold discs, and the door to the Vault, which held his master recordings.

Paisley Park, and a further two on the shores of Lake Riley. In 2005, he tore down a house he had lived in a mile north of the studio on Gilpin Boulevard, leaving only a tennis court and a gatehouse.

From then on—when he wasn't renting a mansion that he named 3121 at 1235 Sierra Alta Way in Los Angeles, for an alleged $70,000 per month—he took up full-time residence in the apartment on the second floor of Paisley Park. He also purchased an opulent waterfront haven on the Caribbean island of Providenciales in the Turks and Caicos. And ironically, in 2015, he bought a house with which he had long been associated but which he had never inhabited: 3420 Snelling Avenue in Longfellow, South Minneapolis, where "The Kid" lives in *Purple Rain*.

But his principal property remained Paisley Park. Prince lived, loved, and made music here, and it seems fitting, too, that he would die here. He was found dead in an elevator at his studio residence on April 21, 2016. His ashes are in an urn at the complex. To emphasize quite how central the place was to his life, the urn was designed at the request of his family by 3-D urn-makers Foreverence in the shape of Paisley Park itself.

It was always Prince's intention that one day Paisley Park would be opened to the public, and in 2017 that came to pass. Although it is very much part of his estate, the studio is now managed by Graceland Holdings, the company that runs the tourist wing of Elvis Presley's Graceland. With that, what was once so private became so public—a true sign of the times.

LAST KNOWN ABODE

THE STARS WHO DIED AT HOME

By Simon Spence

When rock stars are cut down before their time, especially in tragic circumstances, the location of their death can often become a site of pilgrimage for fans. Take, for example, Marc Bolan's fatal car crash in Barnes, London, in 1977. The tree that the twenty-nine-year-old's Mini plowed into was turned into a shrine by devotees and is now recognized by the English Tourist Board as a site of rock 'n' roll importance. Fans of the glam-rock icon still gather there annually to hold vigils on the anniversary of his death.

If such a tragedy unfurls at a young musician's home, his or her followers have a ready-made church where they can pay their last respects, often lighting candles or leaving gifts. In many instances, these gatherings will be respectful one-offs. Occasionally, though, the house becomes a mausoleum for the spirit, if not the body, of the deceased, attracting sightseers all year round and forever more.

When Nirvana figurehead Kurt Cobain took his own life in 1994, aged twenty-seven, at the home he shared with his wife, Courtney Love, the area around their luxury mansion at 171 Lake Washington Boulevard in Madrona, one of Seattle's smartest neighborhoods, was flooded with fans seeking to honor their hero. An all-night vigil was organized at Flag Pavilion, a space designated for cultural events and celebrations in the city, and attended by seven thousand mourners; Love read from Cobain's suicide note at the event and handed out items of his clothing. It didn't end there, though. Although Cobain had only bought the mansion, built in 1902, a few months before his death, in the coming months fans continued to flock to see the place where he'd pulled the trigger on himself—the living quarters above the detached garage, the so-called "carriage house," visible from the road. Black plastic tarpaulin was hung from the trees and bed sheets pulled across the windows to keep out prying eyes. The area around the house was strewn with beer cans and other trash, pools of candlewax clearly visible.

Soon, Love was paying $10,000 per month for guards and surveillance along the border of her property to keep out intruders. The garage was torn down in 1996 but fans kept coming, so a year later Love sold the four-bedroom property for close to $2.9 million—almost twice what Cobain paid for it—and moved out. Nonetheless, the tragic incident still draws people to Seattle from around the world, and they all want to see the house. The '90s grunge equivalent of the Paris tomb of '60s rock legend Jim Morrison are the benches in Viretta Park, which shares a border with Cobain's former home. So continually are they covered with messages from people making pilgrimages to the site that it now has its own Facebook page and is part of a "Stalking Seattle" guided tour.

British torch singer Amy Winehouse was another ill-fated, troubled star who passed away tragically early at her own home. And, like Cobain, she was just twenty-seven when she was found dead in bed after drinking so

—

> **"PEOPLE WOULDN'T GO UP TO HER ANY MORE, SHE WOULDN'T TALK TO PEOPLE. SHE JUST BECAME INCREASINGLY ALIENATED FROM HER OWN WORLD."**
> **Piers Hernu, journalist and friend of Amy Winehouse, 2011**

—

much alcohol that she stopped breathing in 2011. The news of her death spread quickly among fans, with thousands gathering outside her home in Camden in North London, many distraught from grief.

Only five years earlier, Winehouse had been at the height of her fame, collecting five Grammy Awards for

OPPOSITE: A selection of some of the many memorials that were left to Amy Winehouse in Camden Square, North London, just across the way from her home, following her death there in July 2011.

tracks from her twelve-million-selling album *Back to Black*. Since then, her life had spiraled out of control in a whirl of doomed romances, drug addiction, booze, and eating disorders. She had been living in the four-story, semi-detached house at 30 Camden Square for just over a year, with the paparazzi camped outside a permanent feature. Inside, the home had its own gym and music room, where it was hoped Winehouse would recapture her muse.

After her death, the mourners refused to go away, the vigil lasting days. The small strip of grass opposite her house was transformed into an unofficial shrine; various road signs were completely covered in graffiti, while four were taken by souvenir-hunters. Fans continued to visit the site for the next fifteen months, with the local council appealing to them to stop stealing the road signs; fourteen more went missing. Finally, in 2012, the house sold for £1.9 million—almost one million under the asking price, with fan interest in the site said to be a deterrent to many would-be buyers. The house remains an essential destination for sightseeing visitors to Camden, alongside such attractions as the Stables Market (where a life-size statue of the soulful songstress was unveiled in 2014) and the Electric Ballroom. For devotees, a stop-off at Winehouse's favorite Camden boozer, the Hawley Arms, is also a must.

—

"IF I COULD BRING HIM BACK, I WOULD. I WAS AFRAID OF HIM. I THOUGHT I WAS GOING TO GET HURT. I DIDN'T KNOW WHAT WAS GOING TO HAPPEN."
Marvin Gay Sr. at his sentencing, 1984

—

A mythology inevitably surrounds rock stars who die young in heartbreakingly wretched conditions, their allure as tortured artists sustaining through the generations. The posthumous interest in Ian Curtis and Marvin Gaye are both cases in point. Both died appallingly as their careers seemed to be heading for new heights, and their homes continue to be visited by ardent fans from around the world.

The small terrace house at 77 Barton Street in the unremarkable market town of Macclesfield, in Cheshire,

near Manchester, is an unlikely spot for a pilgrimage, but it was here that Joy Division founder Curtis hanged himself in 1980, aged just twenty-three. His band was about to tour the USA for the first time, and chart success with the single "Love Will Tear Us Apart" was imminent, but Curtis suffered from debilitating epilepsy and was wracked with guilt over an affair that threatened his marriage. In 2015, a self-described super-fan bought the property for £190,000 and announced controversial plans to turn it into a museum dedicated to the singer.

Motown legend Marvin Gaye was shot dead by his own father in his Los Angeles home in 1984 during an argument about a misplaced insurance policy document. Gaye was forty-four and appeared to be back on top in North America following the success of his Grammy Award–winning hit "Sexual Healing," from the album *Midnight Love*, after a period of faltering record sales and troubling financial and personal problems (depression, divorce, and cocaine addiction) that saw him briefly living in Belgium.

Marvin Gay Sr. was a cross-dressing church minister who had long had a rocky relationship with the son who, to his disgruntlement (and a result of teasing in the very early stages of his career) had added an e to the end of his surname. In the months prior to his death, Gaye was reportedly depressed and suicidal once again, and it is alleged that on one occasion he even tried to jump out of a moving car. He was also back to using cocaine and had

ABOVE: Police officers, neighbors, and fans gather in front of the house where Marvin Gaye was shot and killed in April 1984.

become increasingly paranoid, having taken to wearing a bulletproof vest after an alleged assassination attempt. Ironically, he had given the pistol that ultimately killed him to his father, to protect him from potential robbers and murderers.

Gaye was staying at the house he had bought for his parents and family in 1973 for $30,500 after a grueling US tour. He had been living at the house, 2101 South Gramercy Place in the West Adams district of Los Angeles, for six months, with the antagonism between father and son increasing throughout the period—so much so that Gaye's two sisters, who had also been living at the property, had moved out. On the night of his death, the disagreement had become physical, with Gaye kicking his father, according to his mother, who witnessed the tragic events. Gay Sr. then took the pistol and fatally shot his son in the chest. He later argued that he had done so in self-defense and claimed he did not know the gun was loaded, pleading no contest to a voluntary manslaughter charge that resulted in a six-year suspended sentence, with five years of probation.

Today, while fans of the singer gather around Gaye's star on the Hollywood Walk of Fame to pay tribute and sing songs in his honor on the anniversary of his death each year, many more still gather to remember the singer at the house where he died.

MICHAEL JACKSON

THE NEVERLAND RANCH, LOS OLIVIOS, CALIFORNIA (HOME FROM 1988 TO 2009)

By Daryl Easlea

Located around eight miles north of the town of Santa Ynez in Santa Barbara County, California, Michael Jackson's Neverland Ranch would become emblematic of the success, excess, and folly of Jackson himself. It was here that he basked at the peak of his megastardom, and here that was a cauldron for his creativity—and, sadly, the scandals that dogged his later career.

By 1988, Michael Jackson was the biggest pop star in the Western world. With all of the money that was coming his way, it was about time he had himself a proper piece of real estate. Finally moving from Hayvenhurst Avenue, where he had lived with his family since 1971, Jackson bought a property set in 2,675 acres of land at 5225 Figueroa Mountain Road. He christened it "Neverland" after the place where Peter Pan lived in his favorite book by J. M. Barrie. The fact it was named after a magical kingdom spoke volumes; it would be the perfect setting for the pop star forever frozen in adolescence, a superstar at thirteen. It was a place where the man-child phenomenon could be left alone to indulge his fantasies and dreams.

The original dream of Neverland's development was not Michael Jackson's, however, but that of its previous incumbent, property developer William Bone. After purchasing the estate—originally known as the Zaca Laderas Ranch—in 1977, he had created a large main house with various outbuildings, plus a four-acre lake with fountains and waterfalls. In building such a mansion in the heart of old cowboy country, Bone's development seemed to encapsulate all the promise and success of the American Dream. "I had a desire to express everything I had learned in fifteen years of home building," he told the *Architectural Digest* in 2009.

Bone enlisted architect Robert Altevers—a man renowned for designing some of California's finest golf clubhouses—to realize his dream, with work on the property completed in 1982. Michael Jackson first came

across the ranch the following year when he was filming the Bob Giraldi–directed promo film for "Say Say Say," his duet with Paul McCartney. Paul and his wife Linda were staying at the Sycamore Valley Ranch, as Bone called it, for the duration of the filming; Jackson stayed there too and expressed the wish to one day own it. Five years later, his wish came true. After protracted negotiations, he purchased the estate from Bone for $30 million.

Although he would very much put his own spin on the property, Jackson retained the interiors Altevers had designed for Bone. Neverland became the greatest single manifestation of the scale of Jackson's success, a larger-than-life metaphor for Jackson himself with its statues, cinema, dance studio, floral clock, zoo, own railway lines and stations—and, of course, the element that all the press would come to focus on: the funfair. The fair had a Ferris wheel, rollercoaster, bumper cars, and carousel, as well as an amusement arcade. The master bedroom

"EVERYTHING THAT I LOVE IS BEHIND THOSE GATES. WE HAVE ELEPHANTS, AND GIRAFFES, AND CROCODILES, AND EVERY KIND OF TIGERS AND LIONS."
Michael Jackson to CBS News, 2003

had a secret safe room, and the property was dotted with Jackson's opulent art collection. The upkeep of the house and grounds alone worked out at $5 million per year.

Jackson's eccentric existence on the ranch became a matter of great speculation throughout the '80s and '90s. Living with Bubbles the chimpanzee and Muscles the boa constrictor, Jackson took friends and family on tours of his amusement park, including Macaulay Culkin and

OPPOSITE: An aerial view of the miniature railway station at the Neverland Ranch in Los Olivios, California—a close replica of the one at Disneyland, a few hours down the coast in Anaheim.

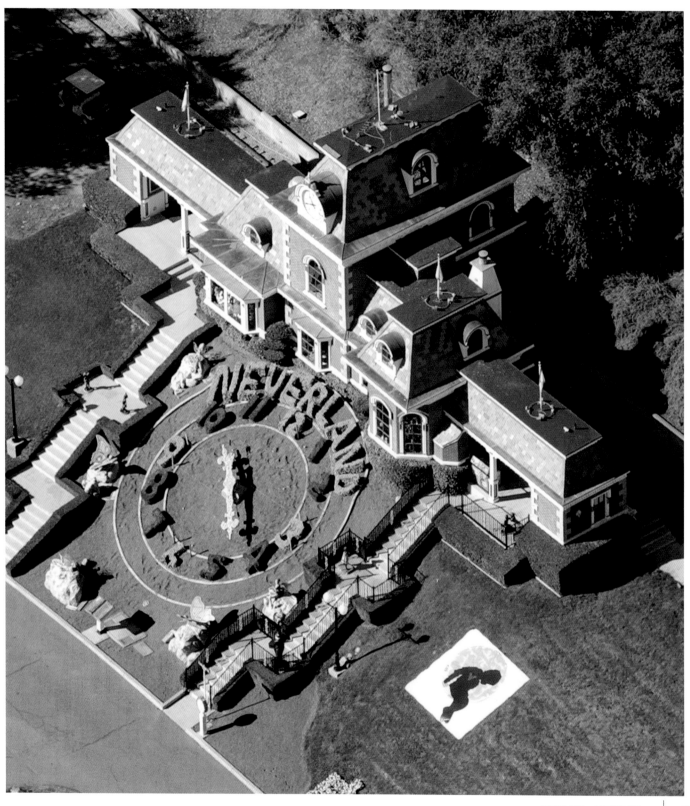

Jordan Chandler (who would later accuse Jackson of sexual abuse). Kim Kardashian enjoyed her fourteenth birthday at Neverland, and it was here that Jackson lived with Lisa Marie Presley during their brief marriage, while his close friend Elizabeth Taylor married Larry

—

"NEVERLAND APPEALS TO THE CHILD INSIDE OF EVERY MAN, WOMAN AND CHILD. IT'S A PLACE WHERE I FEEL THAT YOU CAN RETURN TO YOUR CHILDHOOD."
Michael Jackson, 2003

—

Fortensky— her seventh husband—in a gazebo on the grounds in October 1991. It was here too that Jackson's children—Paris, Prince, and Blanket—grew up.

Neverland was also the principal setting for *Living with Michael Jackson*, the singer's notorious TV interview with journalist Martin Bashir. Shown on ITV in the UK and ABC in the USA in February 2003, it had a seismic effect on the already fragile Jackson. In the style of the early 2000s fly-on-the-wall documentaries, Bashir followed Jackson around as he went about his business. He is shown shopping, at the zoo, even racing Bashir on the racetrack at Neverland. In one key scene, Jackson introduces the Arvizo children, who had been staying at Neverland; one of them, Gavin, was filmed with Jackson while talking about his recovery from cancer. In the context of his relationship with the boy, Jackson tells Bashir, "The most loving thing you can do is to share your bed with someone."

BELOW: Part of the playground at Neverland. Many of the rides were designed and built to Jackson's precise specifications.

OPPOSITE: "Triptych" by David Nordahl, one of a number of idiosyncratic works that Jackson had on display at Neverland.

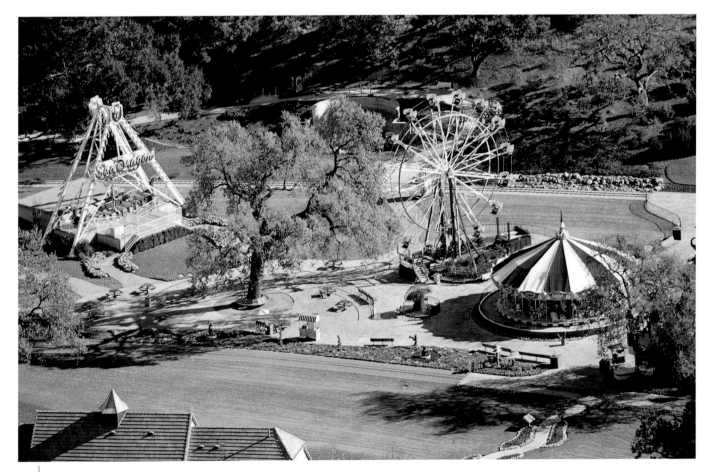

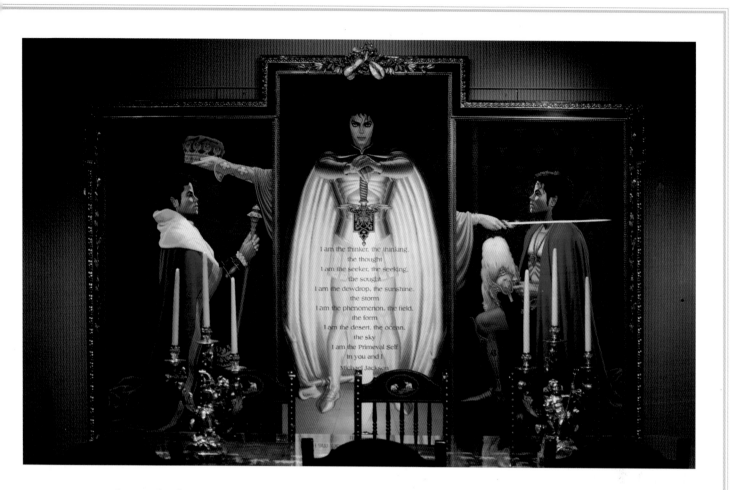

I am the thinker, the thinking,
the thought
I am the seeker, the seeking,
the sought
I am the dewdrop, the sunshine,
the storm
I am the phenomenon, the field,
the form
I am the desert, the ocean,
the sky
I am the Primeval Self
In you and I

Michael Jackson

Within months, the Arvizo family had brought legal proceedings against Jackson. Officers from the Santa Barbara County Sheriff's Office conducted a search of Neverland Ranch, and speculation exploded across the media. As warrants for his arrest were being prepared, on November 20, 2003, Jackson flew in from Las Vegas and surrendered himself to the police. He was charged under section 288(a) of California Penal Code with "lewd or lascivious acts" with a child younger than fourteen. He posted $3 million bail.

Police officers searched Neverland extensively as part of the trial, which began in June 2005. Although Jackson was acquitted, he stated that he couldn't live at the property again as he felt it had been violated. And after the trial came to its conclusion, it was as if he simply disappeared into thin air.

In 2006, the facilities at Neverland were closed and most of its staff dismissed. Jackson was to live a transient,

nomadic existence for the remaining years of his life, spending time in Ireland, Bahrain, Las Vegas, and ultimately at 100 North Carolwood Drive in the Holmby Hills area of Los Angeles. It was from here on Thursday, June 25, 2009, that Jackson made his final journey to the Ronald Reagan UCLA Medical Center.

Rumors that Jackson was to be buried at Neverland were unfounded. Although he retained the majority stake in the property, in the years prior to his passing he had refinanced Neverland several times. In 2013, Jackson's daughter Paris looked to renovate the house, which had become derelict in the years since. Rivaled only by Graceland and Paisley Park in pop for being so inextricably linked with its owners, Neverland—or as it is once again now known, Sycamore Valley Ranch—is today owned by the singer's estate, although efforts have been made to sell it in recent years, first for $100 million and since early 2017 at a reduced price of $67 million.

MUSICAL PLAYGROUNDS

WHEN A MERE HOME ISN'T ENOUGH . . .

By Eddi Fiegel

When it comes to buying homes, the rules are different for celebrities. For a start, the usual budget constraints experienced by mere mortals don't apply, and secondly, there's a whole list of other criteria. It's almost a given that the estate will include at least one and a half acres, so as to comfortably accommodate a house the size of a small hotel, a swimming pool, a guest house for visitors, tennis courts, and, of course, extensive gardens. Most stars also agree that a walk-in wardrobe the size of a ballroom is an absolute must. Beyond that, it's all a matter of personal taste, and the choices are infinite—from the historic country pile to state-of-the-art minimalist mansions and water parks.

For Sting and his wife Trudie Styler, when it came to choosing their British home, they took the traditional route, albeit on a lavish scale, buying Lake House, a sixteenth-century manor house in Wiltshire, South West England. The house featured Gothic Revival stone fireplaces, leaded windows, and a barrel-vaulted dining hall, which Sting transformed into a recording studio, liberally sprinkled with guitars, flutes, and lutes, as well as a spinet that once belonged to Samuel Pepys. The estate also included some sixty acres of rolling hills, water meadows, and streams, and in a kind of millionaire's version of *The Good Life*, the couple installed an organic vegetable garden, as well as goats, cows, and beehives in the grounds.

An interest in sustainability seems to have been less of a priority for Kanye West and wife Kim Kardashian. In August 2014, the couple paid $20 million for a vast mansion complete with its own vineyard in Hidden Hills, a gated community in Los Angeles County whose past residents have included Britney Spears, LeAnn Rimes, and Sharon and Ozzy Osbourne. Whoever your neighbors are, however, you wouldn't want them too close. To avoid being overlooked or disturbed, Kanye and Kim spent a further $2 million buying the house next door. Covering some twenty thousand square feet, the property, which was once owned by Lisa Marie Presley, is now said to include an indoor cinema, a sound studio, two-story playroom, hair salon, and spa.

Hair salons and spas seem relatively modest, meanwhile, in comparison with Céline Dion, whose six-acre home in Jupiter Island, Florida, sprawls along a four-hundred-foot stretch of private beach on the Atlantic coast. The house includes eight bedrooms, a children's play house, and a rec room complete with arcade games, while in the grounds there are tennis, basketball, and croquet courts, a simulated golf range, and a manmade beach—just in case the real one is too

—

"I'M WORKING WITH FIVE ARCHITECTS AT A TIME. THE TIME SPENT IN A BAD APARTMENT, I CAN'T GET THAT BACK. BUT THE EDUCATION I CAN GET FROM WORKING ON IT IS PRICELESS."
Kanye West to BBC Radio 1, 2013

—

far. There's also a moat-style pool that snakes around the house, complete with theme park–style water slides, bridges, and pergolas.

When it comes to building theme parks, though, Dolly Parton must surely take the crown. At Dollywood in the foothills of Tennessee's Smoky Mountains, Dolly created a family-friendly theme park extravaganza where visitors can see replicas of her childhood homes. Elsewhere, there are funfair rides, a "Dollywood Express" steam engine, and a chapel dedicated to the doctor who delivered country's biggest star.

OPPOSITE TOP: Sting relaxes in a hammock at Lake House, his sixteenth-century manor house set in the Wiltshire countryside.

OPPOSITE BOTTOM: Work on Céline Dion's six-acre water-park home in Jupiter Island, Florida, took almost a decade to complete.

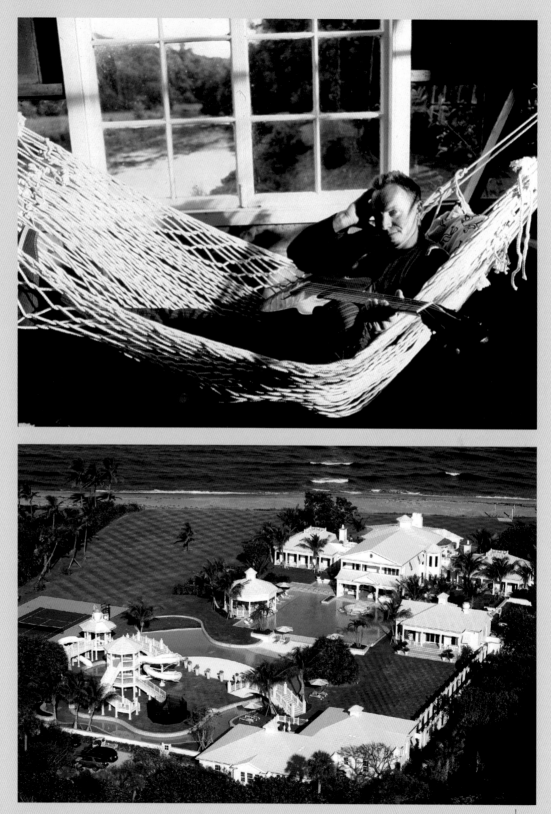

NOEL GALLAGHER

SUPERNOVA HEIGHTS, PRIMROSE HILL, LONDON (HOME FROM 1997 TO 1999)

By Simon Spence

It's rare for bricks and mortar to represent the apex and fall of an era as presciently as 9 Steele's Road. When he moved in with his soon-to-be wife, party girl Meg Matthews, in April 1997, Noel Gallagher and his band, Oasis, were at the very height of their fame, and the new home perfectly reflected the success and bacchanalian excess of the period. The semi-detached, five-story, four-bed property, situated at the Belsize Park end of ultra-fashionable Primrose Hill, cost him £300,000, and in suitably hubristic fashion he dubbed his new home "Supernova Heights" after "Champagne Supernova," the seven-minute anthem that closed Oasis's 1995 album *(What's the Story) Morning Glory?* At the time, Gallagher, who portrayed himself as an unsophisticated football-mad "lad" of the people, could not put a figure on his newfound wealth, telling the press he just knew he had "bucket loads" of cash.

Gallagher emblazoned the name of his new house, in frosted glass, above the front door, large enough to be seen from the street, where there was forever a small army of fans camped. There were even plans to hoist an Oasis flag from the roof, to be lowered to half-mast whenever he and Matthews weren't in. The interior was designed by Darren Gayer, then twenty-seven, who had been introduced to Gallagher and Matthews by their close friend, the supermodel Kate Moss—the figurehead of their close-knit, hedonistic, celebrity circle, dubbed the "Primrose Hill set," as Britpop evolved from a musical movement into a cultural one dubbed "Cool Britannia."

Britpop was '60s-fixated, and Gayer filled every room with appropriately groovy, retro paraphernalia, which included leopard-skin sofas and pink leather chairs, with psychedelic bubble-pattern carpets. In the main bathroom there was a giant circular Jacuzzi lined with expensive mosaic tiles in the fashion of the famous red, white, and blue Mod target logo. In the living room, the central feature was a fourteen-foot, three-and-a-half-ton fish tank. Noel would later reflect that the house was "like a bad advert for drugs."

Supernova Heights quickly became renowned for outrageous, star-studded parties that stretched on for weeks to the delight of the ever-present waiting paparazzi. Incidents stacked up—one of the Charlatans broke his leg falling down the limestone, floating staircase—and gossip swirled. British bad-boy actor Danny Dyer recalled the drugs being plentiful, "like the last days of Rome—with charlie [cocaine]."

For Gallagher, Supernova Heights was an unabashed symbol of achievement, the decadent lifestyle of the Primrose Hill set reflective of the transformative success of Oasis as he lived out his classic rock-star fantasies. He built a full-fledged recording studio on the top floor of the house, which allowed him endless time to tinker, as well as commanding views of central London. It was a long, long way from his childhood in a small council house with no carpets in a poor, grubby suburban district of Manchester. But just as his drunken guests and the ever-present fans and photographers upset his neighbors, there was disquiet too among members of the media, who called out Gallagher for his excess and debauchery, and a lifestyle that conflicted acutely with the "working-class hero" status he projected.

Gallagher saw the backlash coming, and when he returned from touring in 1999 to find Supernova Heights transformed from his home into a nightclub full of people he barely knew, he decided to make radical changes to save himself, at least. He gave up cocaine and in 1999 sold Supernova Heights for a reported £2.5 million, before moving with Matthews to the quiet of the Buckinghamshire countryside.

OPPOSITE: Noel Gallagher and Meg Matthews in the kitchen of their home in Primrose Hill, London, in the late 1990s. "I love Liam," he once said of his brother and bandmate, "but not as much as I love Pot Noodles."

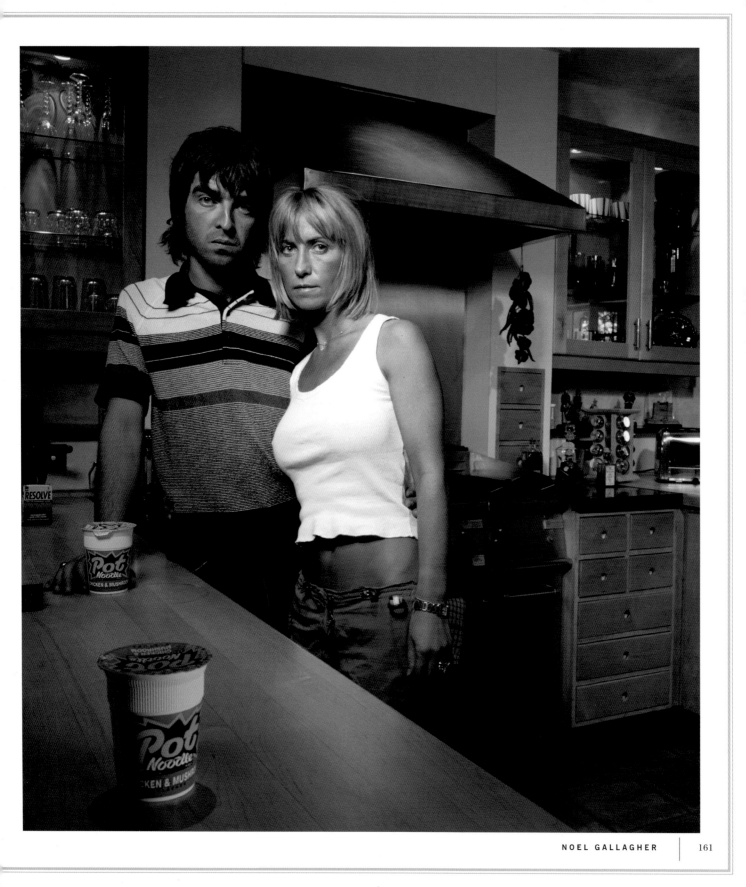

NOEL GALLAGHER | 161

MYSTERIOUS & SPOOKY

HEAVY METAL COLLECTORS

By Bryan Reesman

Many rock stars spend their riches on extravagant homes, sleek cars, and cool instruments. Others like to indulge in collecting pieces of art that express who they are and what they love in a different way. And some rockers very specifically possess a passion for acquiring horror and sci-fi items because of their fascination with the mysterious, otherworldly, and spooky.

Metallica guitarist Kirk Hammett's lifelong horror and sci-fi fetish turned into a collecting obsession after he began acquiring his first horror movie posters in 1987. As he told Kory Grow of *Rolling Stone* in August 2017, his love of poster art transformed into something serious after he purchased an original *Bride of Frankenstein* half-sheet.

"When the thing arrived at my house, it was an eye-opening moment because it *truly* turned my head around because of how cool it was—the graphics, the smell of it, the patina of age," said Hammett. "Not to mention that it was also one of my favorite horror movies of all time. I put the poster up on a huge pedestal and I just started buying all the older stuff. Now I have an amazing collection that I want to share with the world."

That assemblage has become massive and taken up sizable space in his four-bedroom Sea Cliff mansion in San Francisco, which he bought in 2005 for $5.7 million, and which was recently on the market for $13 million. After so many years of accruing these items, he sought to share them with the world. His exhibit at the Peabody Essex Museum in Salem, Massachusetts, *It's Alive! Classic Horror and Sci-Fi Art from the Kirk Hammett Collection*, ran from August to November 2017 and featured 135 pieces from his personal collection, including vintage movie posters, lobby cards, and placards, as well as numerous movie props and horror-themed guitars he has played over the years. His 2012 book *Too Much Horror Business* showcases the more than three hundred items he has on display in his Bay

Area home. He even owns a backup mask from the *Donnie Darko* bunny suit. The man takes scary seriously.

Hammett adores vintage horror from the 1920s through the 1980s, as the Salem exhibit proved. The variety was great: a Swedish *Mummy* poster, an old issue of *Creepy* magazine, a *Creature from the Black Lagoon* mask, a vintage Boris Karloff movie suit, classic *Alien* and *Star Wars* posters, and a black-and-white photo from the 1950s of an American family in a well-stocked bomb shelter. His collection was put on display in a linear way that indicated themes running through his purchases.

Fellow horror maven Rob Zombie has fashioned a career out of fear, from music to movies to comic books, so it's only natural that the metal front man would have his own assemblage of creepy artifacts. They are on display at his fifteen-thousand-square foot home in the Hollywood Hills, which he purchased in 2016 for $2.5 million.

—

"BECAUSE OF THE CULTURAL HISTORY THAT LIVES INSIDE MY COLLECTION, THE WORLD *NEEDS* TO SEE IT."
Kirk Hammett to *Rolling Stone*, 2017

—

While his 1950s house has a modern Gothic vibe to it, the real dark side is contained in the basement. While Zombie's hair-raising assortment includes various horror movie posters, busts, and action figures of everyone from Dracula to Frankenstein to Boo Berry, he also has props from each of his films encased in glass. Since 2003, he has directed six feature films: *The House of 1,000 Corpses*, *The Devil's Rejects*, the *Halloween* I and II reboots, *The Lords of Salem*, and *31*. He also created a faux trailer for *Werewolf Women of the S.S.* for the original release of

OPPOSITE: A life-size figure of Boris Karloff takes center stage amid examples from Kirk Hammett's collection of horror movie posters on display in Salem, Massachusetts, in 2017.

Quentin Tarantino's *Grindhouse*. All of those efforts are represented in his maniacal menagerie.

Zombie told horror streaming service Shudder that his most recent films have greater representation; as he goes back in his cinematic catalog, he holds on to less. It's a ghoulish display that features such items as the Michael Myers masks, severed victims' heads, and various knives fake and real from his *Halloween* movies; Dr. Satan's appliances and the Professor's creepy suit from *The House of 1,000 Corpses*; and various props from *The Lords of Salem*.

Although Corey Taylor performs with the raging metal band Slipknot, who are known for wearing sinister masks onstage, the singer has a big movie and memorabilia collection that is not solely fear-inspired. His extensive home video library includes many shelves of horror, sci-fi, and superhero titles, among others. In a June 2017 story for the *Des Moines Register*, reporter Matthew Leimkuehler proclaimed Taylor to be "Iowa's biggest geek." In his wrap-up, Leimkuehler stated, "His stash of DVDs, comics, pop culture memorabilia, and action figures easily reach the thousands; it's grown so hearty that Taylor uses a list-keeping application on his iPhone to ensure he doesn't buy doubles."

—

"I GREW UP WITHOUT A DAD, SO I WAS DESPERATELY LOOKING FOR A SENSE OF GOOD AND BAD. I FOUND IT IN MY COMICS."
Corey Taylor, 2012

—

Taylor himself wrote a four-issue comic book entitled *House of Gold and Bones*. The series was released in 2013 following the two-part album release of the same name. There were rumors of a film adaptation, too, but nothing has surfaced.

In a 2017 interview with TeamRock.com, Taylor stated that music, comics, and action figures are the only things he traces back to his ten-year-old self; they are, he says, the pleasant childhood memories he prefers to recall, rather than the darker times he experienced. "It's easier to look in the rear-view mirror at all the times I drive back to Iowa to mom and pop's back rooms trying to look for

ABOVE: The man in the mask: Slipknot founder and devoted comic-book fan turned author Corey Taylor.

OPPOSITE: Musician-turned-film-director Rob Zombie in his basement studio, 2007, with props from his *Halloween* remake.

comic books and action figures," he told reporter Ali Cooper. Taylor's toy stash includes Iron Maiden action figures, the full collection of Sex Pistols Kubrick figures, and an Ozzy Osbourne *Bark at the Moon* action figure. He also owns and plays a Spider-Man pinball machine and a sit-down Pac-Man arcade game.

When I spoke with him about his six favorite comic-book characters for my blog, Attention Deficit Delirium, back in 2012, Taylor acknowledged Spider-Man as one, saying, "I find myself going back to the '70s and '80s archetype of Spider-Man and Peter Parker, the guy who I grew up with, the guy who always had his back against the wall and always was ready to do the right thing, but at the end of the day he almost always got screwed. But he always did his best to get it done, and I'm still glad that I had that to grow up with. I grew up without a dad, so I was desperately looking for a sense of good and bad. I found it in my comics, and I found it in *Spider-Man*."

It's no wonder that Taylor, now a father himself, has made Spidey part of his home. It illuminates why many art and media collectors surround themselves with the things they love. They are comfort food for the soul.

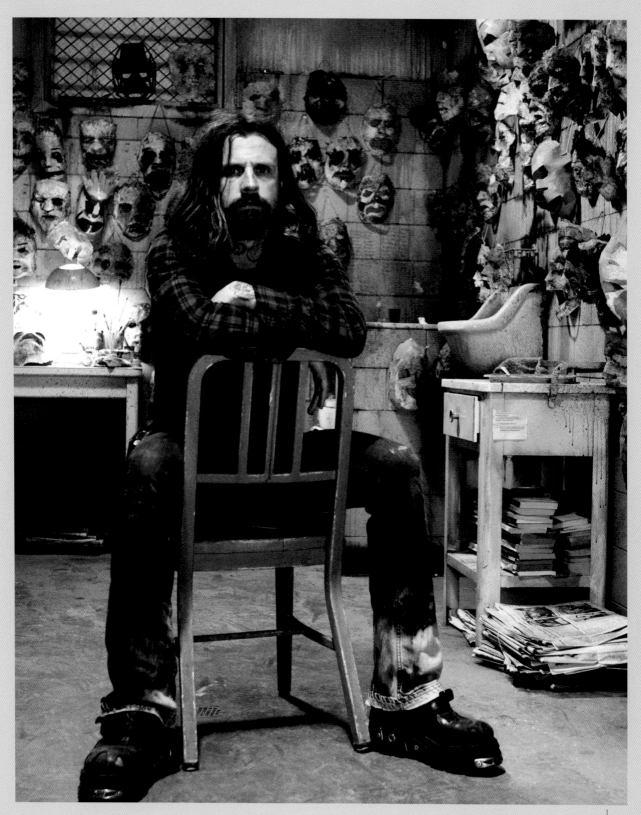

OZZY & SHARON OSBOURNE

513 DOHENY DRIVE, BEVERLY HILLS, CALIFORNIA (HOME FROM 1999 TO 2007)

By Bryan Reesman

In Bowling for Soup's rendition of the SR-71 song "1985," the band memorably asks, "When did Mötley Crüe become classic rock? / And when did Ozzy become an actor? / Please make this stop."

Back when the reality show *The Osbournes* debuted on MTV in March 2001, no one knew what to expect. But infamous heavy metal front man Ozzy Osbourne—known for antics like biting the head off a bat onstage, peeing on the Alamo, and even snorting a line of ants—was about to undergo a cute and cuddly transformation, effectively obliterating a decades-long image as the crazed, sinister figure who enraged Christian groups and enamored his fans.

Ten months earlier, Mötley Crüe had unleashed their no-holds-barred, tell-all book *The Dirt*, which helped solidify their bad-boy image to multiple generations of fans. *The Osbournes* would go the opposite route, making Ozzy, his wife Sharon, and two of their teenagers, Jack and Kelly, palatable to the mainstream. For four seasons, video cameras shot footage at the family's six-bedroom, nine-bathroom Mediterranean-style mansion at 513 Doheny Drive in Beverly Hills, capturing the lunacy within the family confines (along with a few likely staged scenarios).

The pioneering series—the first of its kind that led to a slew of copycats that continues to this day—took place during a lull between Ozzy's studio albums. *Down to Earth* had come out in 2001, and his 2005 covers album *Under Cover* followed after the series had ended. He was still touring solo (2002–2003) and with Black Sabbath (2004) during the summer months with Ozzfest, but the reality series focused more on behind-the-scenes offstage drama and the domesticity that the singer had fallen into.

According to a 2007 story in *Variety*, Ozzy and Sharon had purchased their Hollywood home in 1999 for $3.9 million. "Clearly they've put a few million into customizing and decorating the place with crucifixes, crying angels, depressing Biblical scenes, and other religious paraphernalia," reporter Mark David noted. Despite those Gothic trappings, the house portrayed on the show had a peaceful vibe about it, and the family clearly was not wanting for anything. The many tasteful furnishings clearly came from Sharon and/or a good interior decorator.

By the time the show had ended, practically every inch of that house, along with so many aspects of their lives, had been explored in-depth. However, eldest daughter Aimee, who was eighteen when the show began and has since been developing a synth-pop career, refused to be a part of the televised circus. Outvoted by the family on whether to do the show, she moved out before any of her life could be documented on MTV.

The tone of the series is set immediately by opening and end credits and interstitials that invoke 1950s family

—

"WHEN THE FILMING ENDED, I'D GO IN MY LITTLE BUNKER AND SMOKE A PIPE AND DRINK ABOUT A CASE OF BEER EVERY DAY."

Ozzy Osbourne, 2009

—

sitcoms, with a swing version of Ozzy's "Crazy Train" serving as the theme song. Many scenes in the series were accompanied by swing or classical music rather than the thunderous rock or metal one might expect. That's not a bad thing, but it is clear that MTV wanted to juxtapose the music and images to humorously ironic effect.

OPPOSITE: Ozzy Osbourne shows off his collection of firearms in 1996. "I keep hearing this fucking thing that guns don't kill people, but people kill people," he later said. "If that's the case, why do we give people guns when they go to war?"

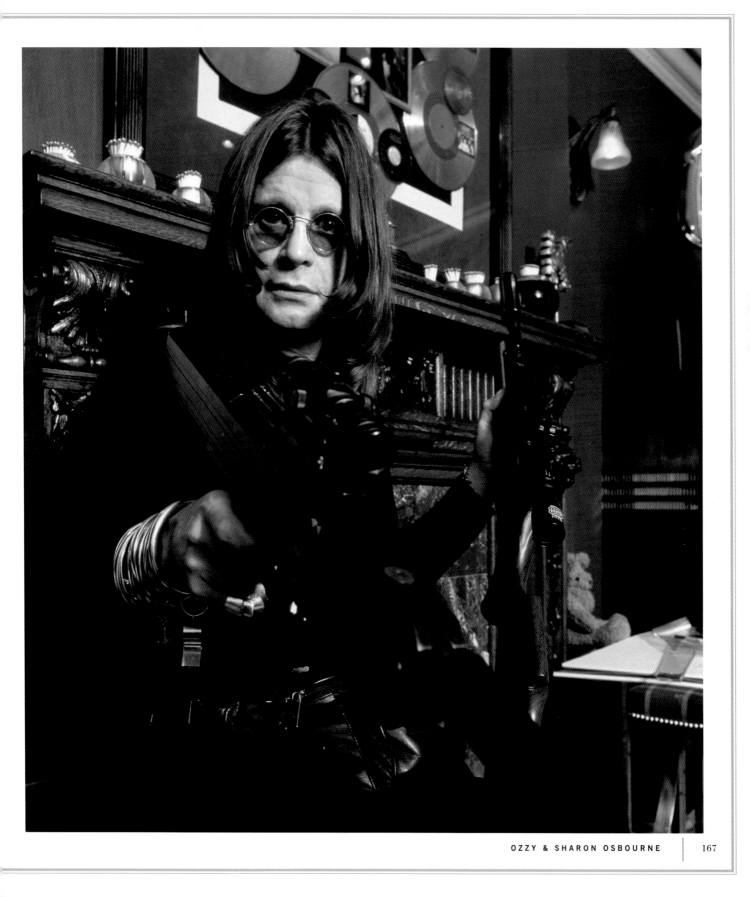

The Osbournes definitely counterbalanced the upscale mansion environment with the family's unconventional style and occasional communication breakdown—Ozzy's often slurred ramblings, Sharon's dirty humor, the kids' rebelliousness, and their parents' bickering. In one episode, everyone but Ozzy is kept up by their neighbors singing the goofy American spiritual "The Whole World in His Hands" late at night, which leads to an expletive-

—

"I SUPPOSE THERE ARE PEOPLE WHO IMAGINE ME GOING TO MY BAVARIAN CASTLE AND HANGING UPSIDE DOWN FROM THE FUCKING RAFTERS EVERY NIGHT."
Ozzy Osbourne, 2010

—

laden, food-tossing, Meshuggah-blasting showdown from the clan. In another, Ozzy crashes an ATV and recuperates in a neck brace.

Sharon's battles with colon cancer in the second season generated viewer empathy. Oftentimes, the clan's shenanigans seemed to emulate those of plenty of other dysfunctional families. Well, rich ones, at least. To many people, such "normalization" made Ozzy (the "Prince of Fucking Darkness") look like the lame duck in the family. To others, it was endearing.

When I interviewed Ozzy for *Inked* magazine in mid-2010, he confessed to me that he had never watched the show and was not so keen on being on television. He was focused on his music. Naturally, the MTV series presented a more family-friendly side to the man. "I suppose there are people who imagine me going to my Bavarian castle and hanging upside down from the fucking rafters every night," Ozzy told me. "I'm just a guy, man, I'm just a crazy guy who started a merry-go-round ride many years ago, and I'm still here. I haven't tried to analyze things."

While Ozzy was often seen getting into shape with a trainer on the show, his life off-camera was markedly different. In a 2009 interview with Rick Fulton for the *Daily Mail*, he admitted he was stoned daily during production. "When the filming ended, I'd go in my little bunker and smoke a pipe and drink about a case of beer every day," he said. "I'd give myself some goodness and get up early in the morning and go jogging for six miles." He also admitted to using "a lot of prescription drugs" as well.

The show also took a toll on Ozzy's children, both of whom went into rehab. In a late-2013 interview on *The Graham Norton Show* in the UK, Sharon lamented having done the show. "We both worked to continue a lifestyle we had become accustomed to, and we had to travel so my kids spent quite a time away from us, and you can never get that time back," she told Norton. "It was the biggest mistake I ever did, but would I have wanted to live a lesser life? You make the most of what you have. I don't know how, but Jack and Kelly came out just great."

BELOW LEFT: The Beverly Hills home where *The Osbournes* was filmed, as later purchased by pop singer Christina Aguilera.

BELOW RIGHT: Kelly, Jack, and Ozzy in a still from *The Osbournes*. Many of the show's most famous scenes were later revealed to be staged.

ABOVE: Sharon and Ozzy Osbourne with their children Jack, Kelly, and Aimee, at their Georgian mansion home in Amersham, Buckinghamshire, in March 1986.

"One of the downsides of the *Osbournes* reality show was that my kids at a very early age started getting involved in drugs and alcohol," Ozzy told me in 2010. "My son has had more clean time than I've had, and my daughter's doing really well. Unfortunately, it's what goes on now. People don't think it's as dangerous anymore. It still is dangerous, but people expect it more now." Osbourne himself relapsed into his addictions during that time. When I spoke with him, he sounded far more lucid than he had on the show.

The Osbournes became the classic "be careful what you wish for" scenario. But the family did become household names thanks to the show, and certainly profited from it. Jack got into music management; Kelly had a brief pop career before finding steadier work on fashion-oriented TV shows like *Project Runway*; and Sharon appeared regularly on reality and talent competition shows, before landing her current host seat on *The Talk*.

Ironically, after their kids flew the bat's lair, the Osbournes sold the home to Christina Aguilera in 2007 for $11.5 million. The pop diva then transformed the home's Gothic vibe into a glam one. Once again, the house was going through changes.

COLORFULLY
ENHANCED CRIBS

WHERE THE MAGIC HAPPENS

By Bryan Reesman

The hedonistic and luxurious lifestyle of rock stars is a mythology unto itself—a fantasy that many people dream about but few get to live. When producers at MTV set about developing the show *Cribs*, they knew that music fans were eager to see how rock and pop royalty lived and spent their hard-earned cash, and they delivered the goods. Running from 2000 to 2011 (before being revived via Snapchat Discover in June 2017), *Cribs* became the *Lifestyles of the Rich and Famous* for the youth of the new millennium.

For a majority of the celebrities displaying their homes, excess was the name of the game. Mariah Carey's Manhattan penthouse had an art deco feel, extravagant furnishings, and a view of the Empire State Building. Her lingerie closet and shoe room were each probably the size of an ordinary person's bedroom. Richard Branson's seventy-four-acre Necker Island in the British Virgin Islands—home to an estate that featured ten bedrooms and ten bathrooms, a large rock, and waterfalls—was a paradise stunner. He built it up gradually, he said, from profits of each new hit single from his Virgin Records label starting when he was twenty-four. (Mariah Carey was lounging about in his Balinese spa near "the great house.")

Tommy Lee and Pamela Anderson's place was all about living loud—a giant bedroom (the "Love Space") with an open shower visible from all vantage points, a kitchen shark tank, a screening room made of purple velvet, and a giant basement dance space dubbed "Club Mayhem." (There are so many examples of luxury overdrive from this series that it would run much longer than this feature.)

The craziest *Cribs* setup belonged to Lil' Romeo, the twelve-year-old son of rap legend Master P. Yes, that's

right, he was twelve. Behind his parents' house in Sugarland, Texas, the pint-sized rapper had his own abode: four bedrooms, six bathrooms, a small pool, recording studio, vintage arcade collection, screening room, built-in aquarium, and his own car, which he clearly could not drive. How anyone could grow up normal living like that is unclear.

Given the fact that MTV was an early purveyor of modern reality TV, the network and its subjects shrewdly knew they would need to *embellish* to make them more palatable to the vicarious needs of the masses. It seemed only natural that some of the episodes of *Cribs* would be accessorily enhanced—after all, producers on MTV's *The Real World* had reportedly coaxed drama out of some of

—

"I THINK EVERYBODY WANTS TO SEE WHAT OTHER PEOPLE HAVE. I THINK IT'S A REAL FANTASY ELEMENT OF, YOU KNOW, 'IF I HAD THAT MUCH MONEY, IF I WAS THAT SUCCESSFUL, WOULD I DO STUFF LIKE THAT?'"
Cribs executive producer David Sirulnick to ABC News, 2002

—

their subjects, while many of the revamped cars on the network's *Pimp My Ride* did not last very long after they were souped up.

The first *Cribs* deception occurred during the debut episode, when pop star Robbie Williams showed off his two-story, six-bedroom, nine-bathroom home in L.A., complete with waterslide. Even though Williams enjoyed showing off the property—everything from the fish tank

OPPOSITE: Mariah Carey in the living room of her New York City apartment, 2013. According to the interior designer Mario Buatta, the art deco styling inside was inspired by the architecture of the building itself.

turned cuddle nook to a bedroom with a wall-sized projection screen—it was clear that the cheeky Brit was mocking fame and fortune. Thus it probably should not have been a surprise when his pad was later revealed to be a house that he was renting from actress Jane Seymour. Once the con was discovered, Williams agreed to show off his real, more recently acquired home to the show. But he gets points for joking about himself, like saying he spent Christmas alone because he found it hard to make friends.

Other stars also tried to pull one over on fans. Rapper 50 Cent was a massive success when he appeared on *Cribs*, proudly showing off his vintage sports cars—none of which he owned. They were on loan from a classic

—

"WHILE EVERYBODY WAS TRYING TO SHOW A LAVISH HOUSE, THE LAVISH LIFE OF LIVING, THAT'S NOT ALWAYS THE CASE. NOT EVERY ENTERTAINER'S LIVING LAVISH."
Redman to *Thrillist*, 2016

—

car collector. Lil' Bow Wow was easier to ferret out; his sports cars all bore the name Prestige, a well-known car rental company in Miami. Thirteen-year-old pop star JoJo, meanwhile, showed off her uncle's home because she and her mother had been living in hotels at the time. She later admitted the ruse to the *Daily Star* in the UK.

The funniest example of misrepresentation on *Cribs* occurs during the episode where rapper Ja Rule shows off his "open paradise," a five-bedroom Star Island colonial home rental with a boat dock located in the Miami Beach area. He threw a poolside house party for the cameras that drew the likes of Jay-Z, Redman, Vin Diesel, and Michelle Rodriguez. But it turns out that Ja was only renting this place for the weekend—the baby grand piano and many of the accoutrements seemed out of place with his personality—and the owner of the house sued MTV for not asking for permission to film in his place, and for property damage caused during the party. The rapper had cribbed someone else's crib. It's kinda like throwing a party when your parents are away and them finding the evidence later on Instagram.

It's easy to roll your eyes at the excesses of so many of the *Cribs* stars. So much of it was beyond necessary that it became entertaining for people to see how much the 1 percent really did waste their wealth.

The most unusual profile was of Redman's Staten Island house. This is a rapper who many of his peers would think was slumming it in a rather dilapidated house lacking a garage and even a proper doorbell. He had his money stored in a box, and his cousin was sleeping on the floor because the leather couch was too hot. The producers were shocked, but it made for great viewing.

What made the Redman episode so refreshing was that he did not care what people thought. He wanted to offer something different and reveal the domestic reality of his own life. In a 2016 interview with *Thrillist*, he said, "While everybody was trying to show a lavish house, the lavish life of living, that's not always the case. Not every entertainer's living lavish. They may have a more lavish set on the street, but it's still real for a lot of cats out here in the entertainment game. We're okay, but we're not rich, and that's what I wanted to display to my fans." In doing so, Redman brought a little dose of reality to reality TV.

ABOVE: The pool area at Richard Branson's home on Necker Island, as featured on a memorable episode of *Cribs*.

OPPOSITE: Jane's Addiction/Red Hot Chili Peppers guitarist Dave Navarro enjoys a quiet moment in his Hollywood bedroom, 1998.